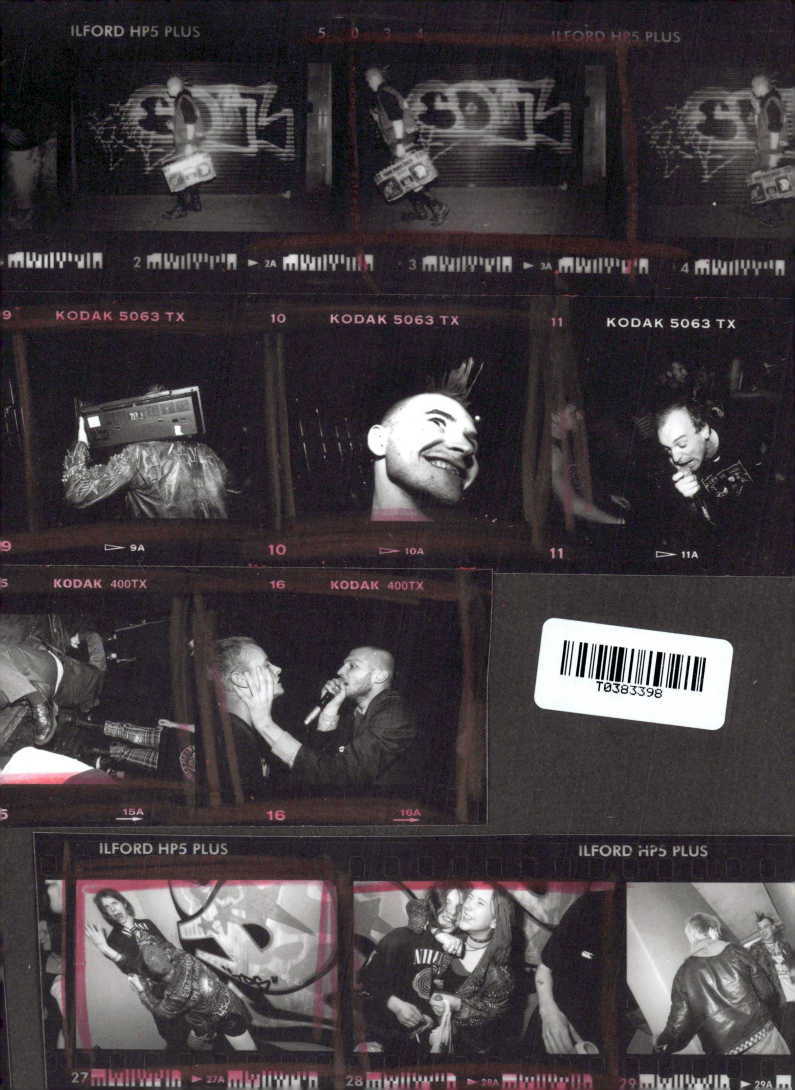

BELFAST PUNK

WARZONE CENTRE
1997 - 2003

RICKY ADAM

I AM NOT A CATHOLIC
I AM NOT A PROTESTANT
I AM NOT IRISH
I AM NOT BRITISH
I AM ME
I AM AN INDIVIDUAL
FUCK YOUR POLITICS
FUCK YOUR RELIGION
I WILL BE FREE

- TOXIC WASTE

BURN

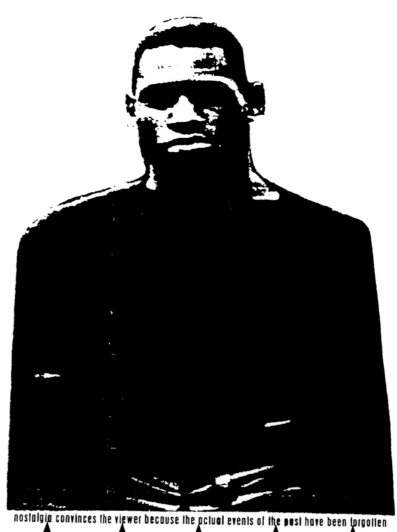

nostalgia convinces the viewer because the actual events of the past have been forgotten

★ ★ ★ ★ ★

ONE MORE tiME/ fROM UEMA SWEDEN/ HAAD KOA

aBHinanDa
PLUS SUPPORT/tBC
at tHE CENtRE
donegall street belfast
sunday 06 september 1998
doors 1900/£3.50

BELfast gig cOLLECtivE/WARZONE©
presentation
★ ★ ★ ★ ★

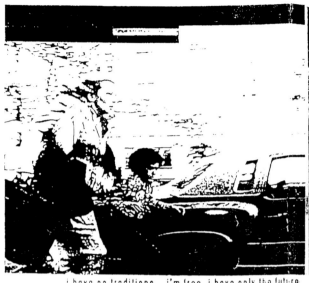

i have no traditions. i'm free. i have only the future.

i have no traditions. i'm free. i have only the future.

HAL-AL-SHEDAD (THE
*from the united statesofamerica. dc-stylehcim
CASTLES + CARWRECKS
from across the water. progression ©
ZERO TOLERANCE
more from over there. punk rock ®
plus 1 local to be confirmed)
the CENTRE
DONEGALL STREET BELFAST
£2.30/ £3.50/ all ages etc
friday september 19
*a belfast gig collective/ centre split
show

7.6°

RUNNIN' RIOT
SKINT
MR NIPPLES
& THE DANGLEBERRIES

@ Giros / Warzone
Saturday
10th March
£3.50 / 8:30pm

Jackbeast
Innovative hardcore from Dublin
Cheapskate
Anarcho-punkers from Dublin
The Kabinboy
Slow & heavy from Belfast

The Centre.Fri.27th Feb.8pm
Admission 3 quid.Bring yer own

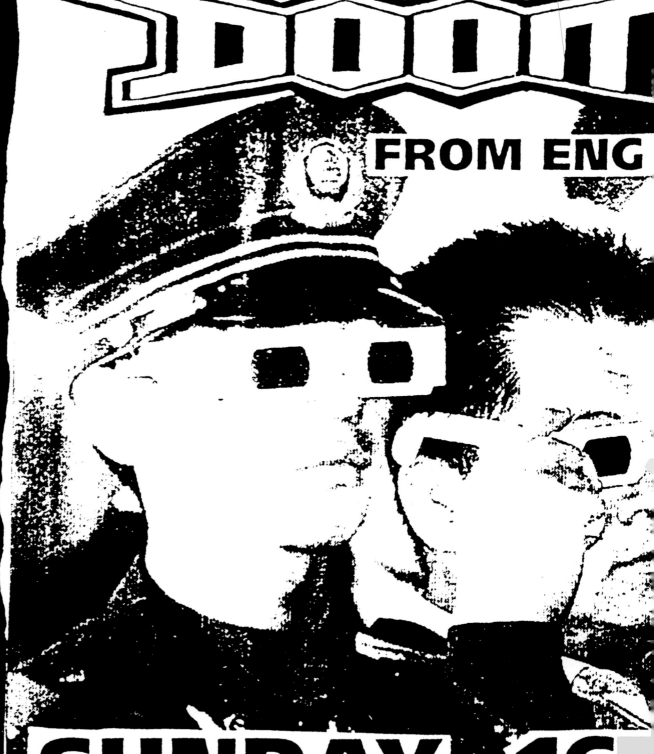

THE GODS OF GRIND RE

DOO

FROM ENG

SUNDAY 16

THE CE

URKO
FROM ENGLAN
SCALD
FROM BELFAS

DOORS OPEN 8:0
BRING YOUR OW

RN

ND

MARCH
ITRE £3.50

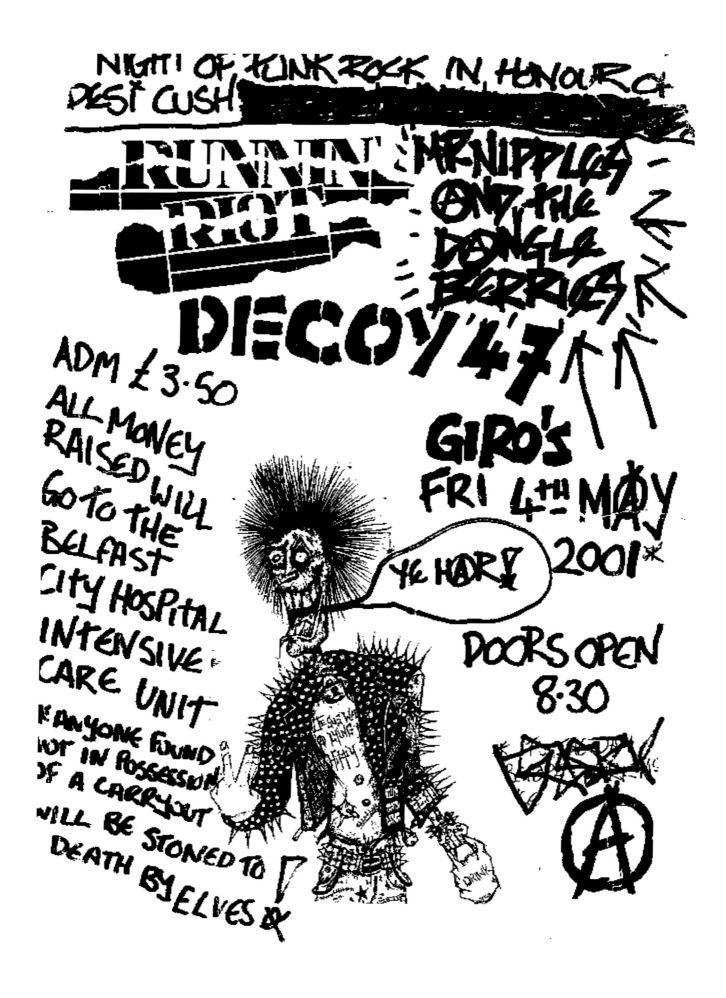

PLUS SUPPORT FROM "THE Y-FRONTS'

LIVE AT "THE CENTRE"
WED. 2ND JUNE †999

5 QUID ON THE DOOR
DOORS OPEN 8.30 PM
BRING YOUR OWN BOOZE

THE CENTRE,
5 LONEGAL LANE,
LONEGAL ST,
belfast

Legacy Issues:
by Chris Magee

Looking back, it all seems so long ago. Our most recent round of elections in the North brought out newly enfranchised voters all of whom were born after the ceasefires, who have not known the violence which scarred the majority of the period covered in this book. So much has changed, in our society and more broadly. Trying to refresh memories by examining old technologies - posters, flyers, contact sheets, video tapes - only emphasises this. As well as our world changing, our vocabulary has shifted as well. 'The Troubles' are over. 'Accommodation' has replaced 'confrontation.' 'Legacy issues' remain. 'The Past' has taken on enough importance to warrant capitalisation. And a 'post-conflict society' has replaced the 'Warzone'.

The Warzone Centre, in its various incarnations, was not unique. It followed in the tradition of autonomous centres and venues which were established in the wake of that brief period where punk was popular culture. Many had been inspired by punk's DIY ethic and they had taken the original movement's lip-service adherence to anarchism and run with it. Musically, the Pistols and the Clash may have inspired a generation, but it was bands like Crass who had offered them a political outlook and framework to go with it. What was different about the Centre was the society that spawned it. The political situation in Northern Ireland in the late '80s meant there was a genuine necessity to doing it yourself.

By then, the Troubles had run for twenty years. Violence had erupted in the wake of the inability of the Northern Ireland government to respond to the demands of a nascent civil rights movement in the late '60s. It had led to the state's collapse, the imposition of direct rule from London and the militarisation of the conflict. By the '80s, sectarian divisions between catholic and protestant had been deepened and were becoming ossified. The separation between the two communities which had always been apparent since the creation of Northern Ireland was exacerbated. Educated apart, young people rarely socialised with anyone from the other side. With the risk of violence, communities - especially the working-class communities of both sides - turned inward.

The punk scene offered an escape from that. Where you were from did not matter. And in Belfast and the North, where you were from carried a tell-tale incrimination. Where you lived invariably indicated what religion you were. And what religion you were invariably indicated what your politics were. Punk not only ignored that, it increasingly offered a space where questions could be asked about why society was divided and how those divisions could be overcome, offering a new politics entirely. More immediately, and more practically, it offered an actual physical space in the form of the Warzone which provided a venue and practice rooms as well as a cafe and drop-in centre. Belfast had literally bunkered down in the period. A bombing campaign by paramilitaries had reduced the city centre to a 9 to 5 existence and venues were at a premium.

The scene looked out as well as in and other, wider questions were asked. Irish society - north and south, catholic and protestant, was profoundly conservative. This was a time when clergy from both sides could come together to campaign to 'Save Ulster from Sodomy', to ensure that education was kept along strict sectarian lines. More, the period of course saw the radical right in the ascendent with the North feeling the effects of Thatcherism and the associated economic downturn. There was a nod to this with the Centre's cafe being called 'Giro's' after the name of the welfare payments of the time. And it was the Belfast Unemployed Resource Centre who helped with the original premises. The future prospects of the generation who were coming of age in the '80s and '90s were limited both by entrenched political violence and the new realpolitik of the era.

The punk scene's ethos and identity offered an alternative to this cultural staidness and economic determinism. The Centre allowed a space to develop where questions could be asked about the position of women in society, on issues of sexuality, on environmentalism and animal rights and on the role of religion. It encouraged an environment and atmosphere where fanzines could be written and printed; bands could form, rehearse and perform; ideas could discussed and debated; the like-minded could be encountered. The libertarian underpinning of the DIY ethos shared little with the libertarianism of the New Right. This wasn't a radical individualism but rather a collectivism often driven by necessity - a pooling of ideas as well as resources. In this, it built upon the foundations which had existed in the city - those laid down by the Belfast Anarchist Collective's Just Books bookshop and its Anarchy Centre, which had hosted Crass's 1982 gig.

The line that runs from the Centre's prehistory in the late '70s and early '80s continues on through the end of the first incarnations of the Warzone into the 'new' Northern Ireland. After a hiatus, the Warzone centre was relaunched in 2011 in a new location in Belfast and, in 2016, Just Books was re-established in the city centre. Many of the same people continue to be involved. Inspiration for these projects comes from an understanding that, while society has moved on from the Troubles, there is still much to do. Sectarianism still exists, new economic orthodoxies need to be challenged and there remains a distance to go on issues of reproductive rights and gender equality. And there are still those who want to make music, take photos, create art, encourage ideas, provide spaces which welcome, nurture and challenge.

Welcome to Ulster:
by Petesy Burns

Welcome to Ulster '71. A trade fair in the leafy suburbs of South Belfast during one of the worst years of what affectionately became known as the troubles. As communities battened down the hatches, the ads added insult to injury … "Ulster '71, come and join in the fun!"

Welcome to Ulster '78. In the true fashion of being 2 years behind whatever happened across the water, Belfast got punk rock, a few years after it had exploded in London. The Harp Bar opened its doors to the punks. The Young Americans, and early punks who had frequented the likes of the Viking and The Trident in Bangor in '76 and '77, were by and large reluctant comrades with working and middle class kids who were new to the scene. Vital in the midst of a music scene that had been blown apart by bombs, shot up with guns and intimidated into itself.

Welcome to Ulster '84. The dreams of changing the world transformed into disillusion. Rebellion truly had turned into money, and punk rock had to a large extent become a sorry parody of itself. The words 'The leaders sold out, now we all pay the cost' were still ringing in our ears, and the troubles hadn't gone away you know. The anti sectarian seed that punk rock had planted in our hearts had germinated, but needed more room to flourish. There were still young and not so young people coming to punk, there were still bands, there were still a few places to play, but on whose terms? There was definitely a pattern of rejection, closely followed by ejection, when it no longer became profitable for bars and clubs to allow punk bands to play there.

The Belfast Anarchist Collective had given us a glimpse of something else, another way of doing things when they opened the Anarchy Centre in Belfast in '81. The message was simple: if you want to control what you create, you gotta do it yourself and not wait for someone to do it for you.

I could say that we chose 1984 to form the Warzone Collective as a utopian gesture of positivity, a polar opposite of the Orwellian dystopian negativity of the book, but that would be bollocks. It just happened to be 1984 when interest in playing here from bands from outside Belfast, mostly connected with the anarcho punk scene, substantially increased and we were together enough to help them out. When I say we, I am talking about a handful of bands who played about Belfast, and were used to pooling their individual resources in order to make gigs possible. Although the Anarchy Centre was long gone, the Belfast Anarchist Collective was still running their bookshop/printshop/drop-in in Belfast city centre. Fortunately for us, the people running the drop-in dropped out, and we were asked would we be interested in taking it on. So a bunch of skint musicians and friends with lofty ideals now had a base to start working on them.

It would take 2 years of hard work, and a very fortunate involvement with Belfast's new Centre for the Unemployed, before we would have our own premises in the heart of what was to become Belfast's cultural quarter. Back then, it was the forgotten part of the city centre.

We set about soundproofing the ground floor as a practice space, kitting out the middle floor for a veggie/vegan cafe/drop-in, and the top floor as a screen printing and general workspace. We created the Belfast Musicians Collective, and within months our membership was at capacity. Our practice room was permanently booked out weeks in advance. Volunteers who ran the drop-in found it hard to keep up with demand - the place had a queue up the stairs most days. Activist groups were using the place as a meeting space: we had poetry nights, impromptu gigs in the practice space, mad all night parties... Belfast hadn't seen the like of it, and the people flooding through our doors couldn't get enough.

We got a lot more adventurous and started to use the Belfast Art College for gigs, including daytime all ages ones. Warzone, in collaboration with the Belfast Gig Collective (which was also based at our centre) brought touring bands from all over the world to Belfast audiences, and they lapped it up. The need for a bigger building was more than obvious so in 1991, five years after opening our first premises we moved to a much bigger building just up the street. We continued in the same vein, only this time we were able to establish our own 200 capacity venue and a recording studio. We stayed in this place until we decided to call it a day in 2003. Seventeen years of running a social centre where all we earned was stress and burnout, had taken its toll.

People who flirted with punk, be they the first wave or those who came to the party late, never quite got it. We witnessed every wave of punk and each was every bit as vital as its predecessor. The early punks would have you believe they were pioneers, and there is an element of truth in that. The birth of punk in Belfast certainly was a momentous event and life changing for many. It endured, changed shape and still goes on today. Ricky captured the last 5 years of the original Warzone Collective, a snapshot of a history that has been all too often overlooked. The spirit, the energy, the passion, the pain, the sheer madness of what was termed by the late Mairtin Crawford as *Ramshackle Bohemia* has been immortalised.

D.I.Y:
by Marty Martin

It has often been said that the reason punk was more popular in the north of Ireland than anywhere else in the world, is because we needed it more, and it's true.

The late seventies and early eighties were a desperate time for growing up. The bitter little civil war that had been going on for over a decade was reaching its climax: the full power of Thatcher's Britain was about go into full revenge mode, and the whole world seemed to be on the verge of self destruction. It was against this backdrop that me and a few friends from Newtownards (a small shithole town on the outskirts of Belfast City) were persuaded to start a punk band, move up to the big smoke, and start a revolution. Influenced by English anarcho bands like Crass, Conflict, Flux of Pink Indians, and Dirt, as well as the previous old guard of Irish punk bands like SLF, the Defects and the Outcasts, Toxic Waste was born. Within a year of moving to Belfast we had released a split 12" with our old comrades in arms, Stalag 17, and embarked on a tour of England. It was quite an eye opener.

All the venues (apart from the Station and the Bunker in Sunderland and Newcastle) were shithole pubs with precious little of the solidarity we were used to in Belfast, and with even less money from the door, we had barely enough to pay for petrol to get to the next gig. A year later however, we set off on a tour of Europe, and this time it was different. All the venues were superbly organized, whether squats or social centres, and they treated every touring band (even no names like ourselves) with decency and respect. Stalag 17 had similar experiences to ourselves, so on returning we vowed that, together with other like minded punks from the local scene, we would start a similar centre that we had visited in the likes of Antwerp and Bremen. A DIY centre free from licensing laws, bouncers and petty restrictions, where everyone who worked there had an equal say in the running of the building. A venue, practice room, recording studio, café, screen printing workshop, and photography dark room all run for the benefit of everyone in our local scene. We called it the Warzone Centre because that was how it felt at the time.

The years went by and the Centre only got bigger and more
popular. By 1997 (10 years after it started) I had played
in a couple more punk bands (Pink Turds in Space and Bleeding
Rectum — yes that was what they were called — you had to be
there at the time!) and was now an ageing burnt out punk rocker
at the ripe old age of 30. My playing days behind me, I had
taken on the recording studio and was now recording the latest
crop of punk rock upstarts. It was around this time that I first
met Ricky and his band the Kabinboy, who I loved on the very
first hearing. No vocals, gigantic riffs and 7 minute songs, of
which 5 minutes would be nothing but screeching guitar feedback
— brilliant! There were other great bands around then that also
recorded in the studio: The Dagda, My Name is Satan, and Runnin
Riot, to name but a few of the classics.

Punk always seemed to come in waves and this time was one of
the biggest, and there to capture it all with his camera was
Ricky. I don't think I ever saw him actually take a picture...
it was only ever afterwards when he produced them that I went
wow! The action, atmosphere, rawness….the truth, he always got
it. I always thought somebody would eventually write a book
about those times, but memories fade and the spirit gets lost.
Not so with Ricky's images. If only he had been about in 1984!

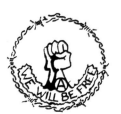

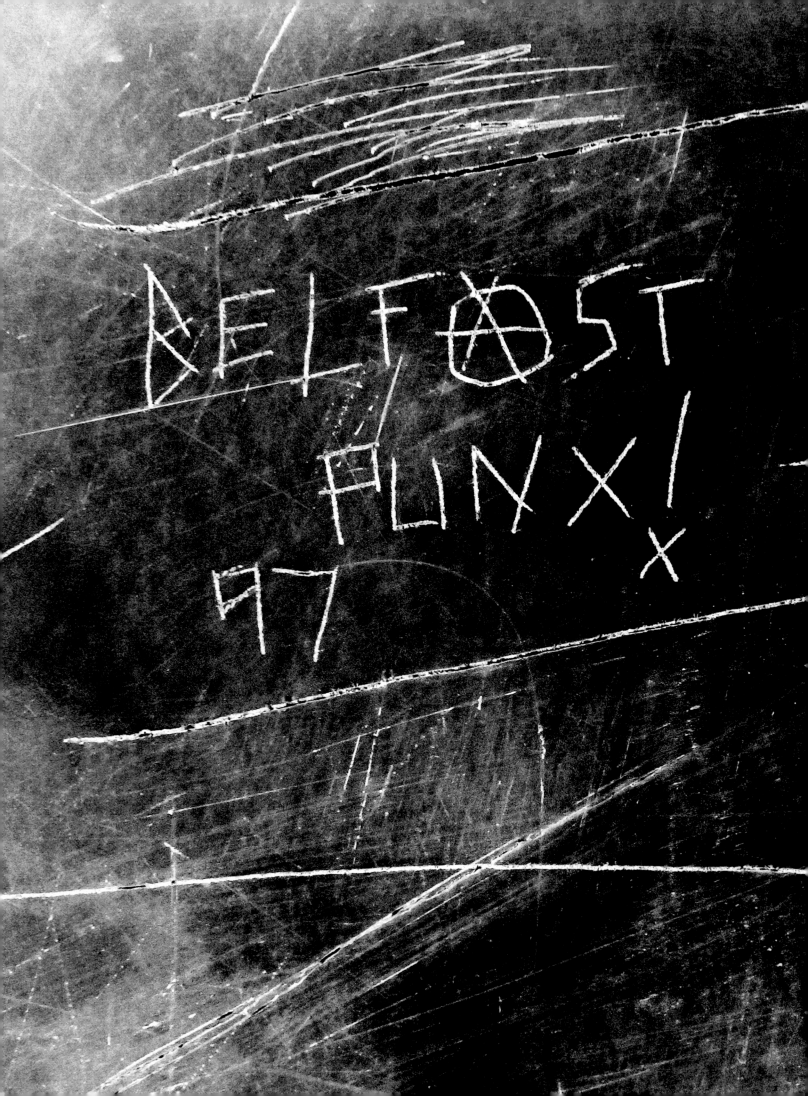

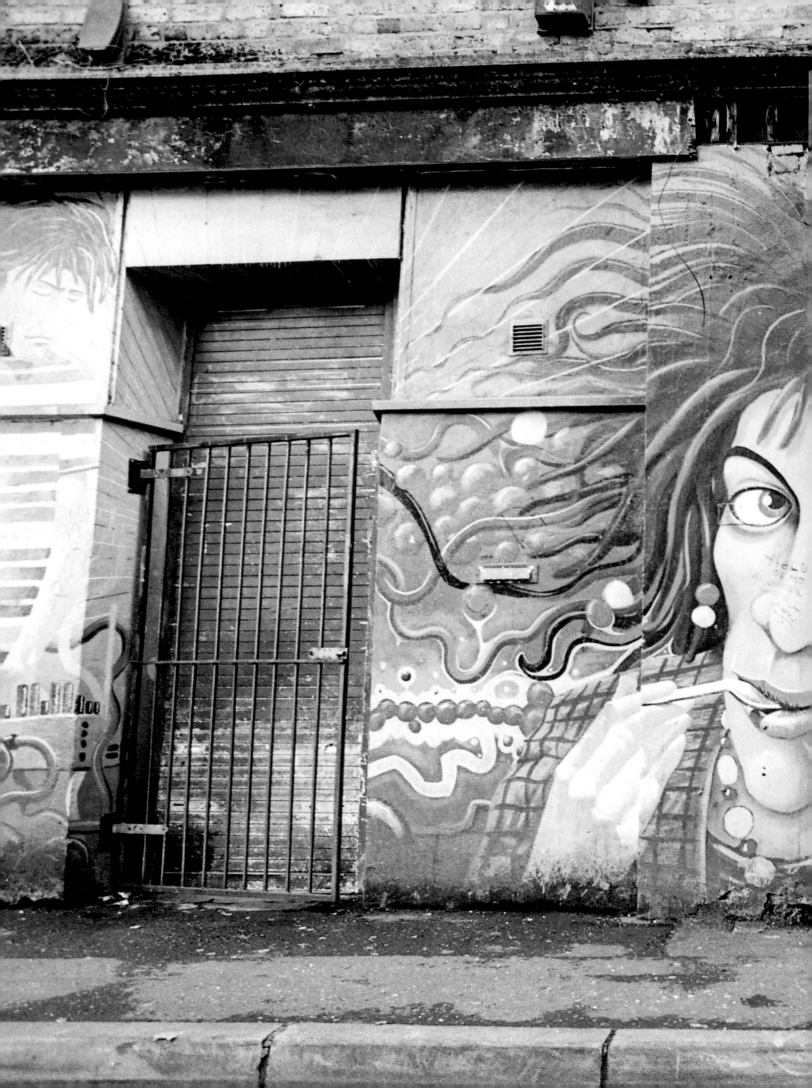

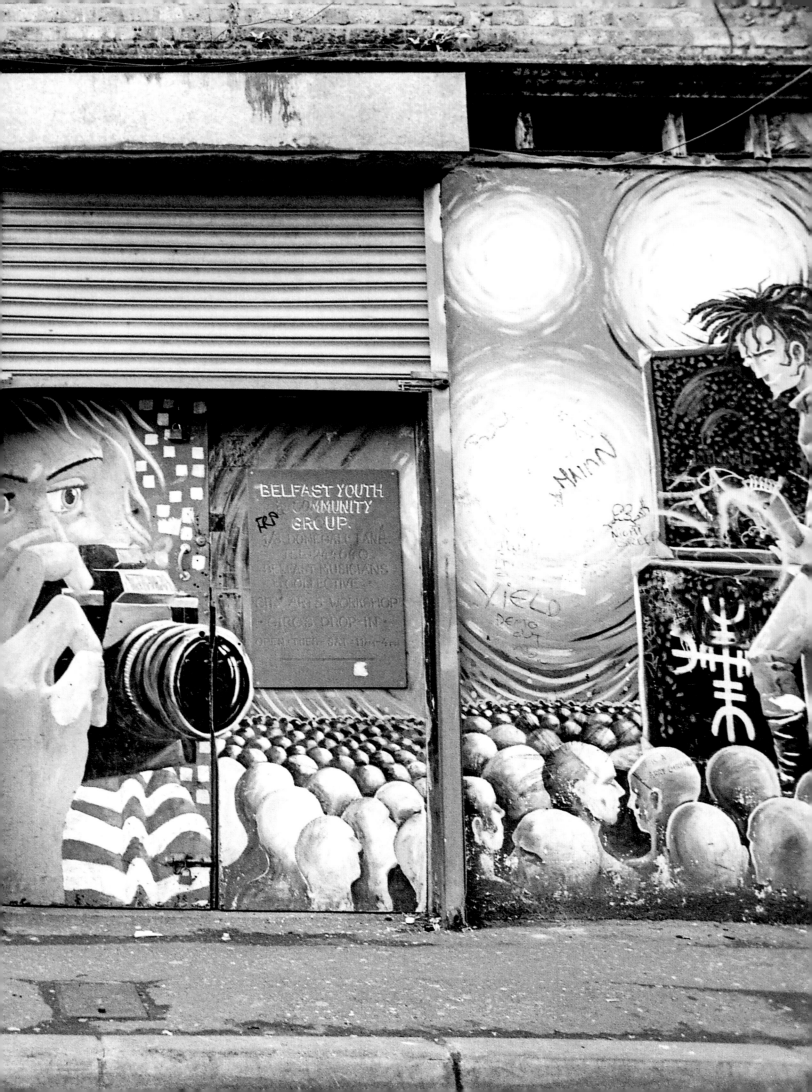

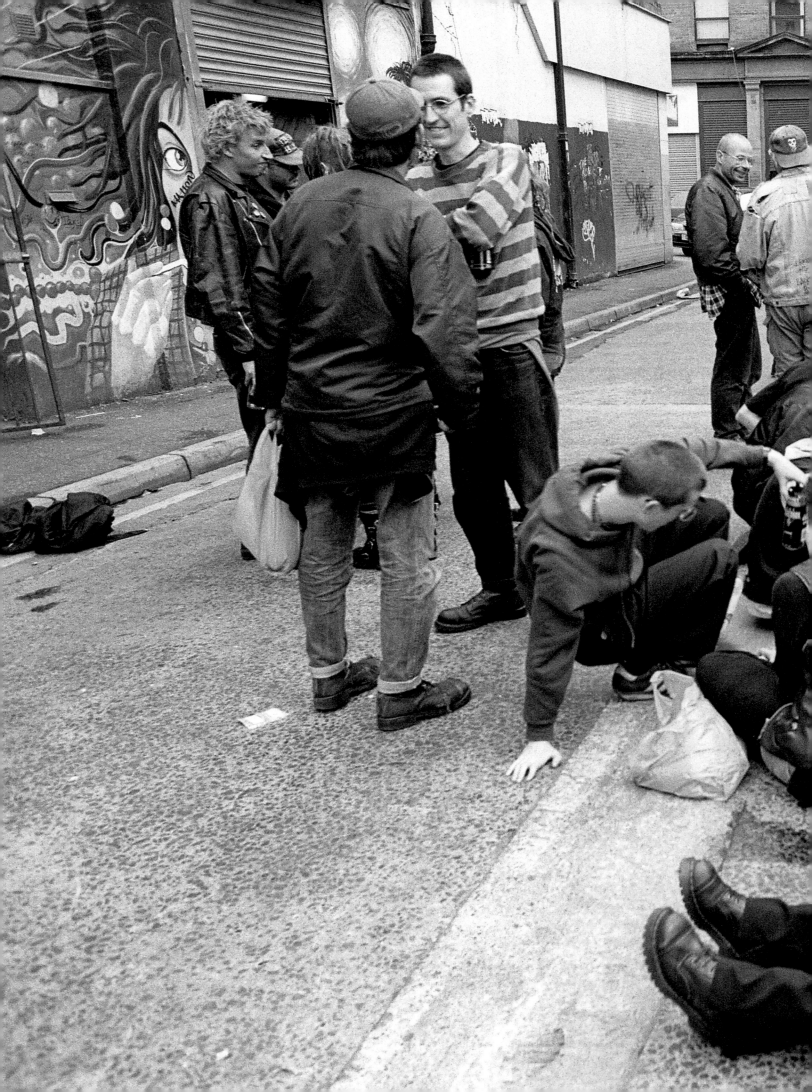

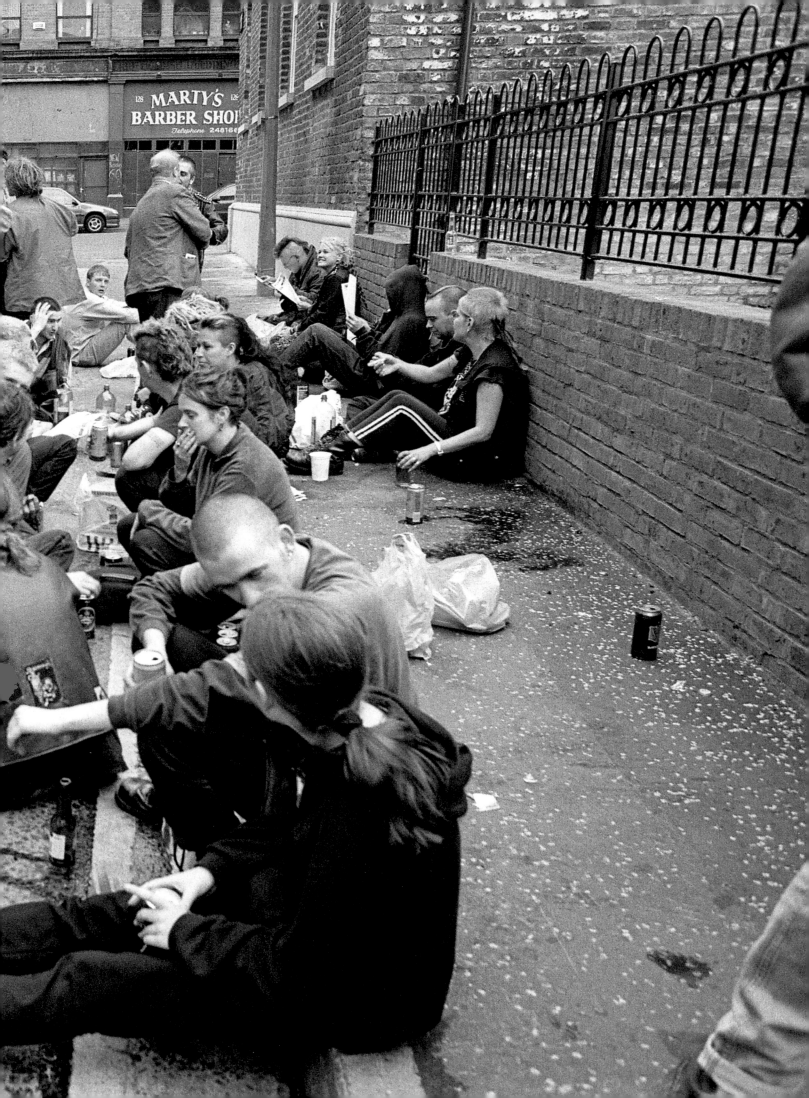

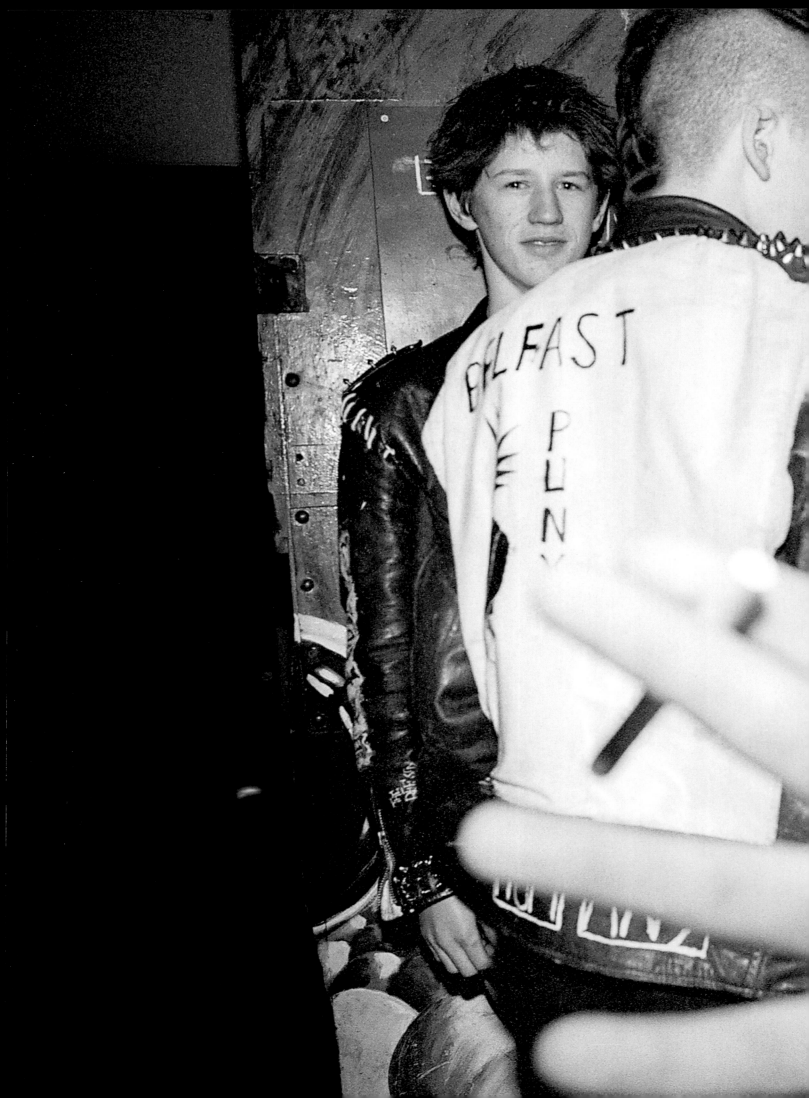

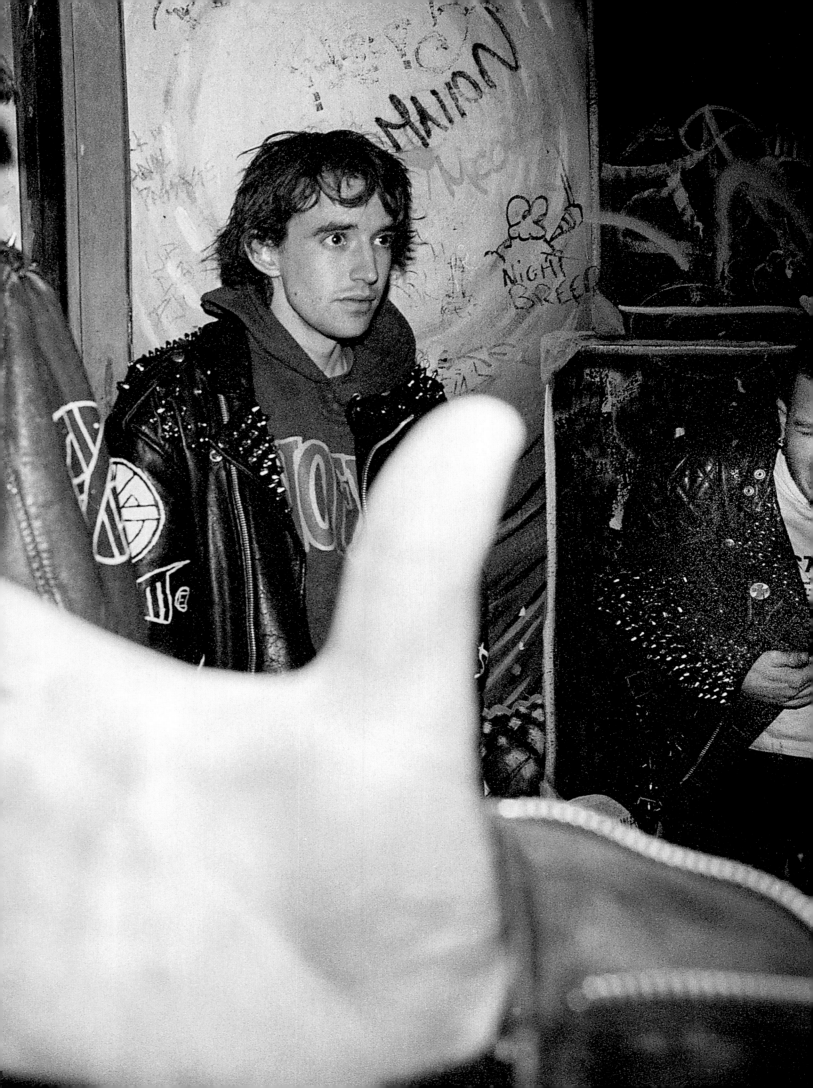

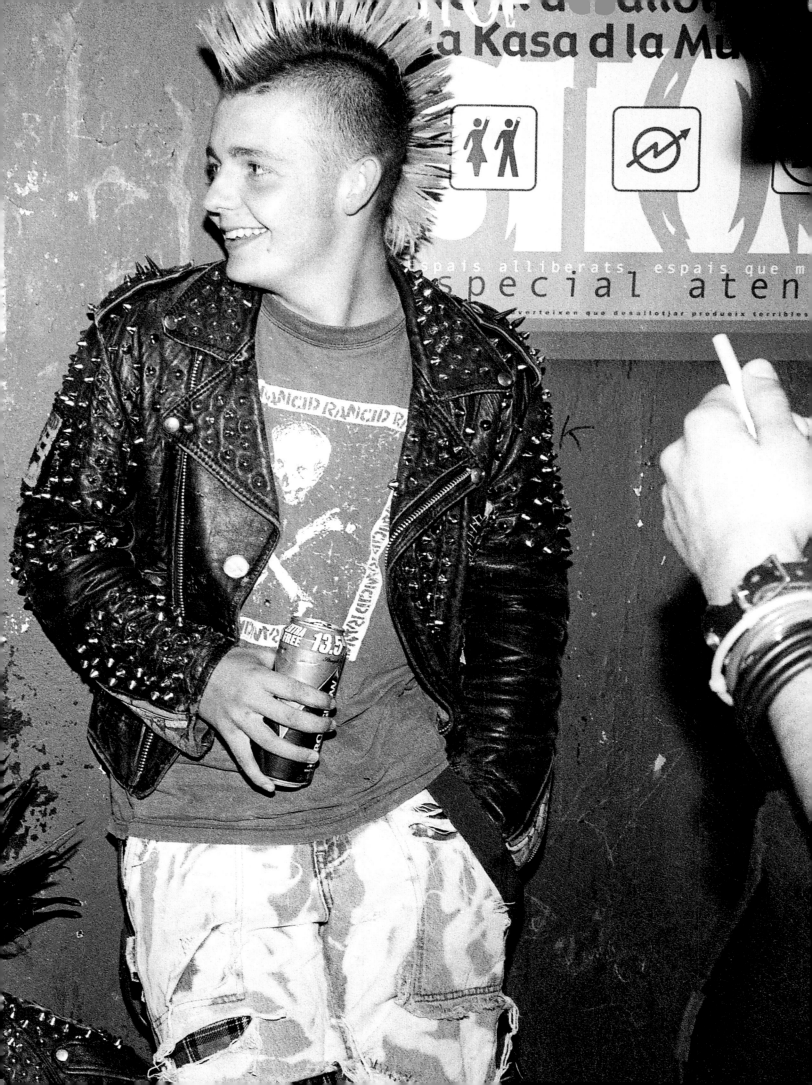

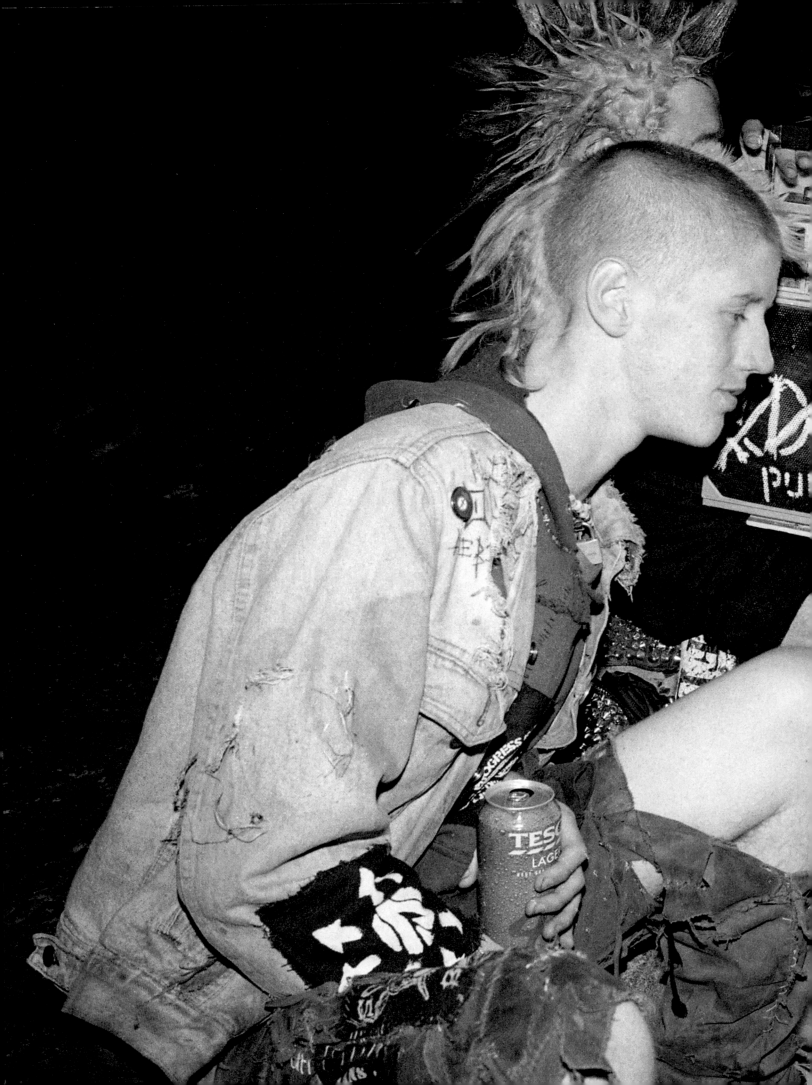

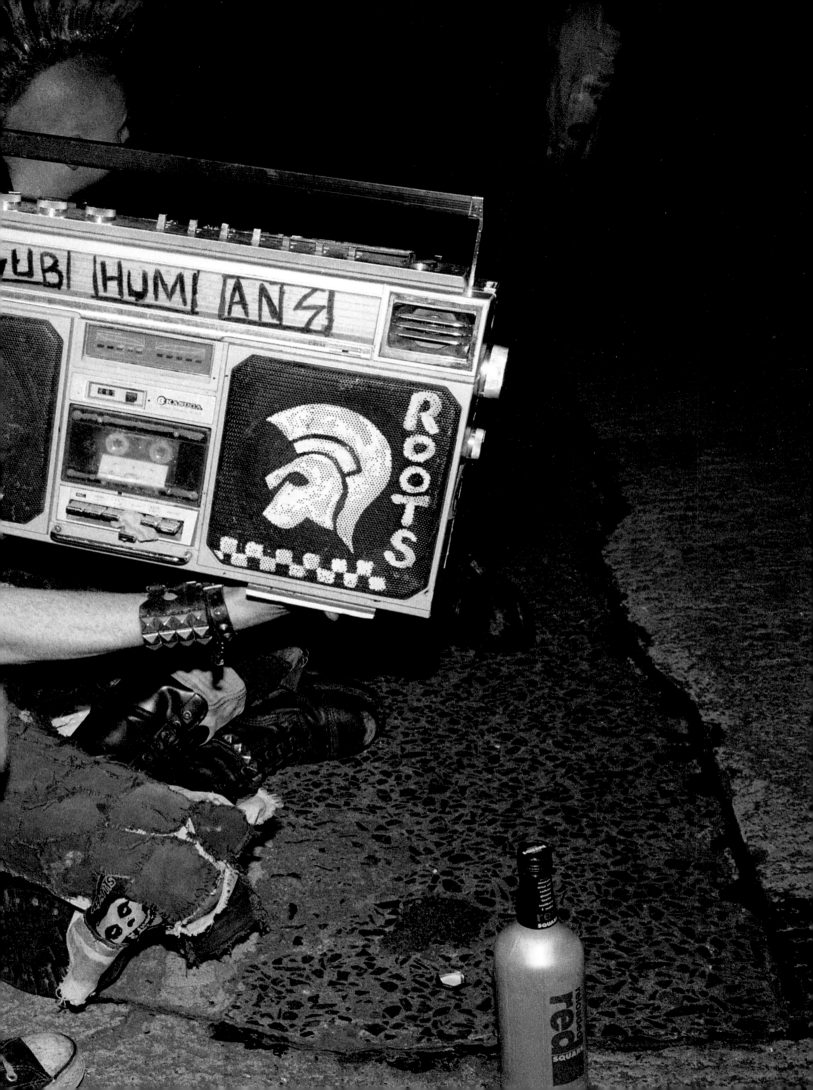

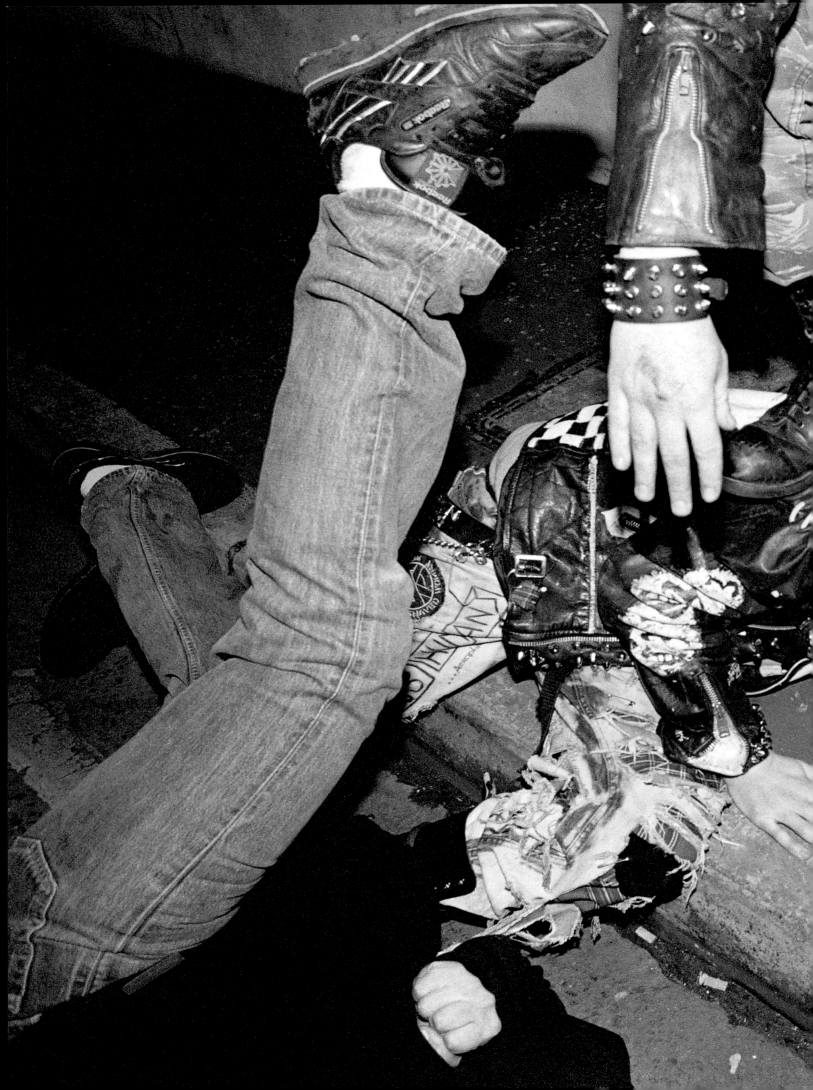

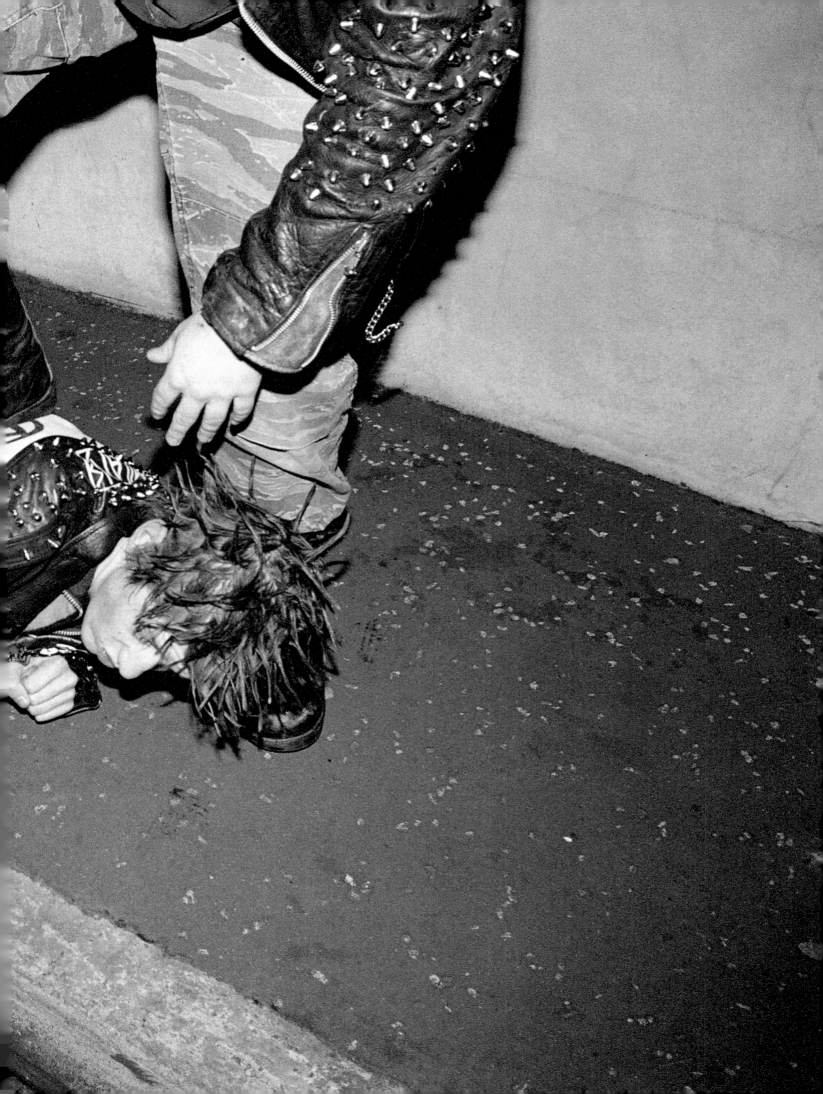

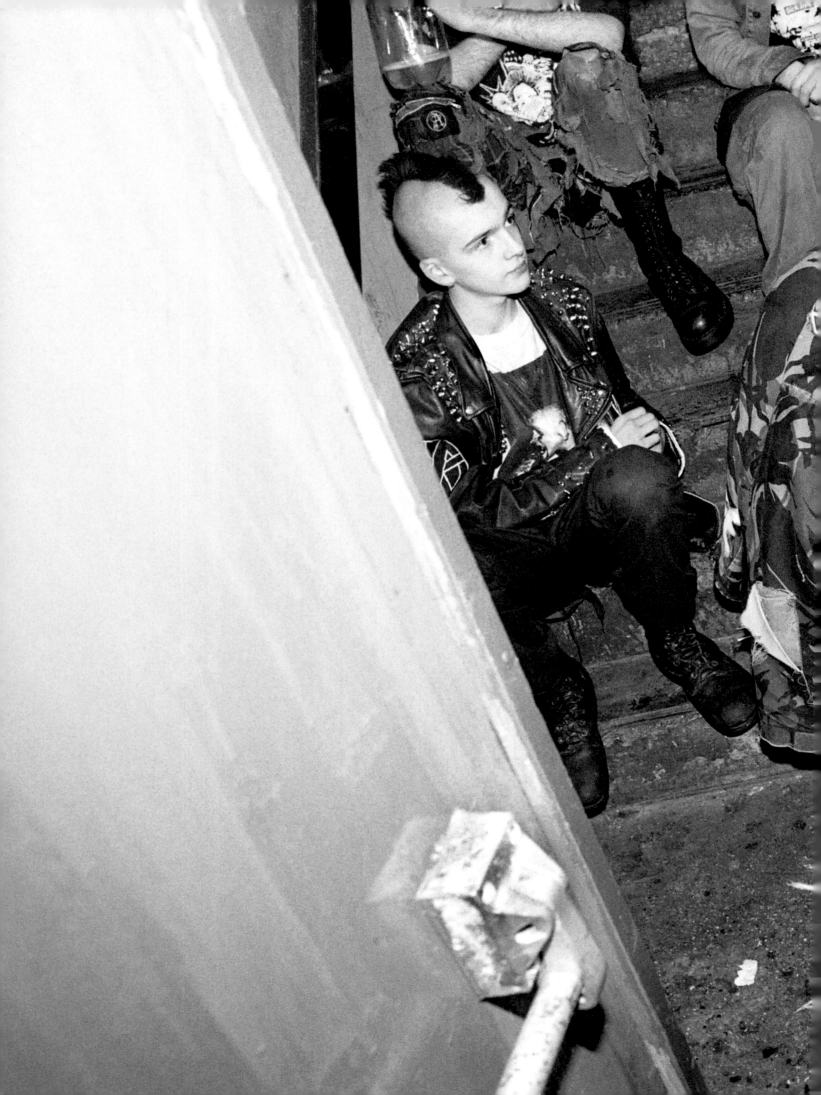

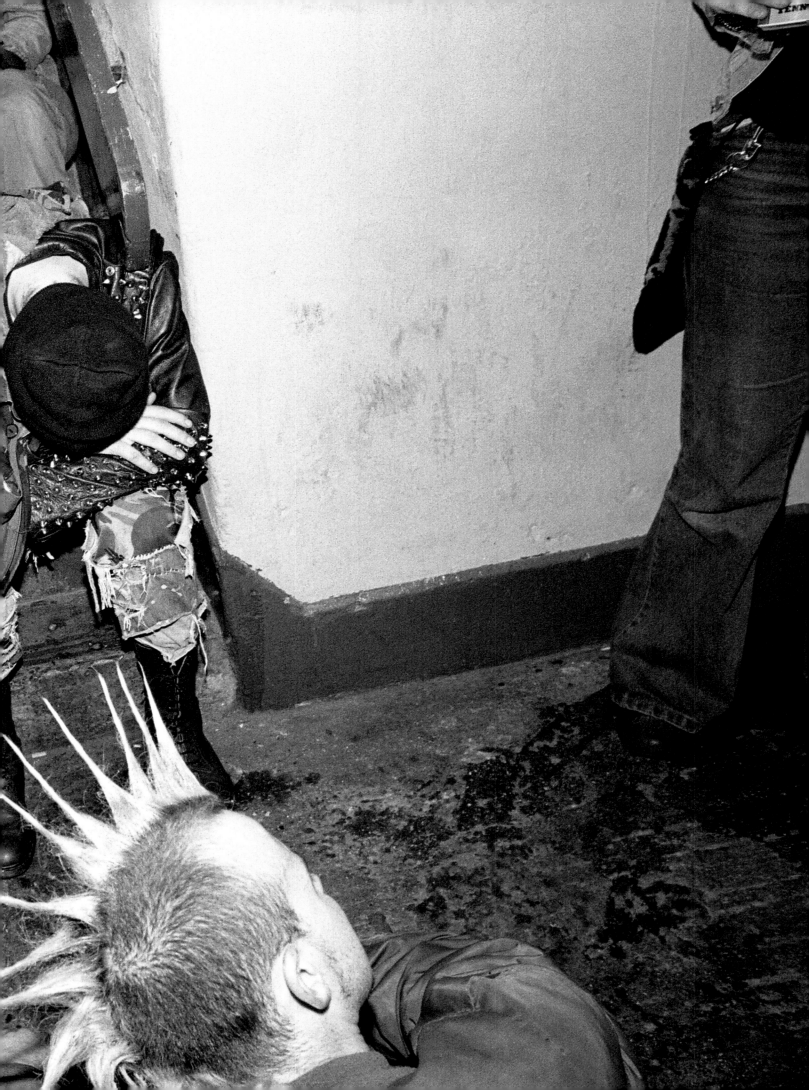

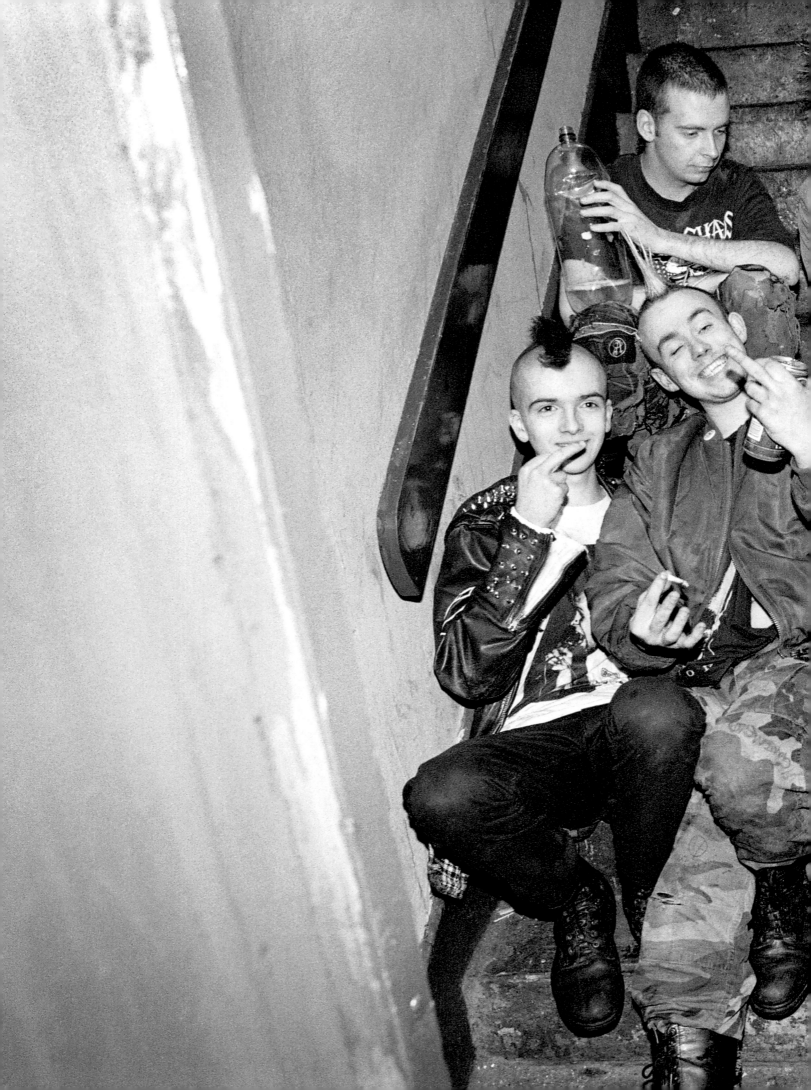

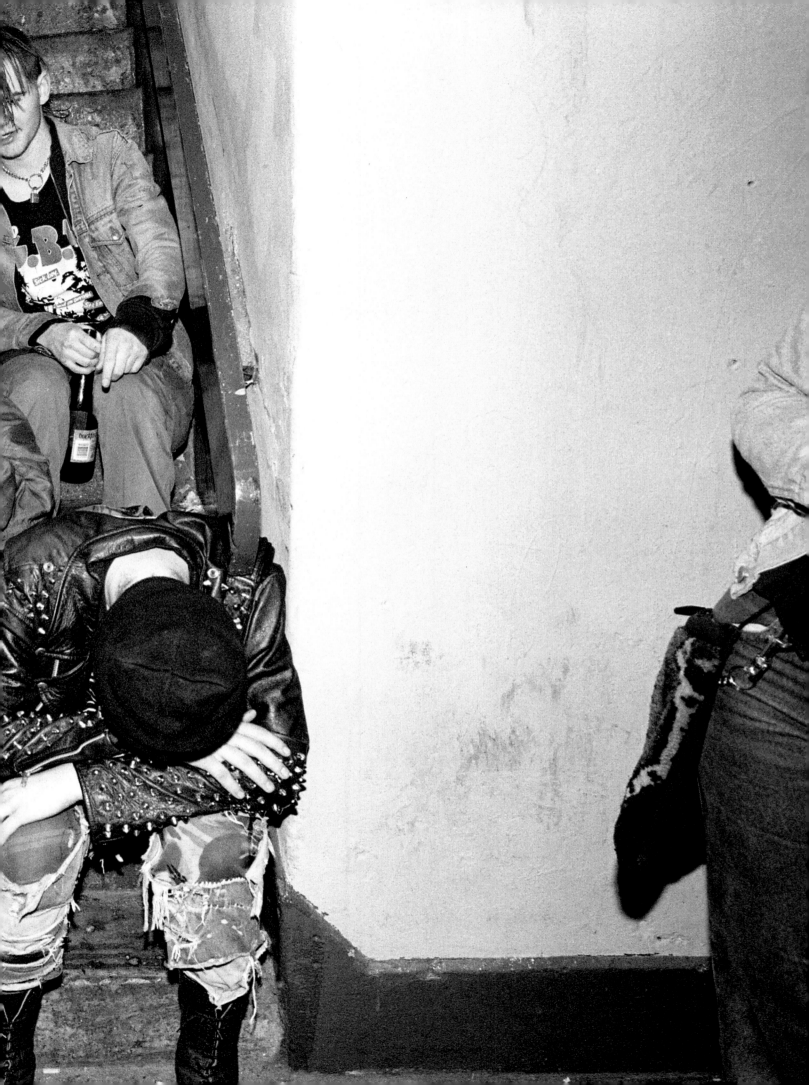

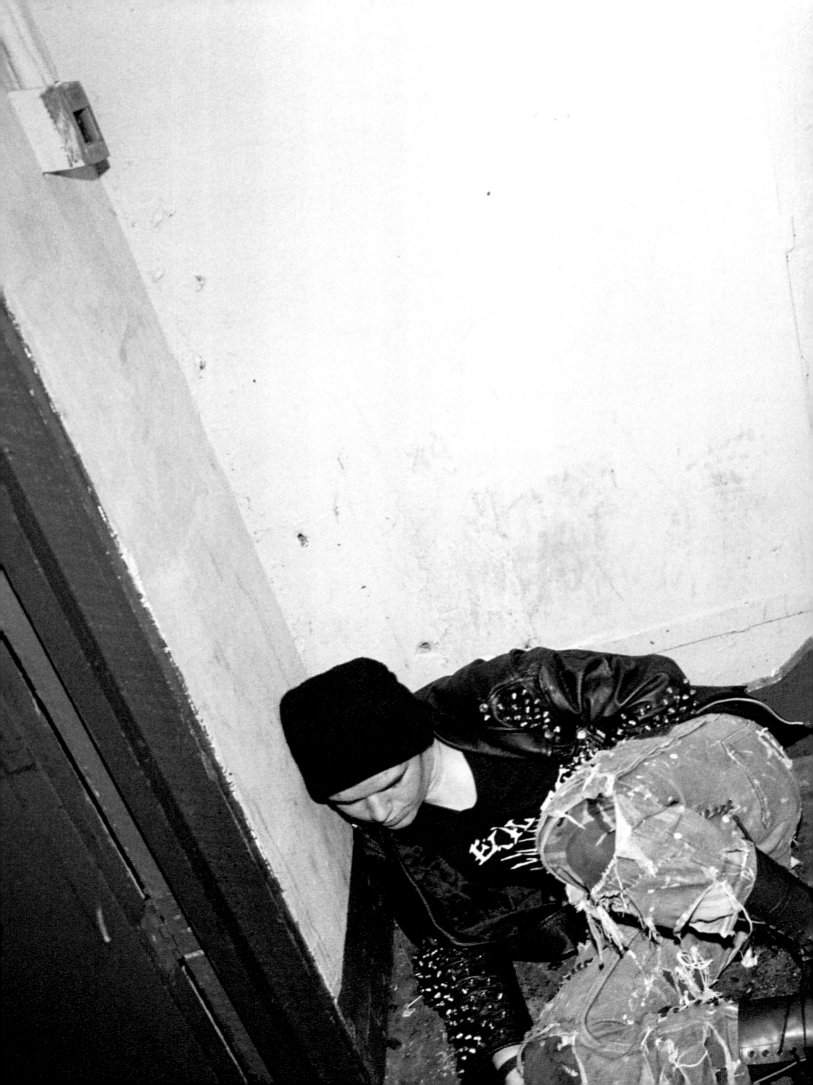

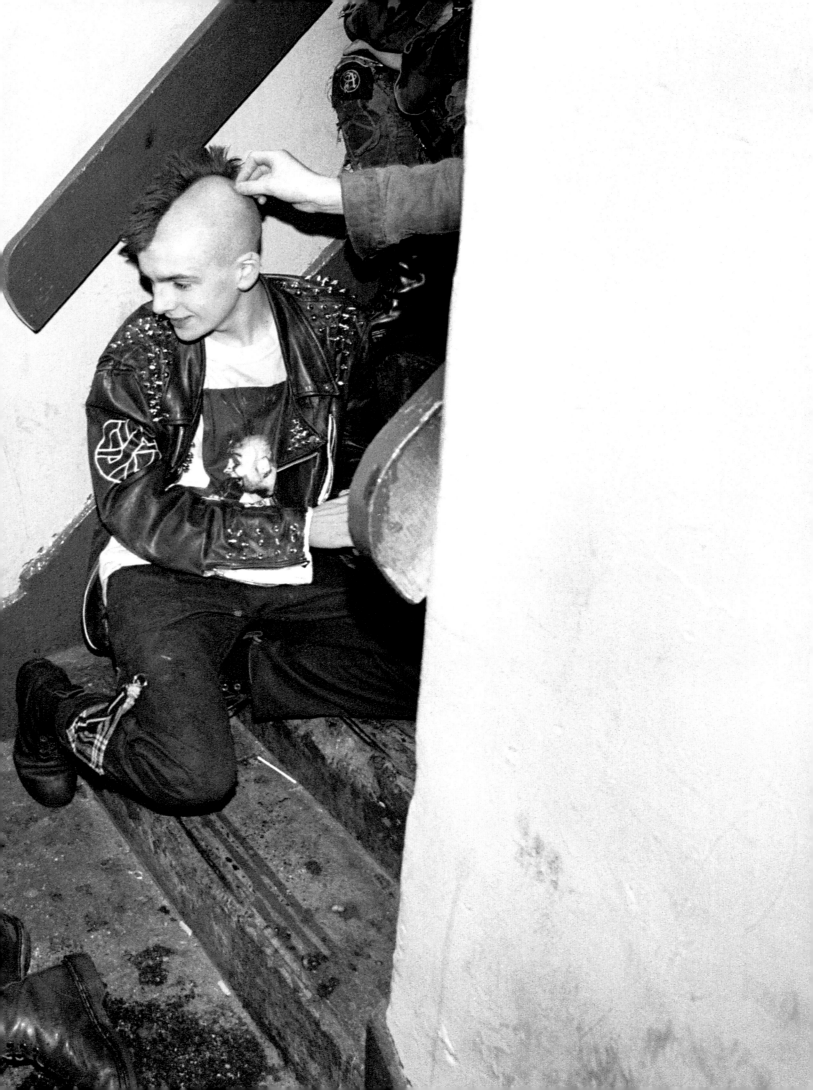

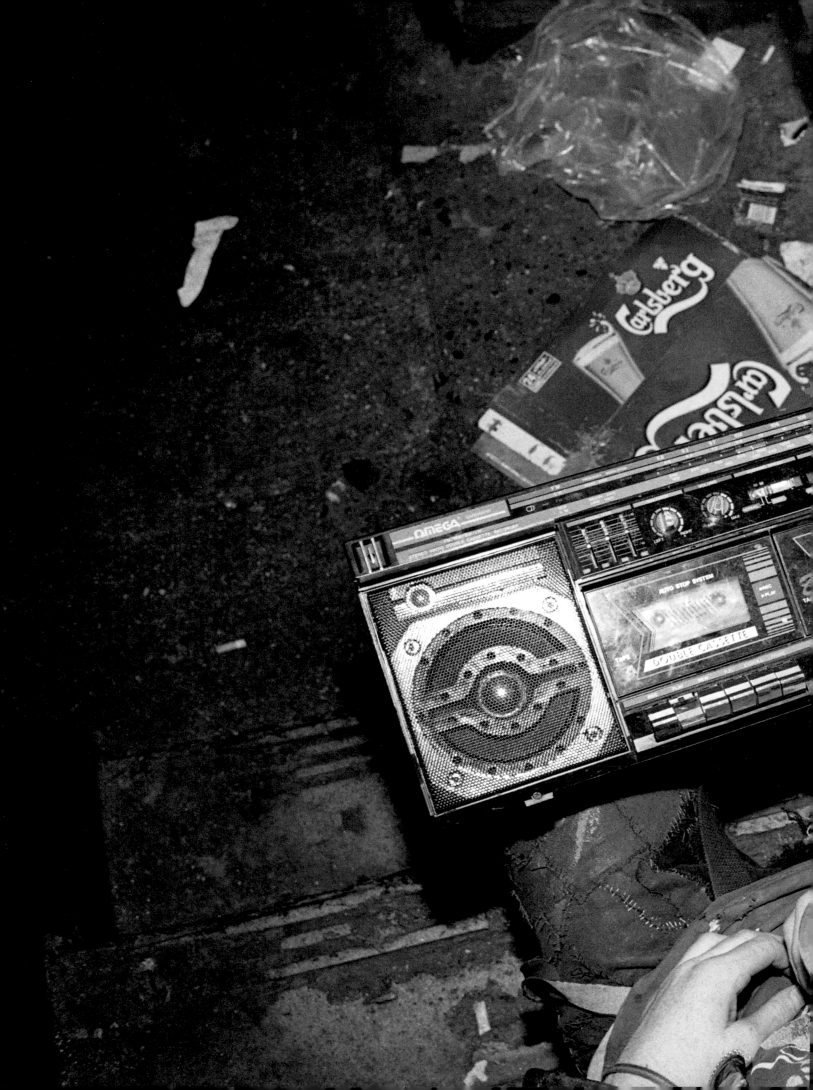

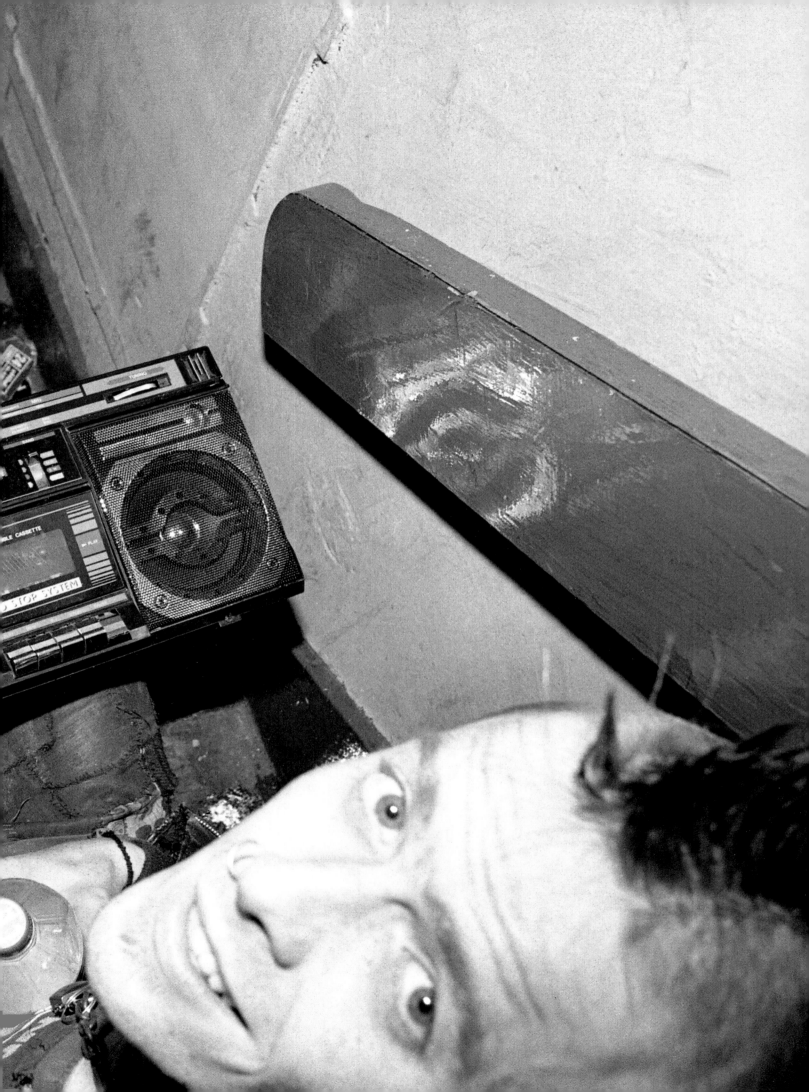

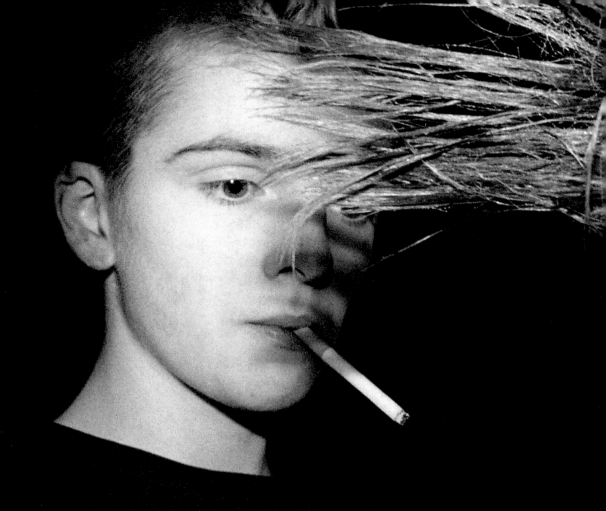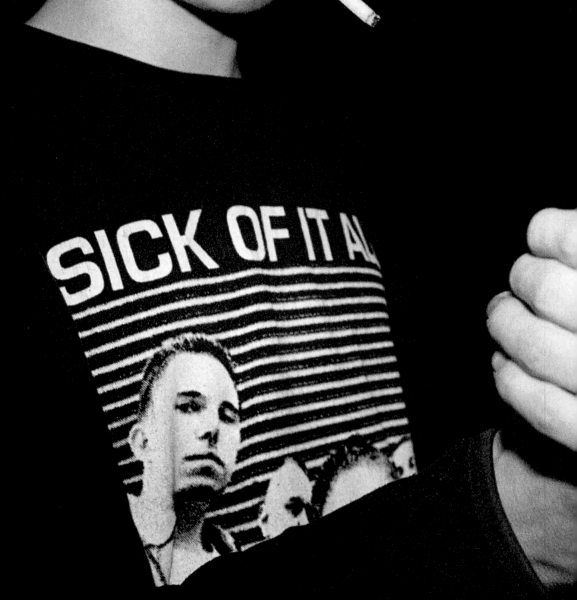

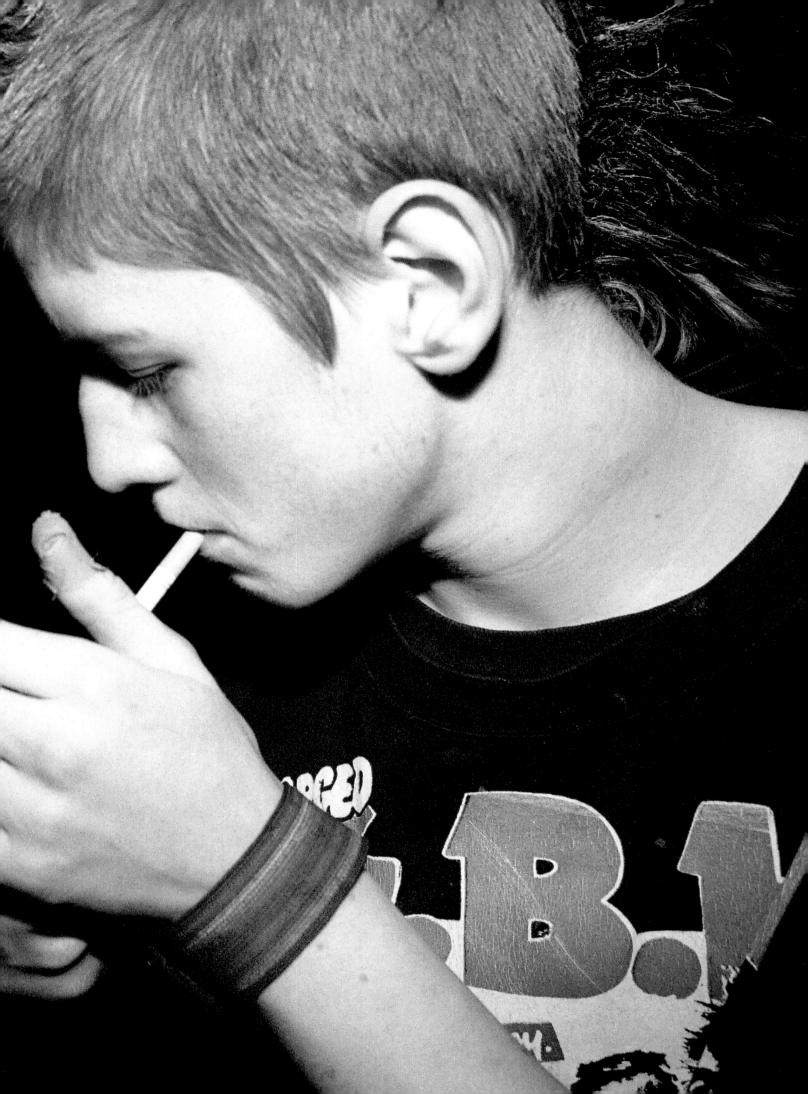

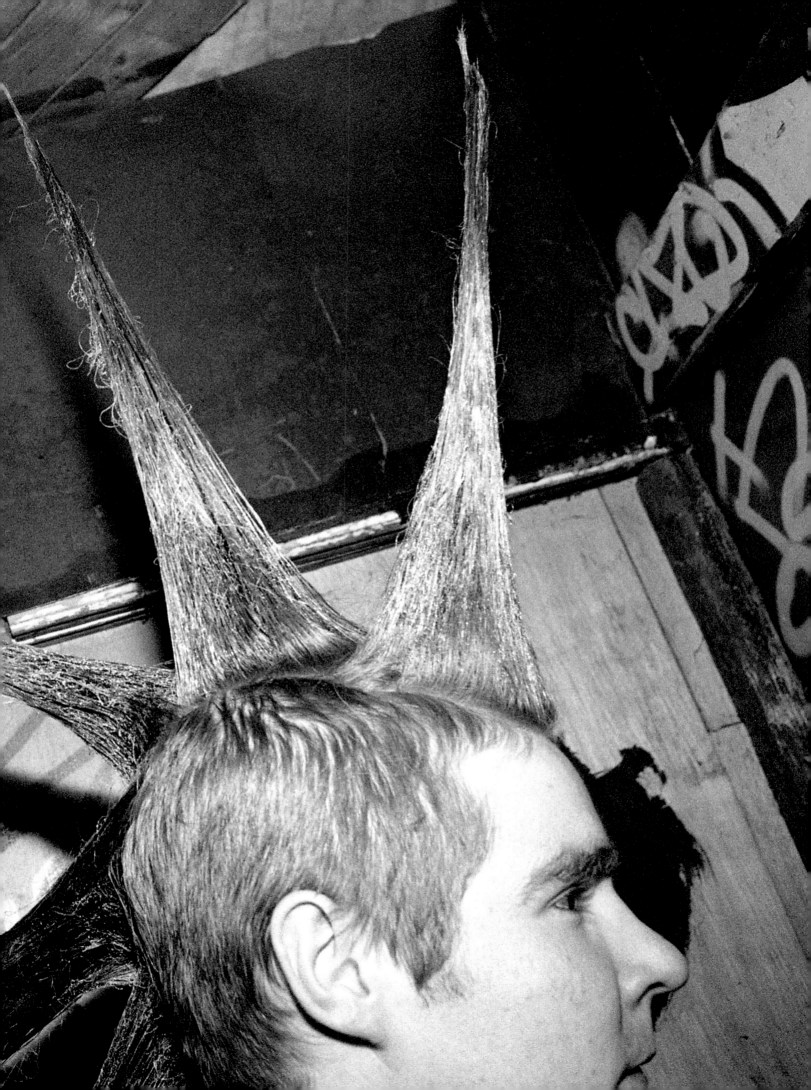

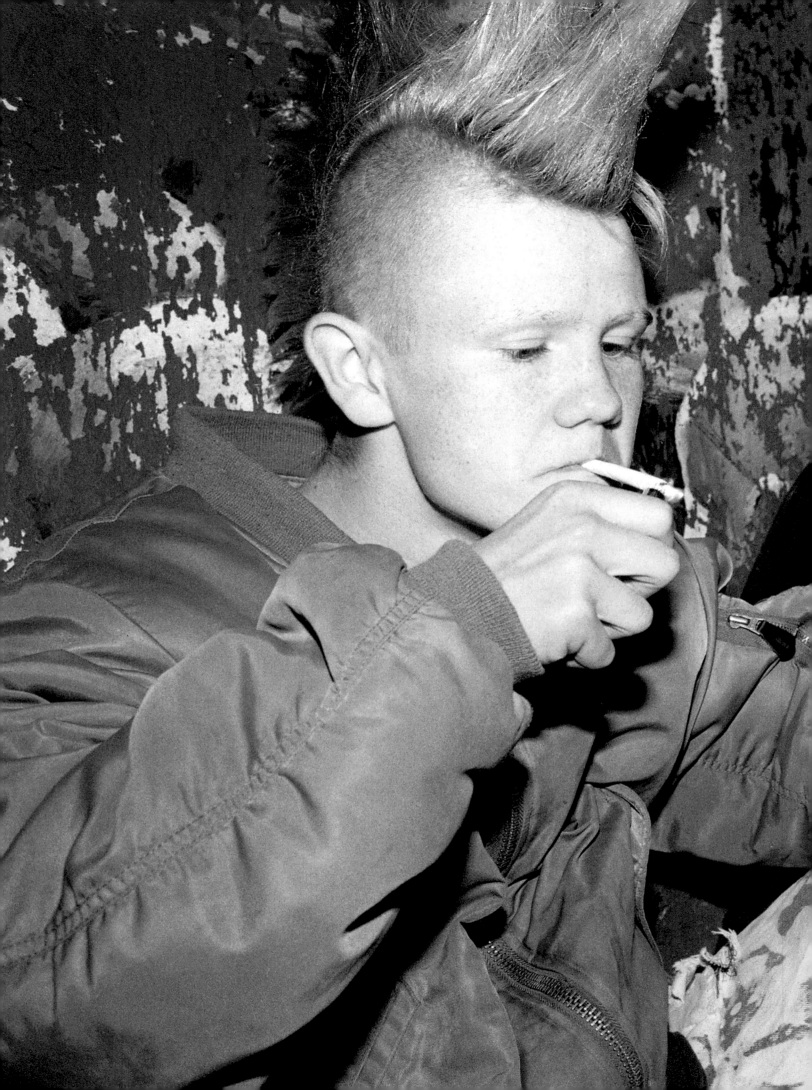

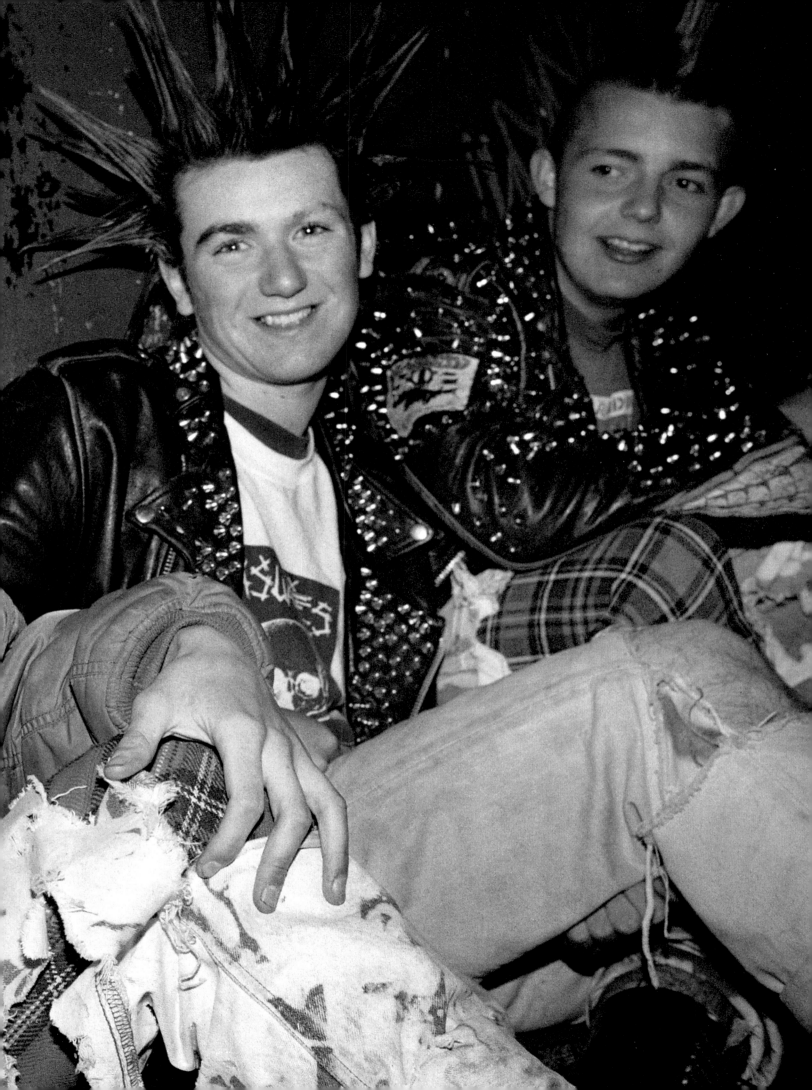

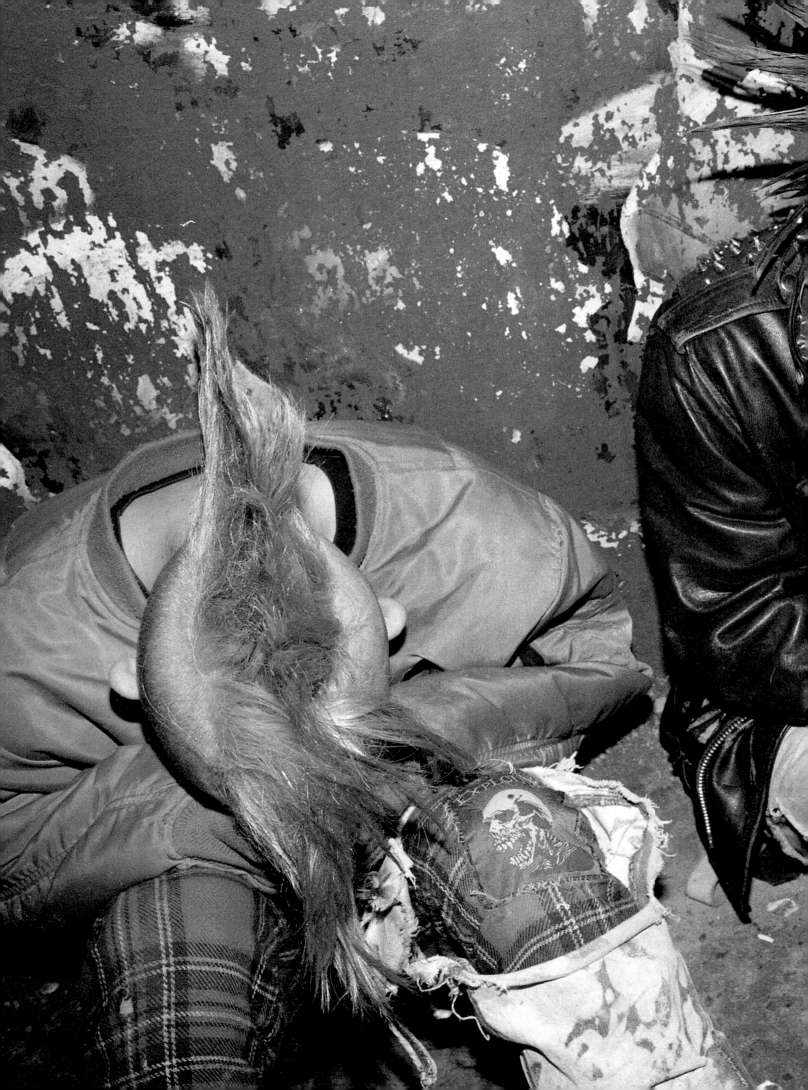

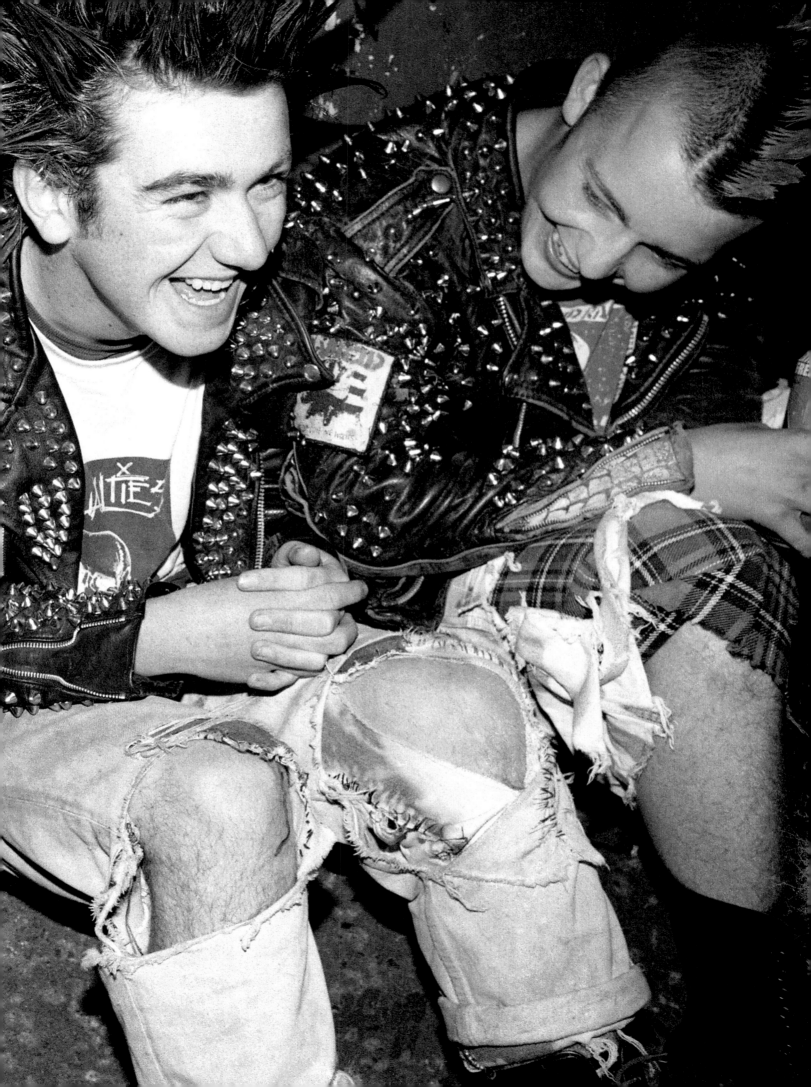

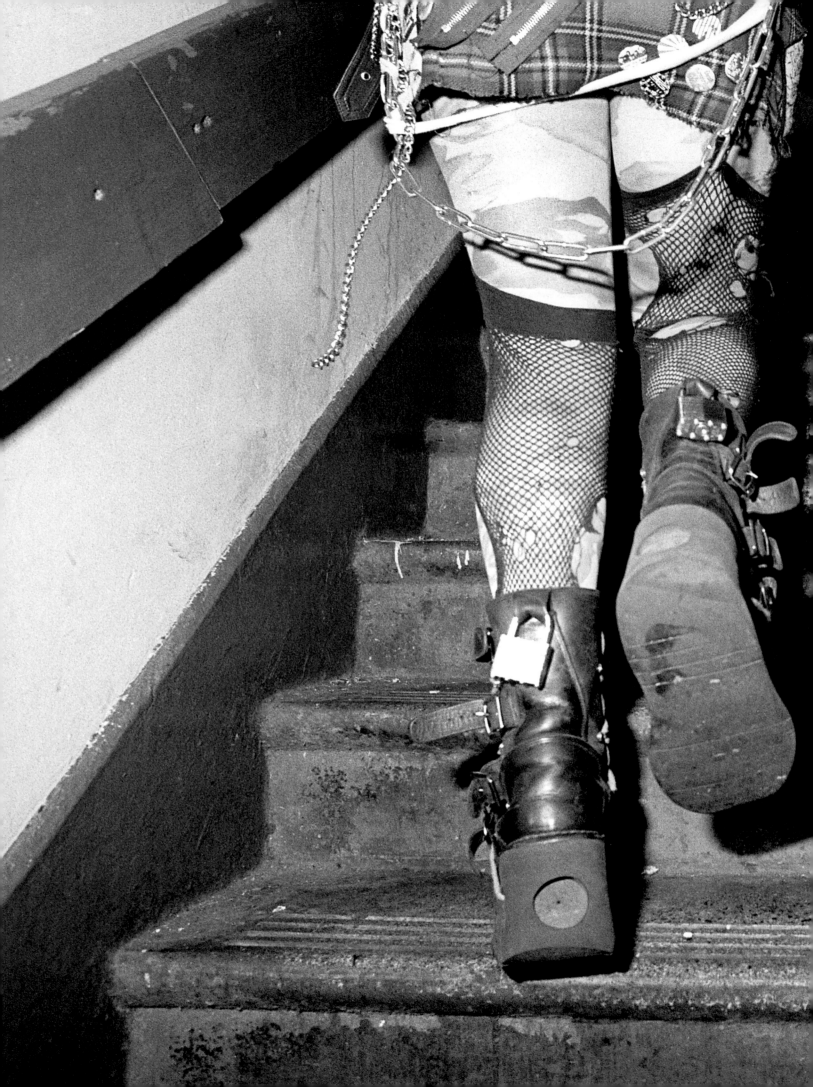

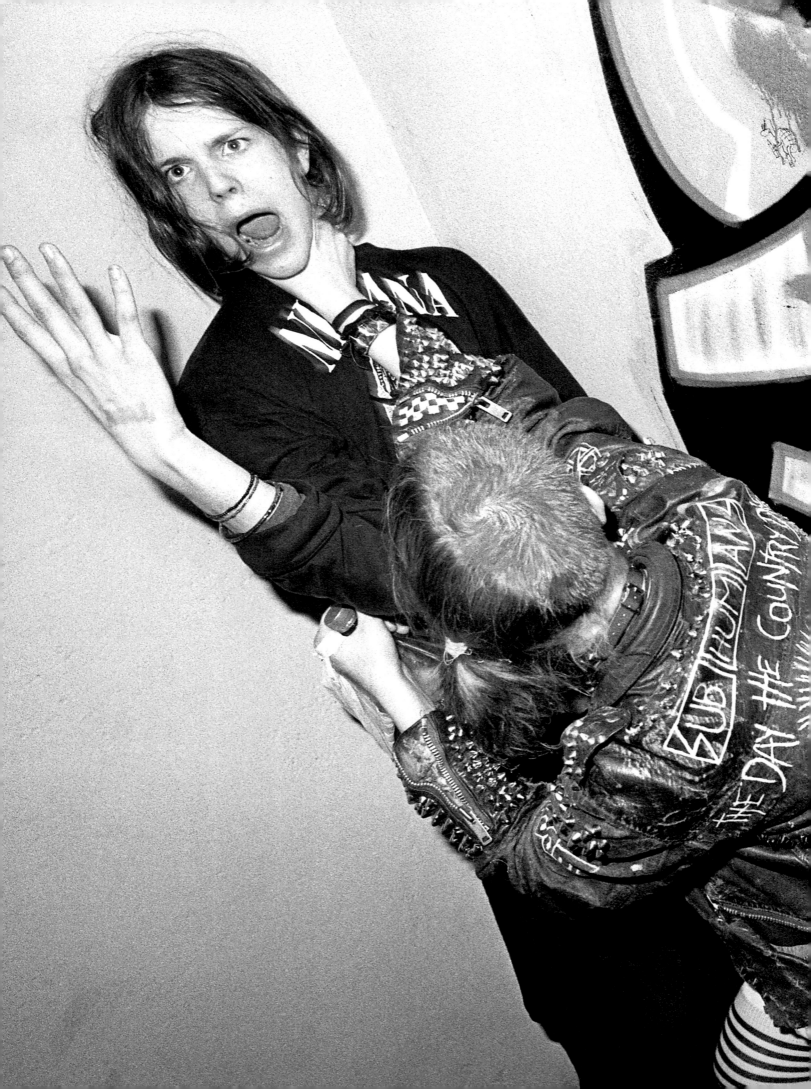

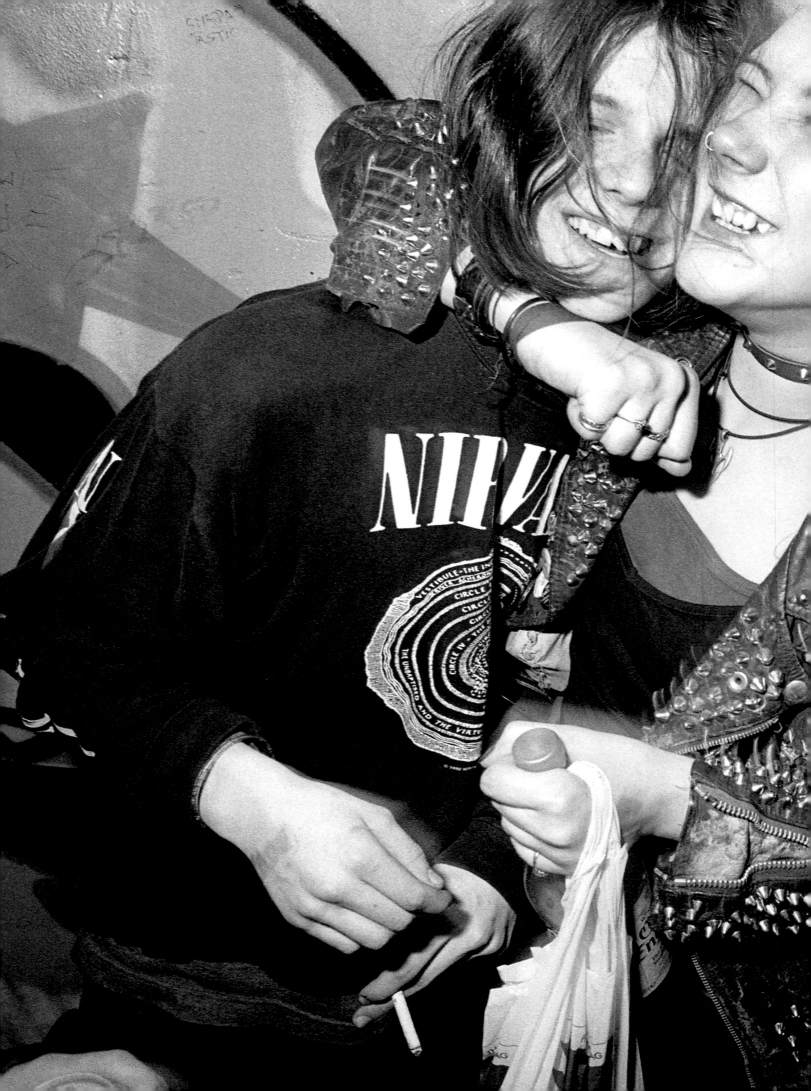

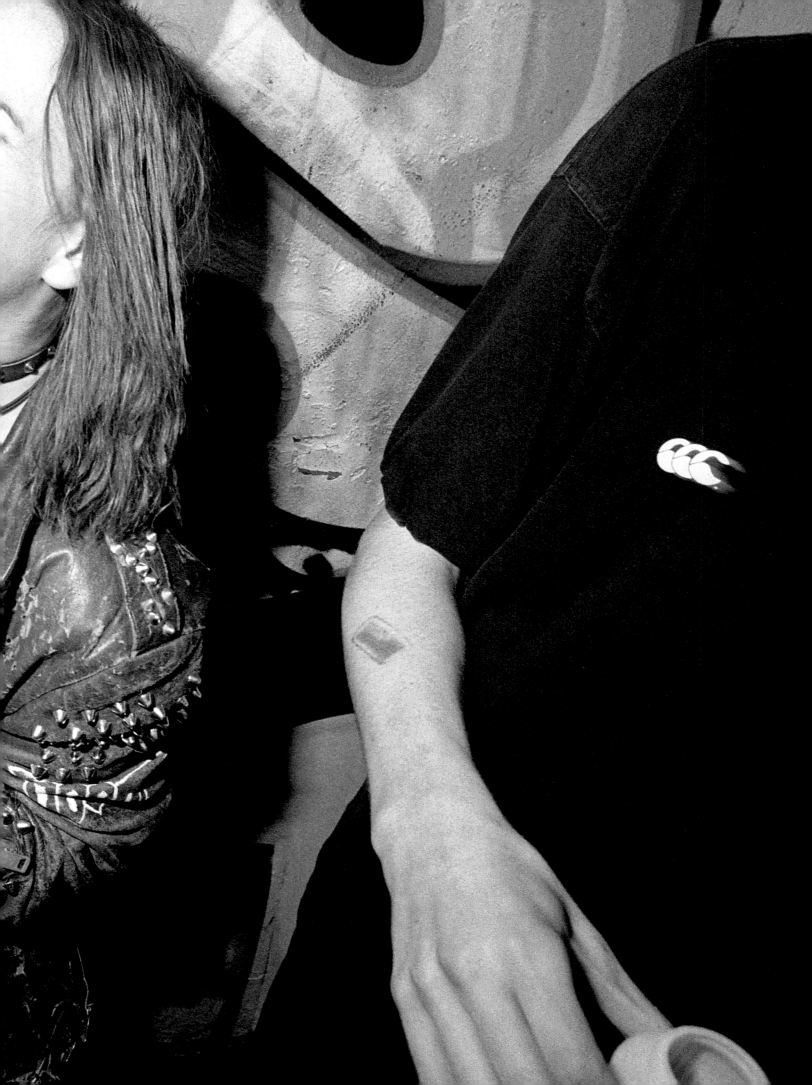

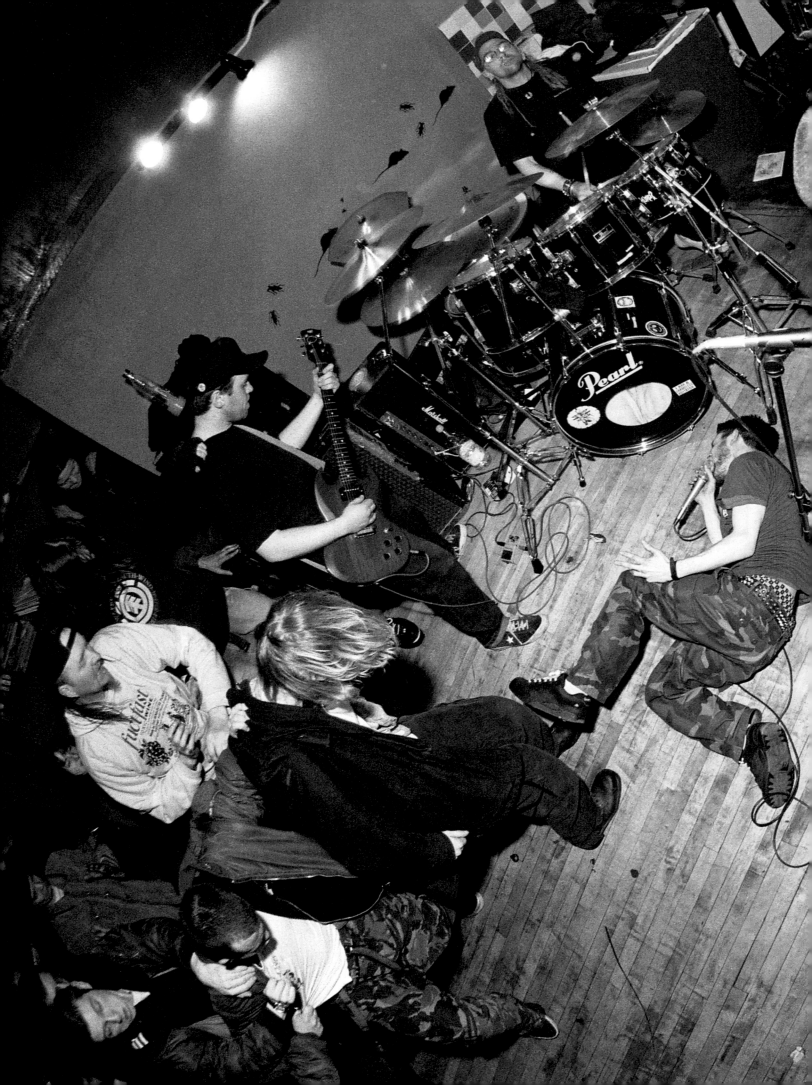

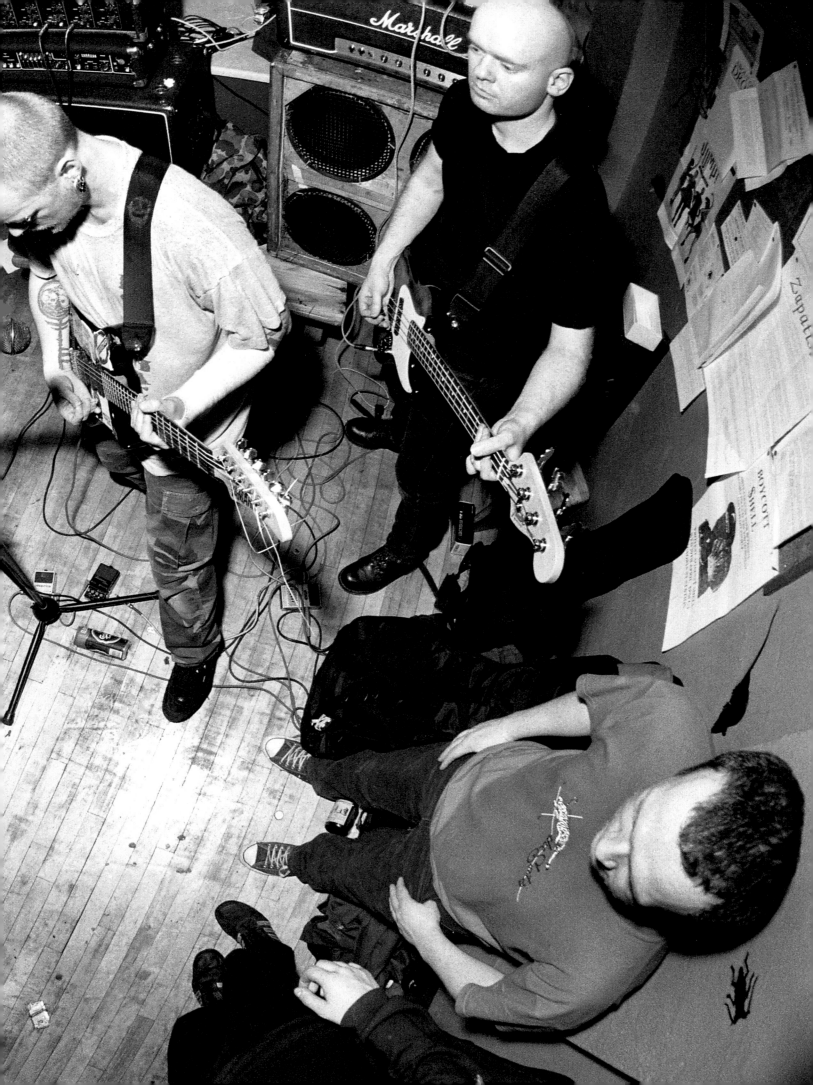

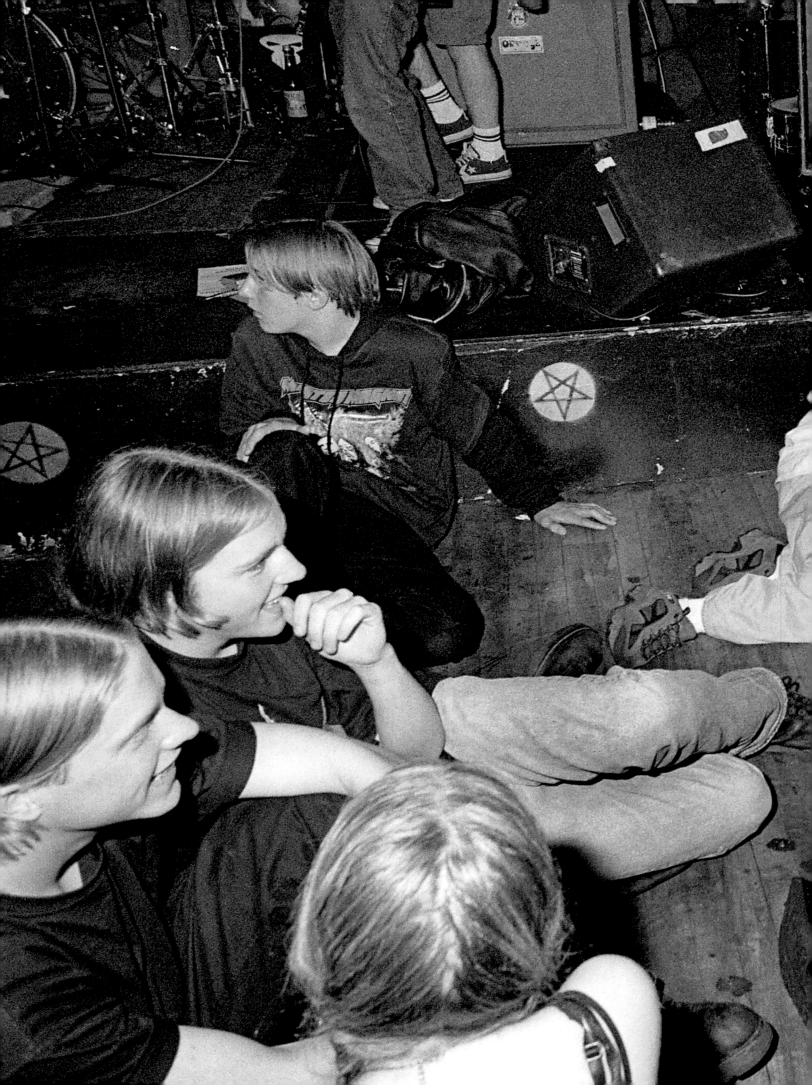

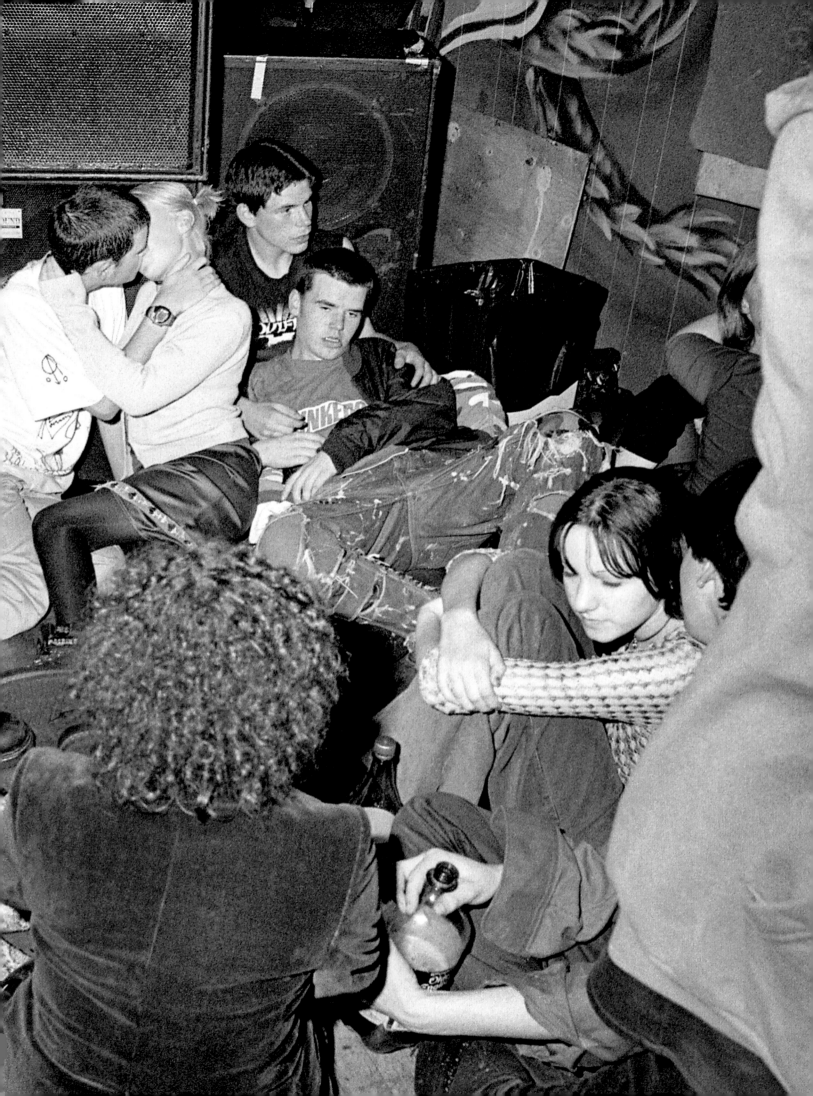

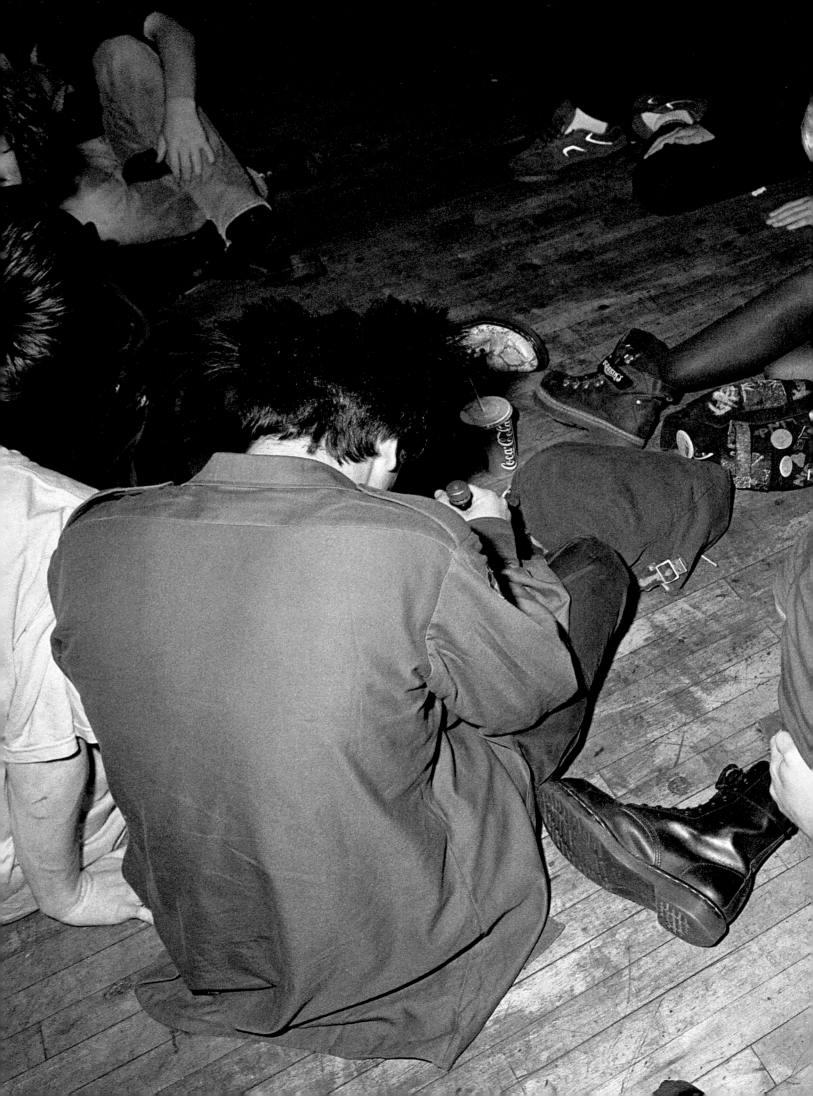

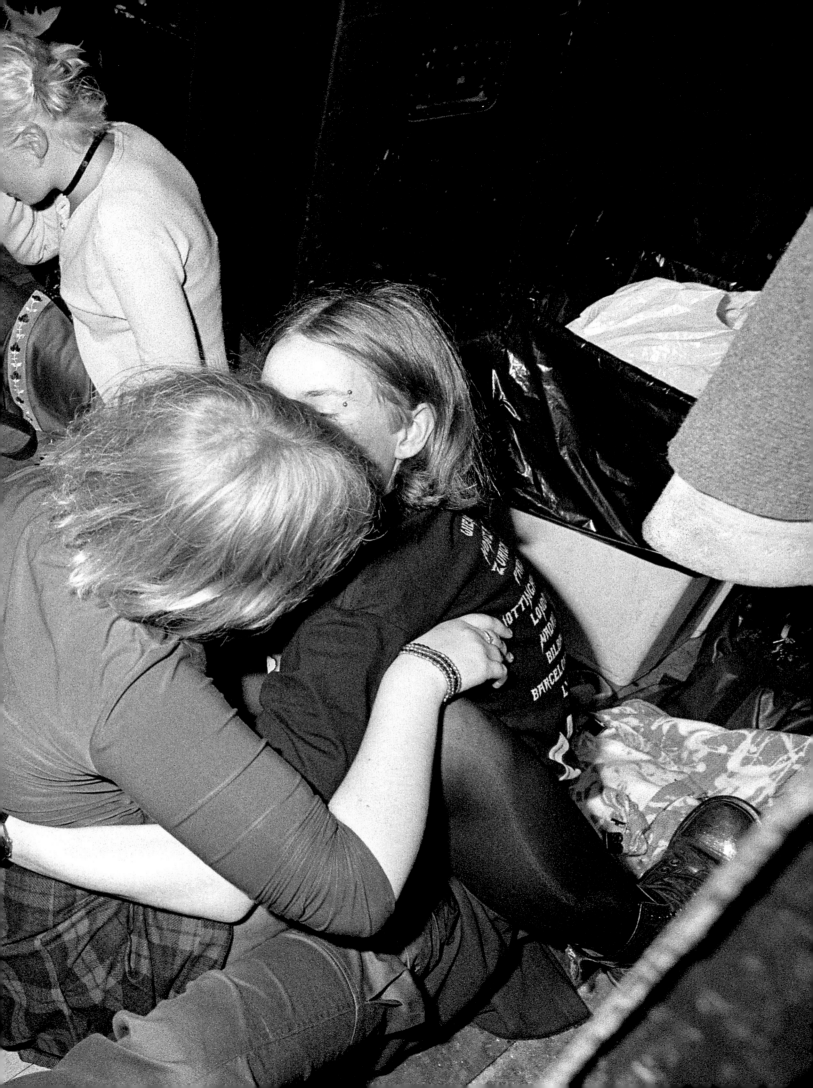

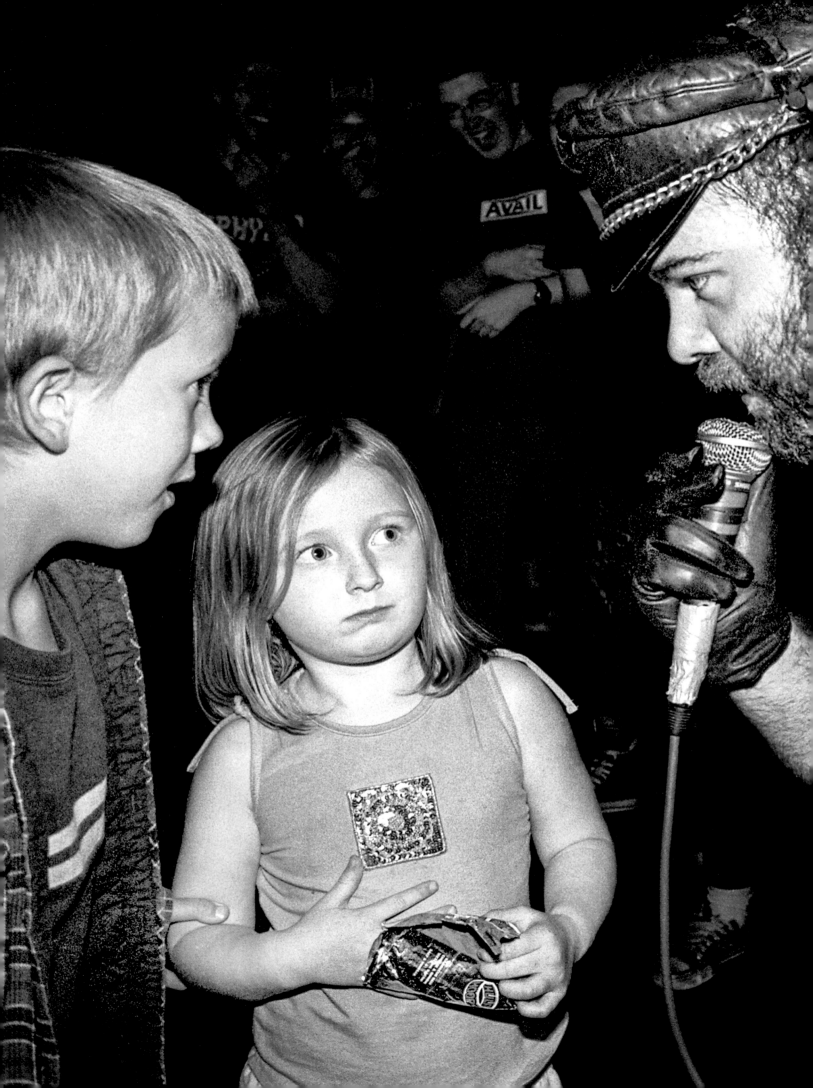

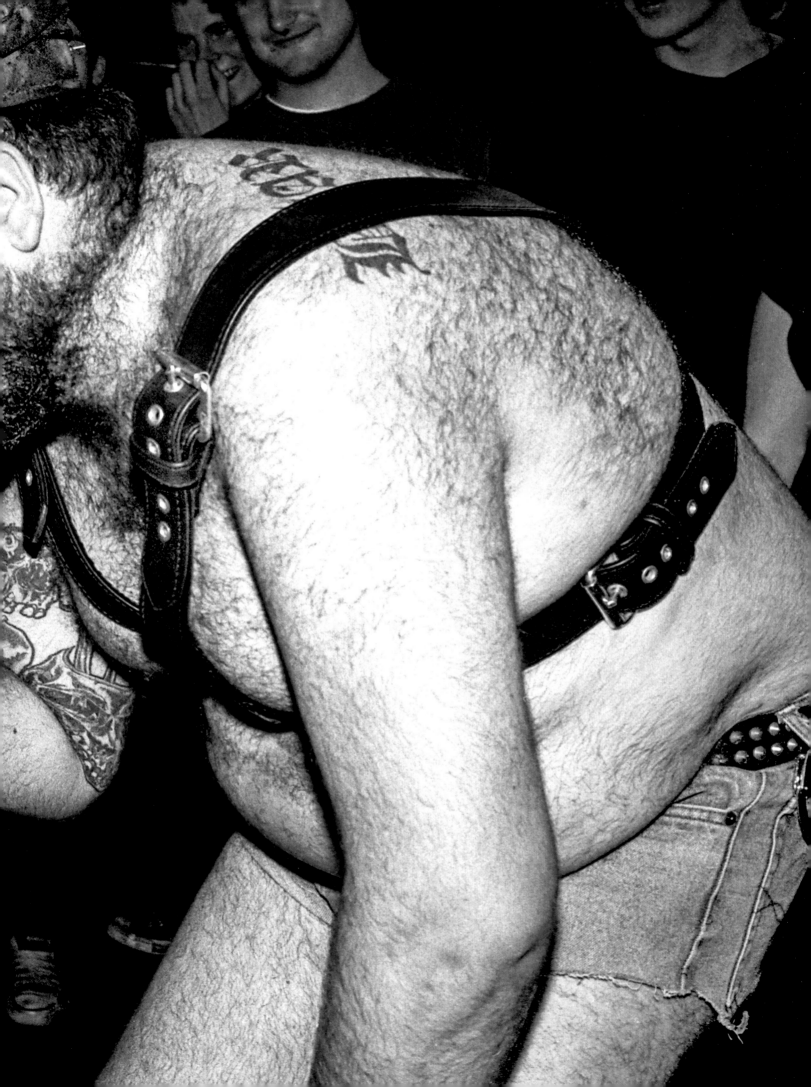

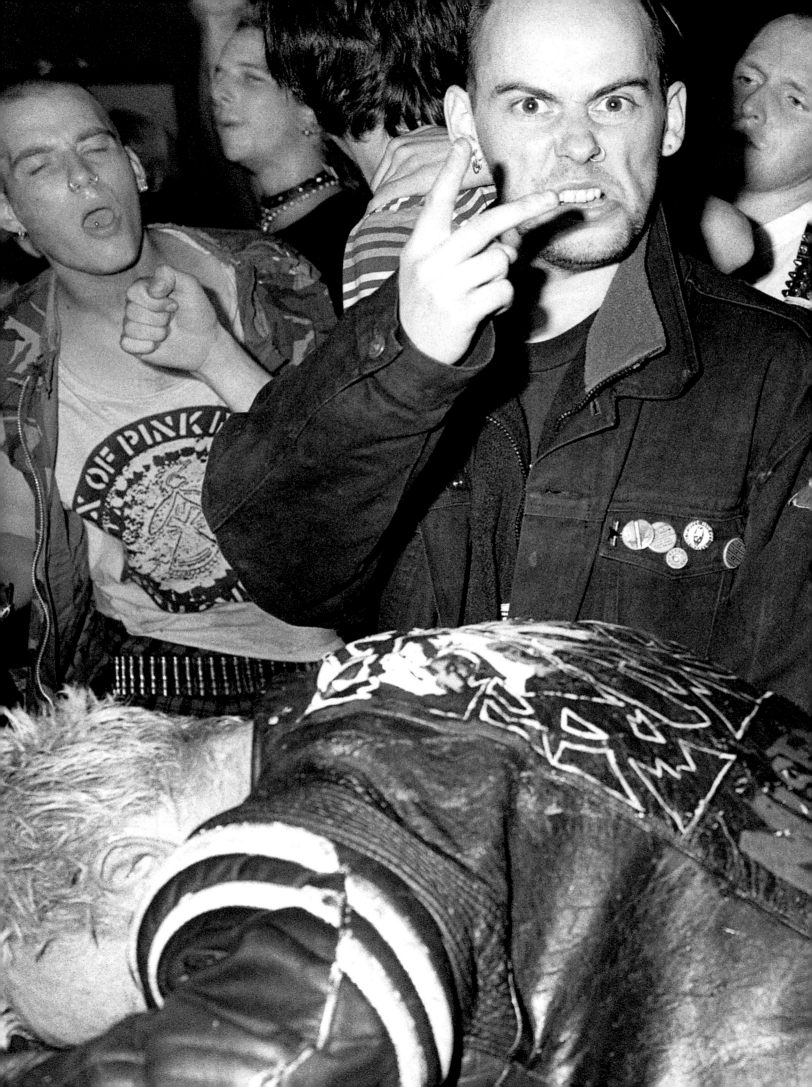

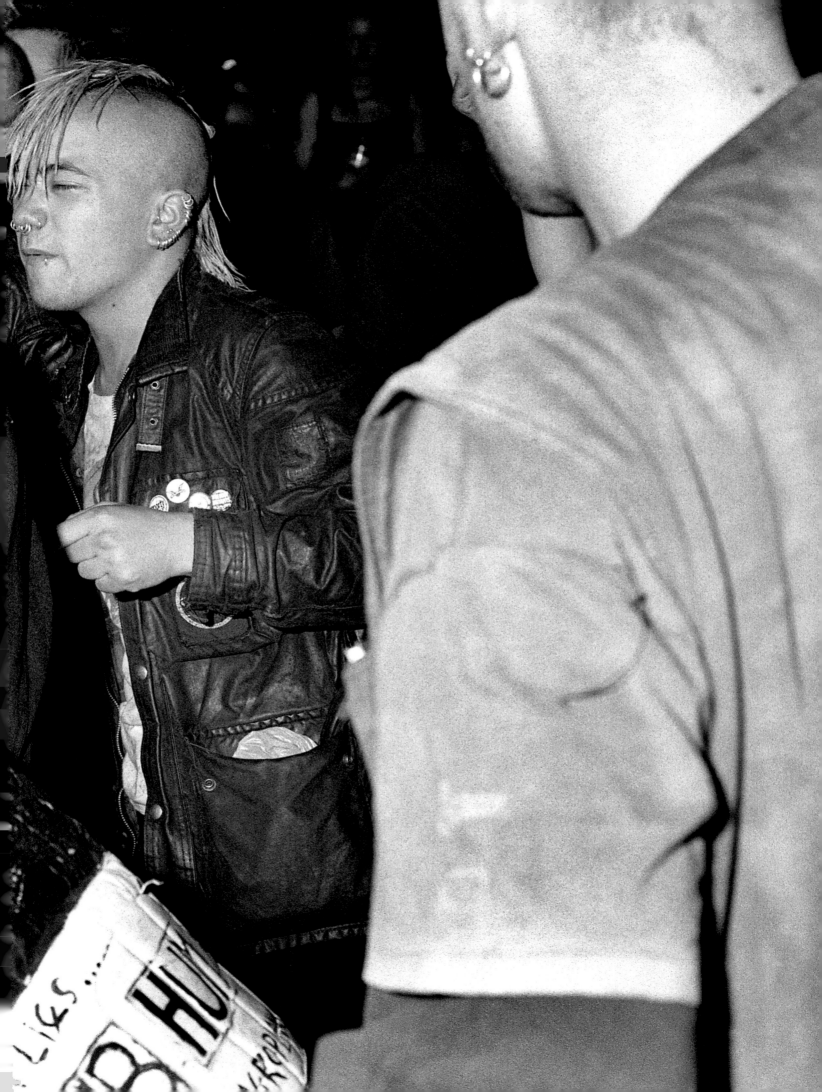

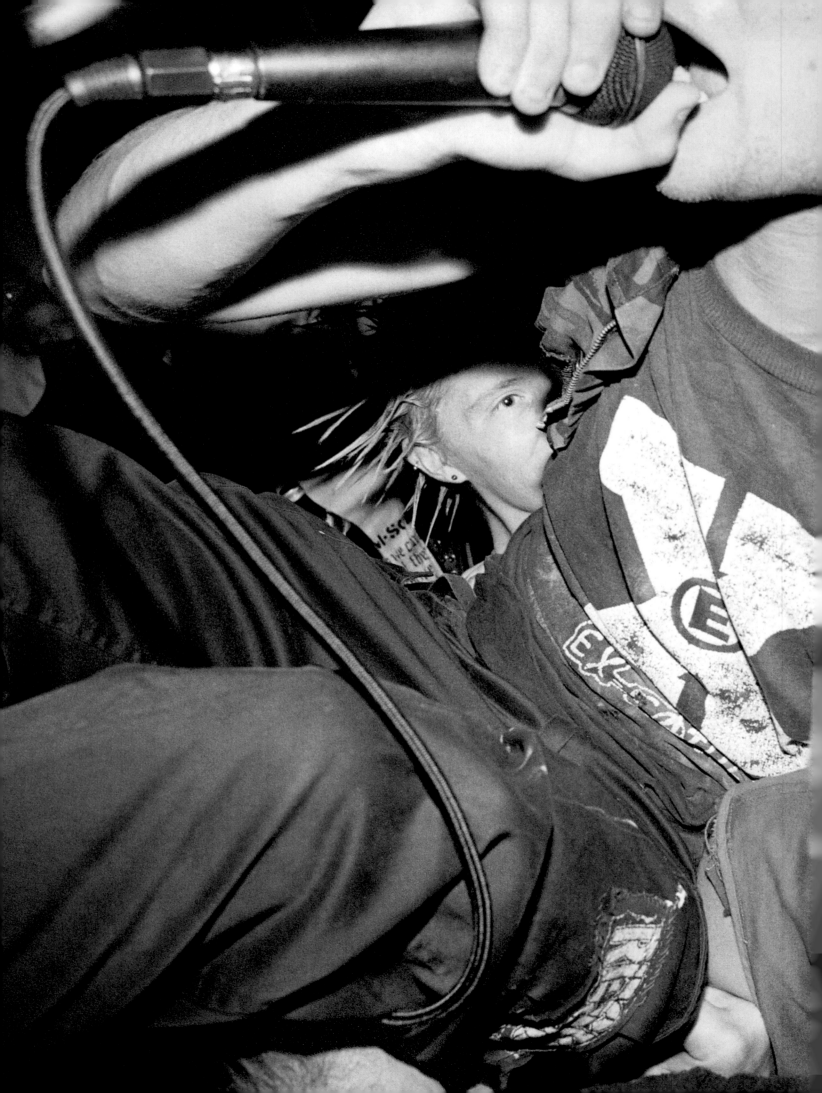

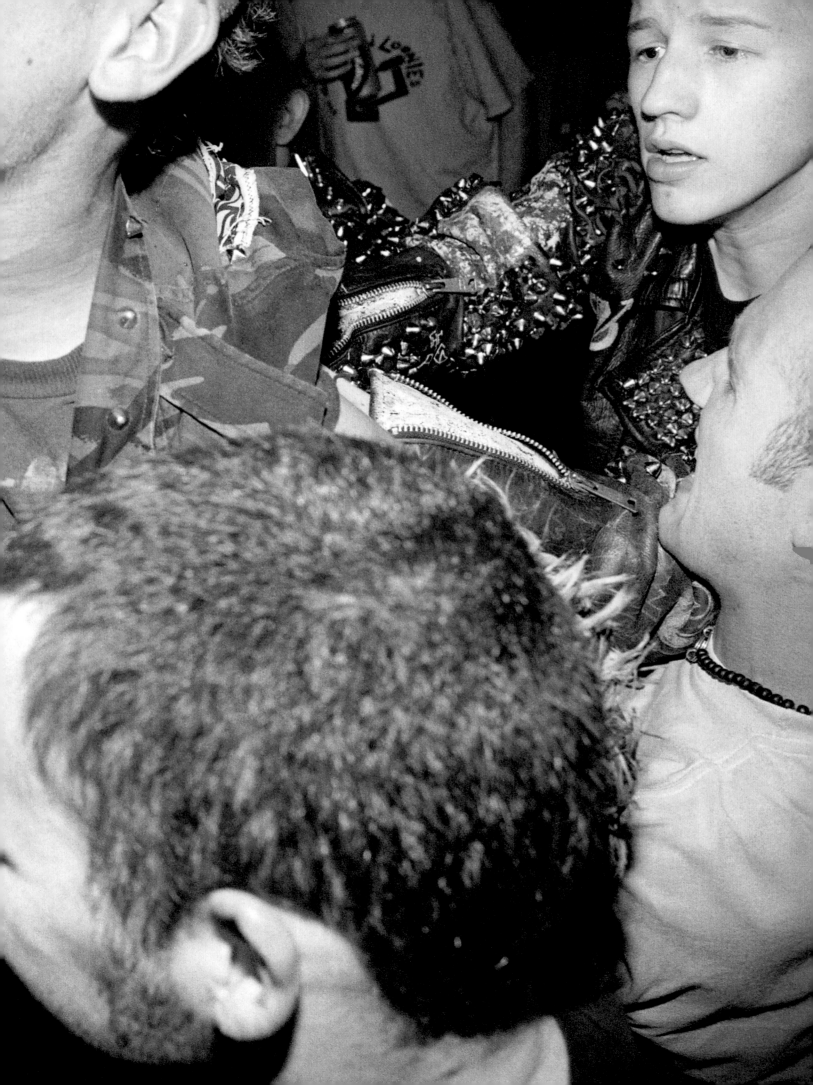

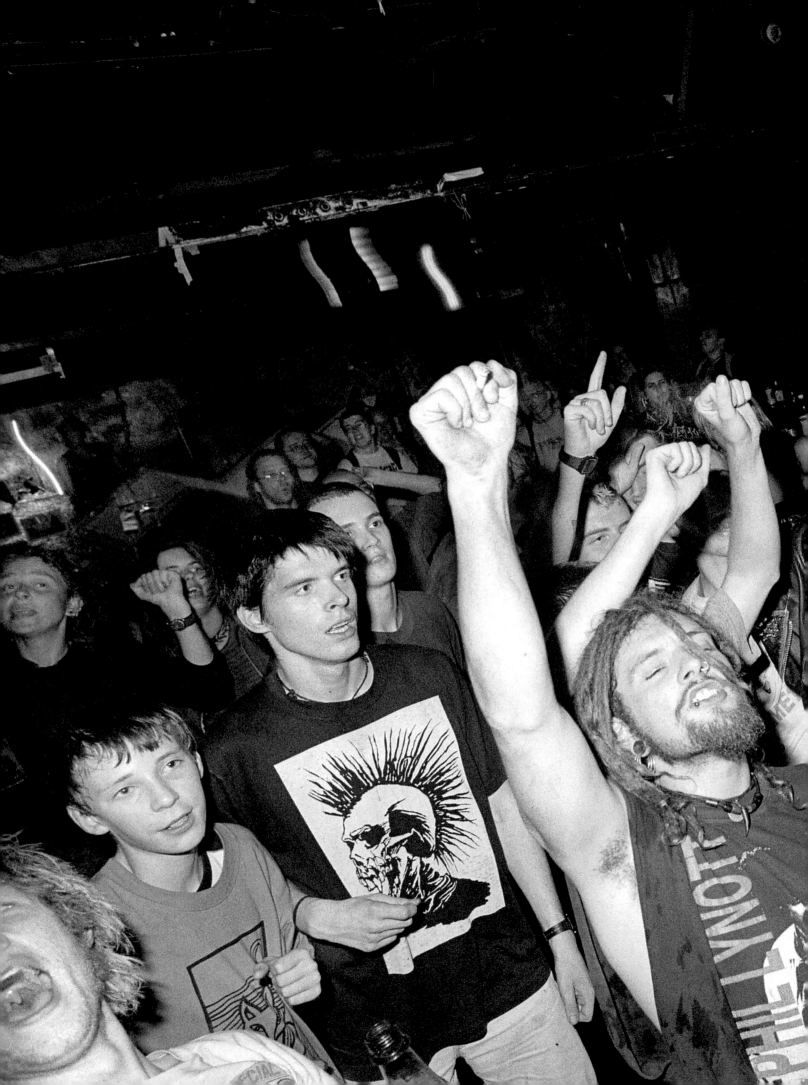

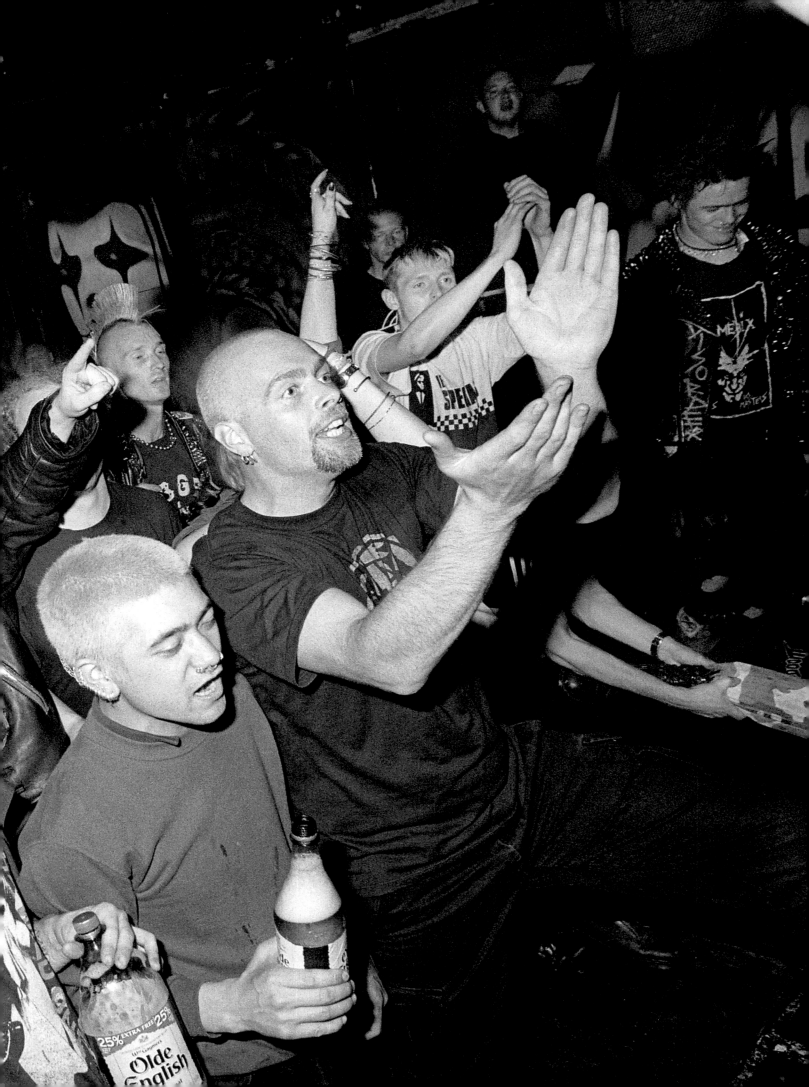

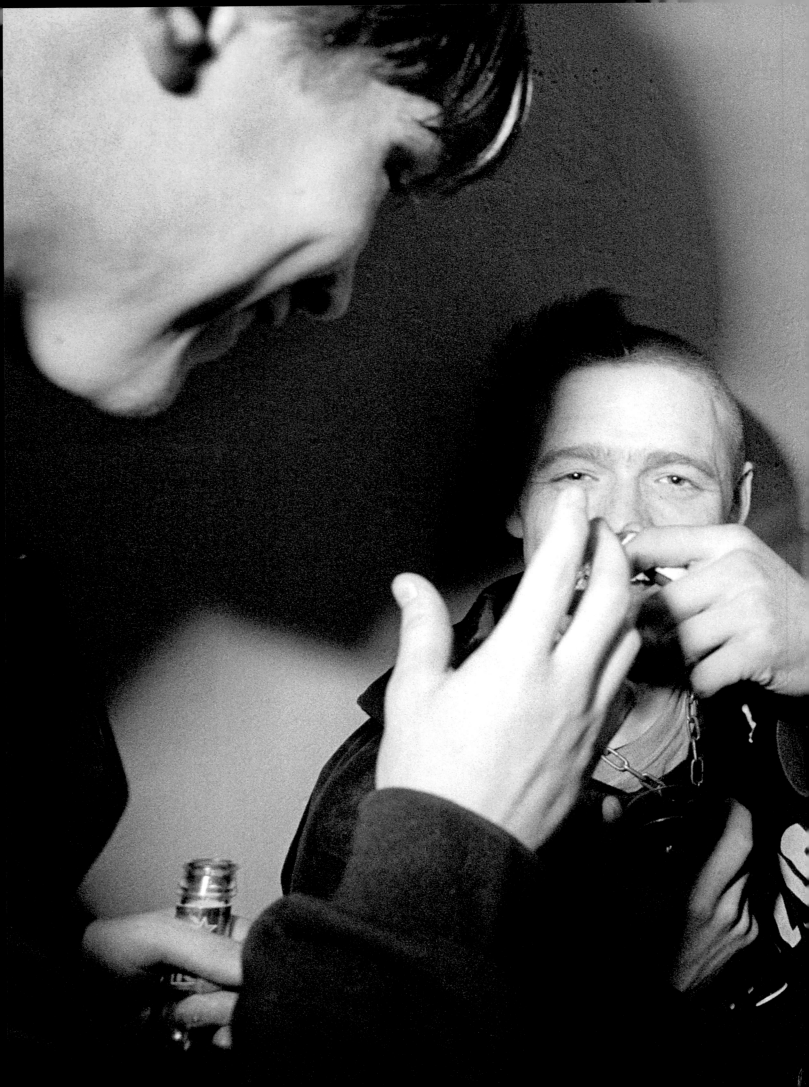

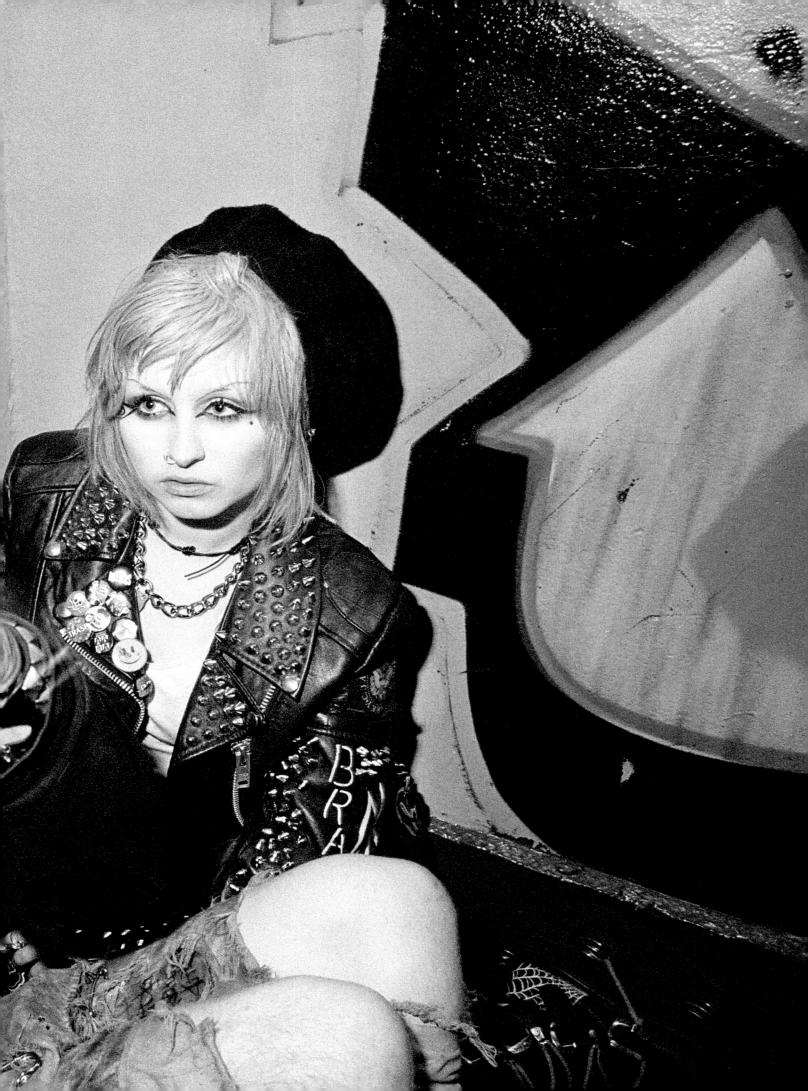

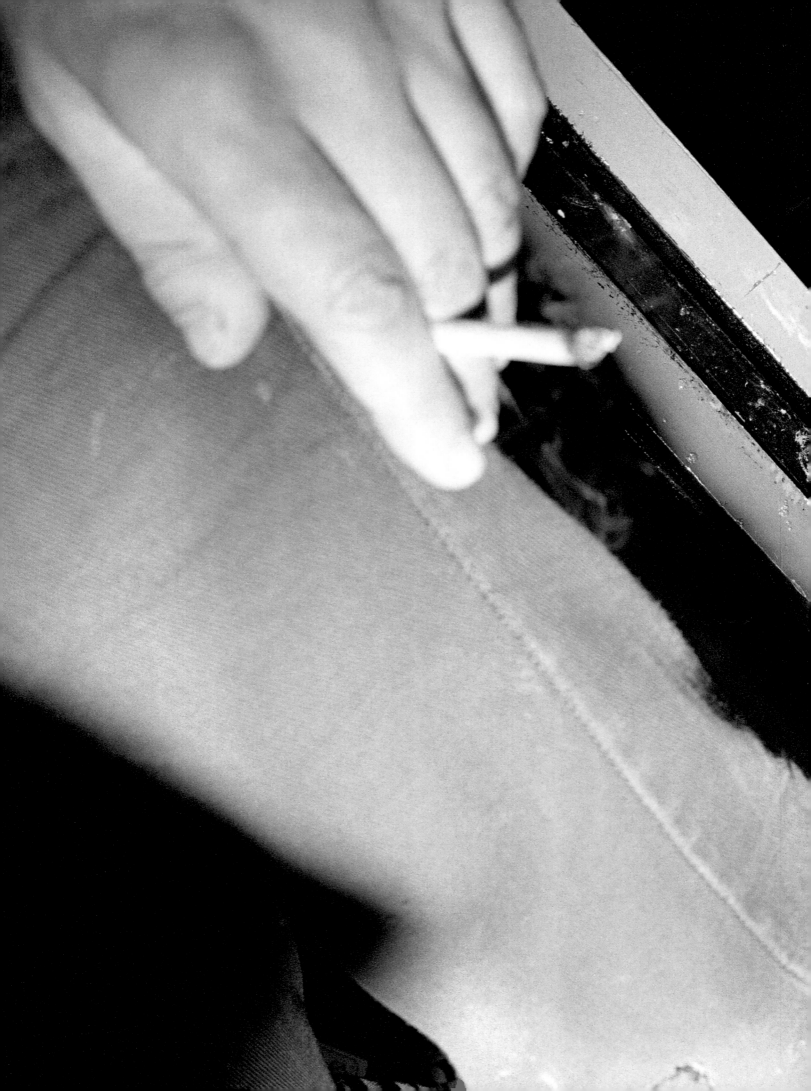

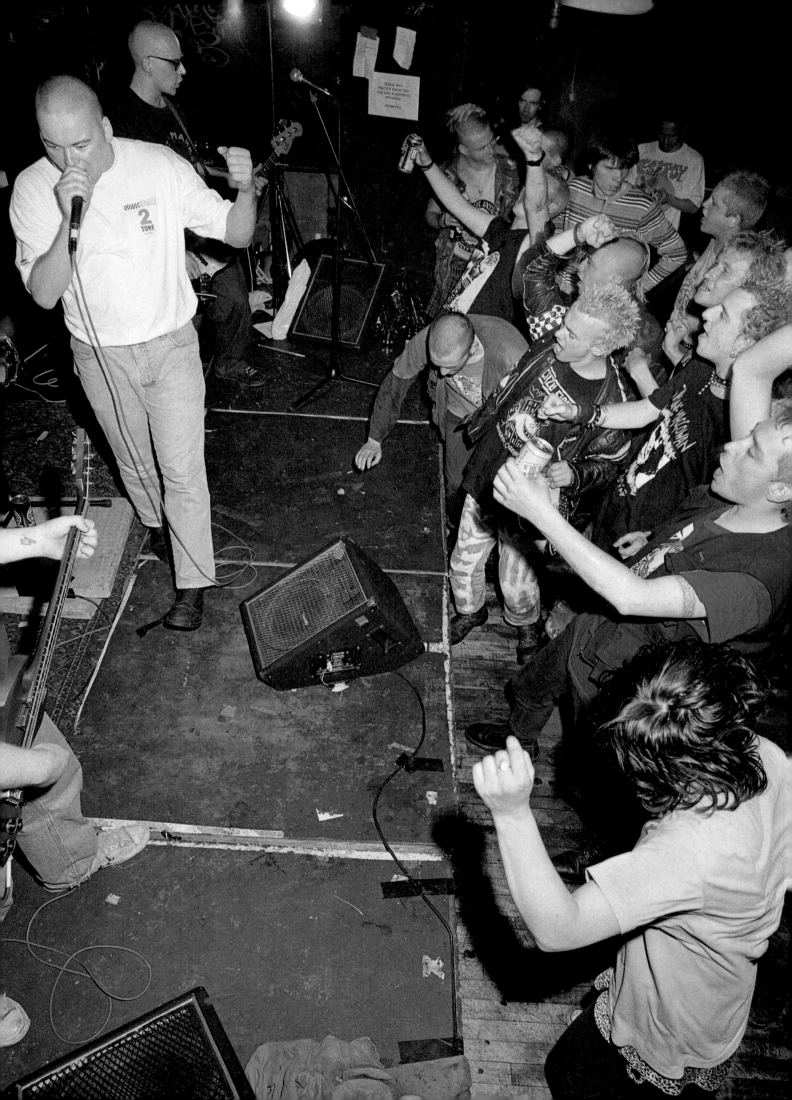

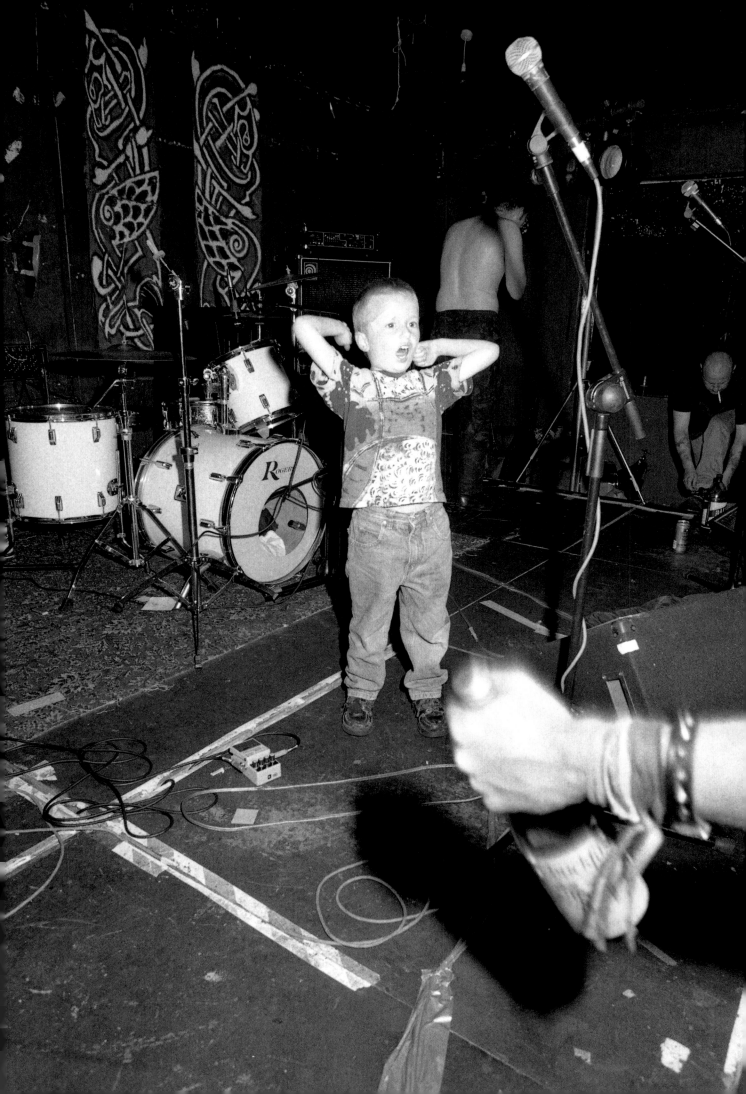

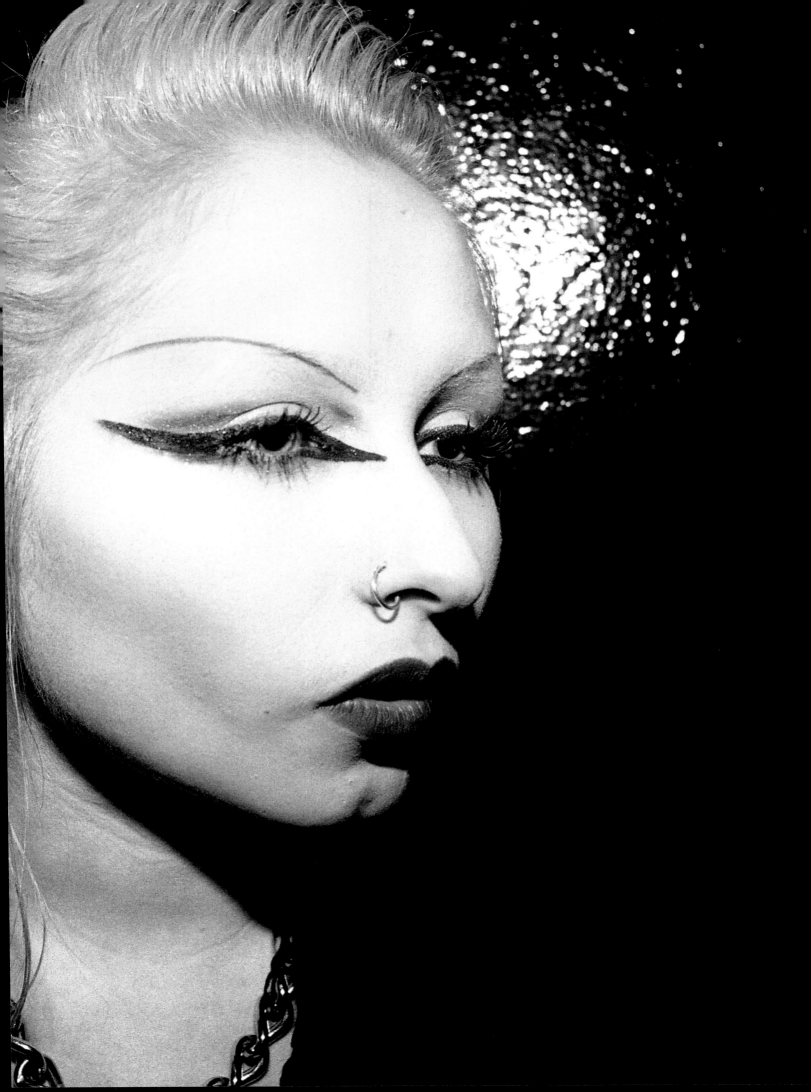

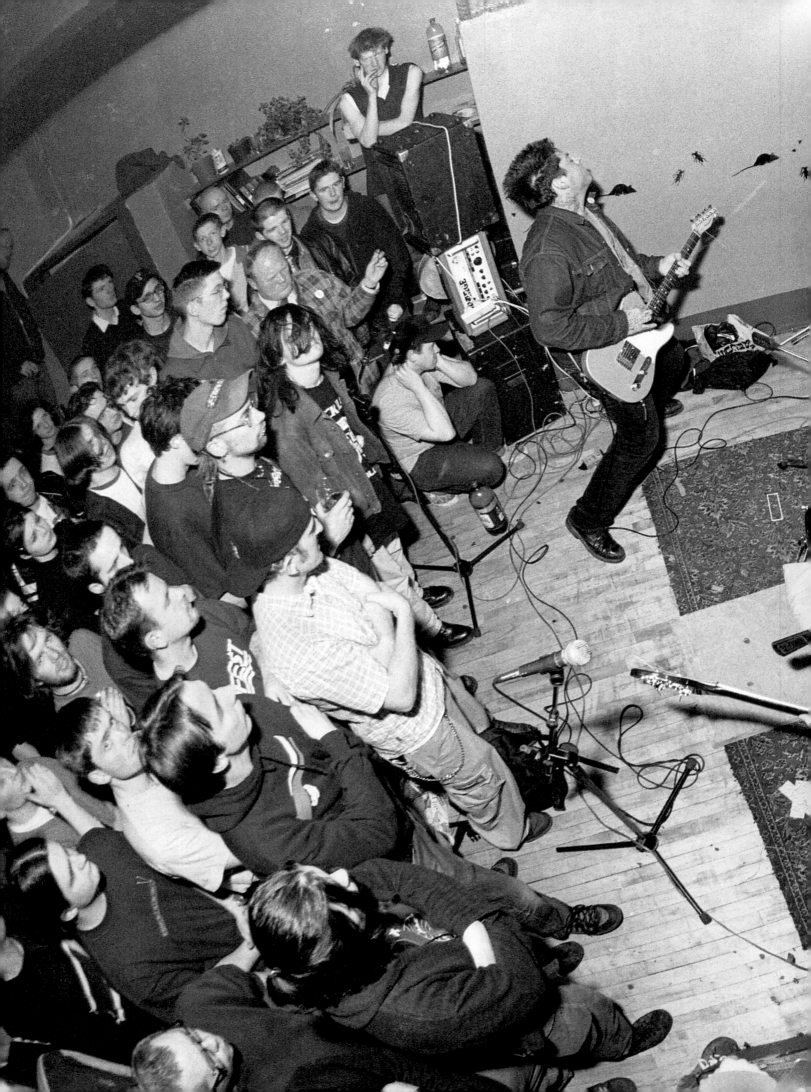

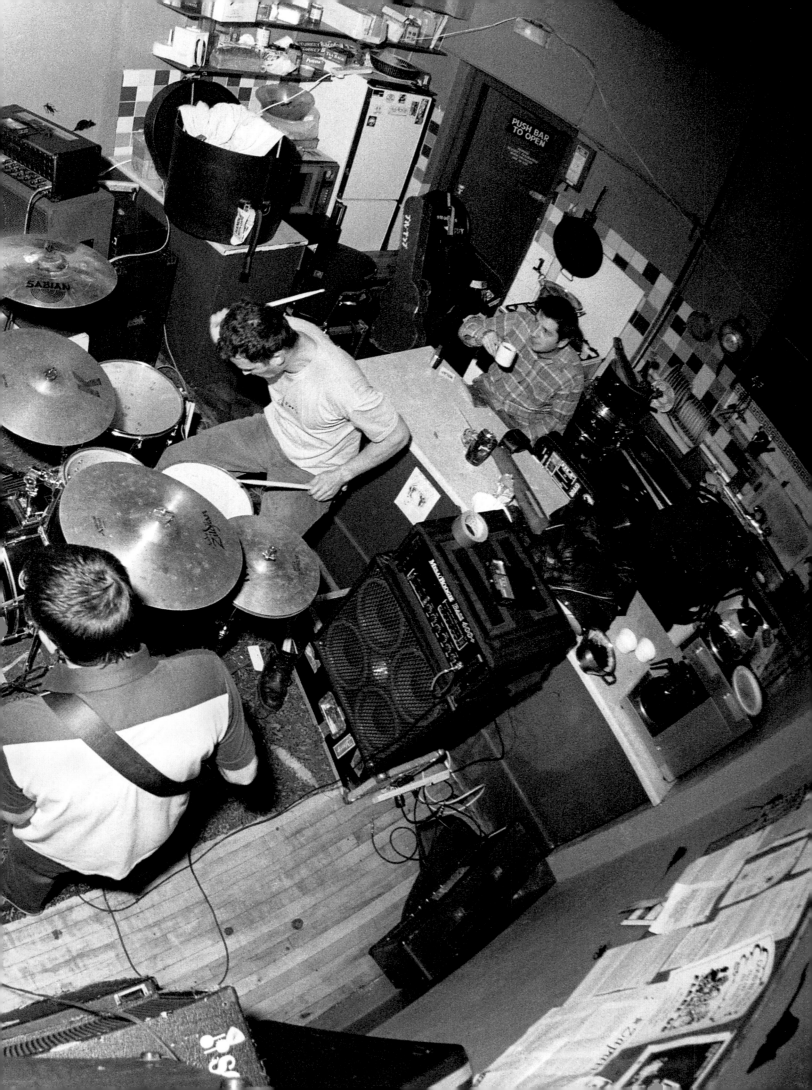

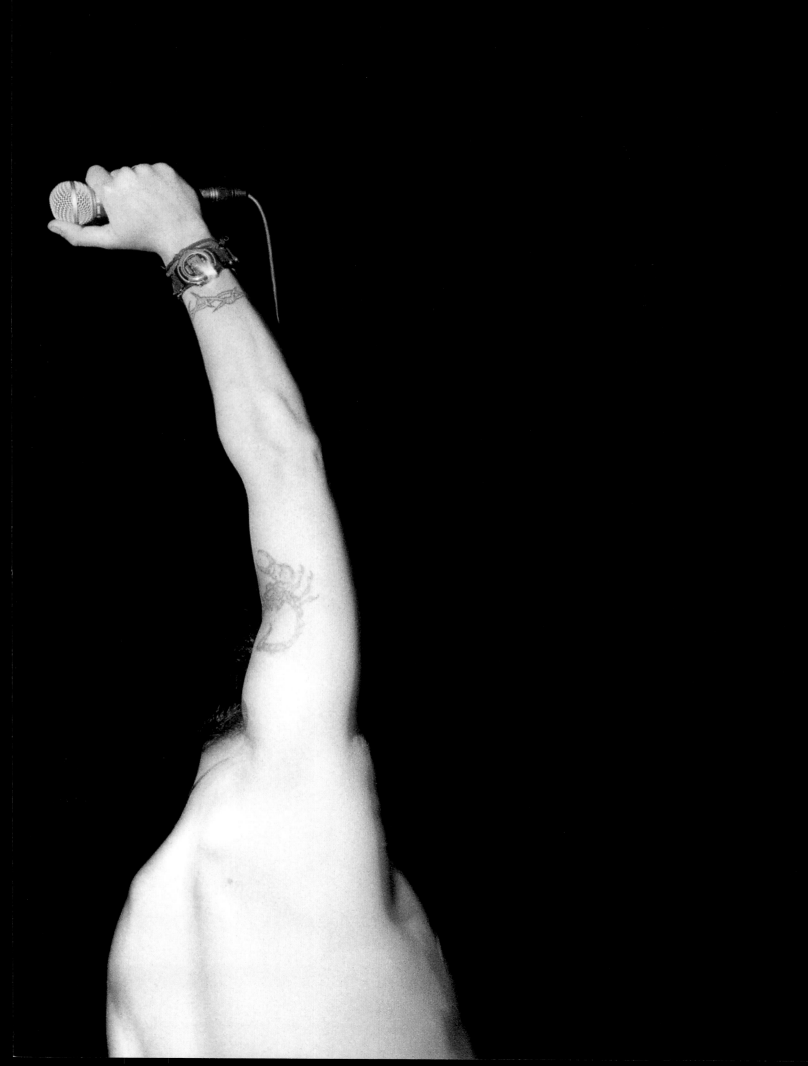

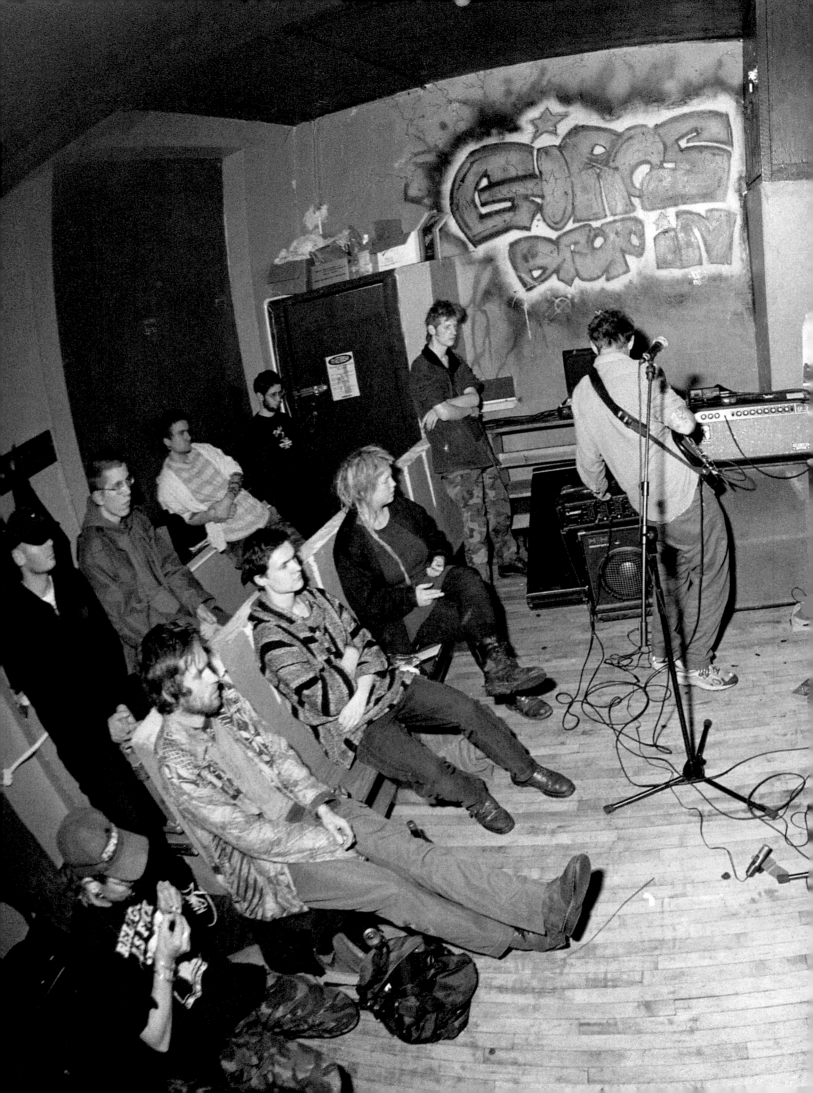

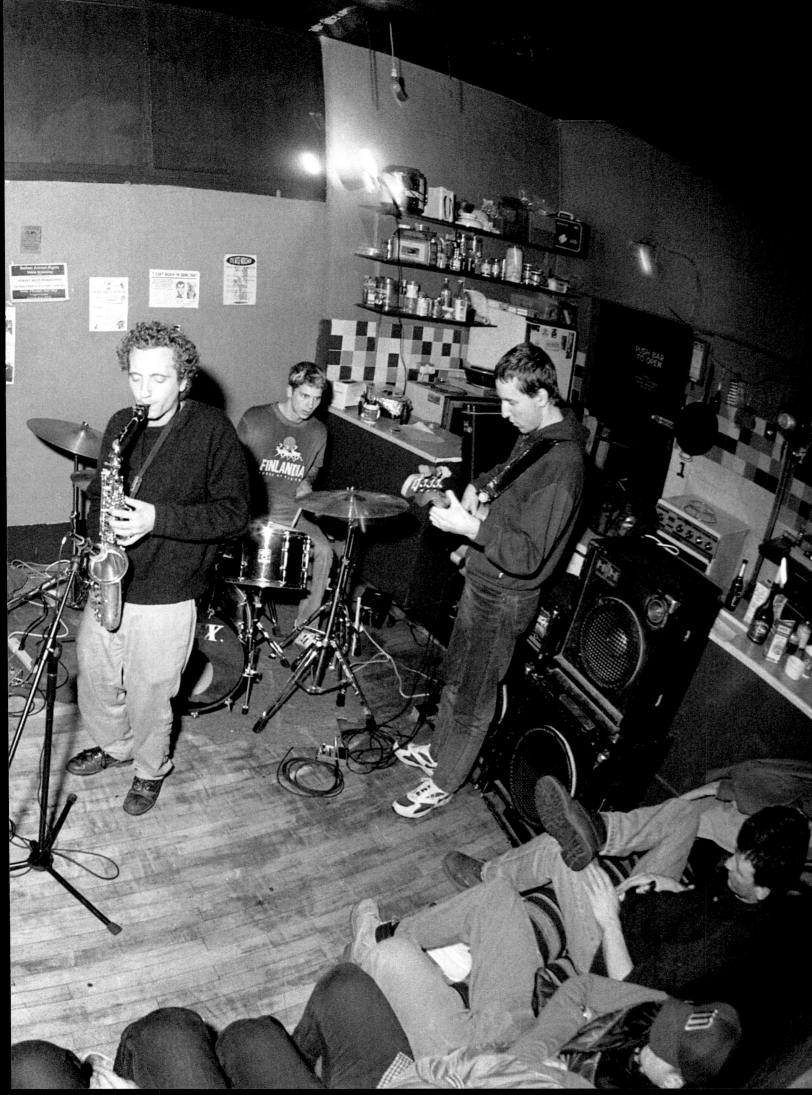

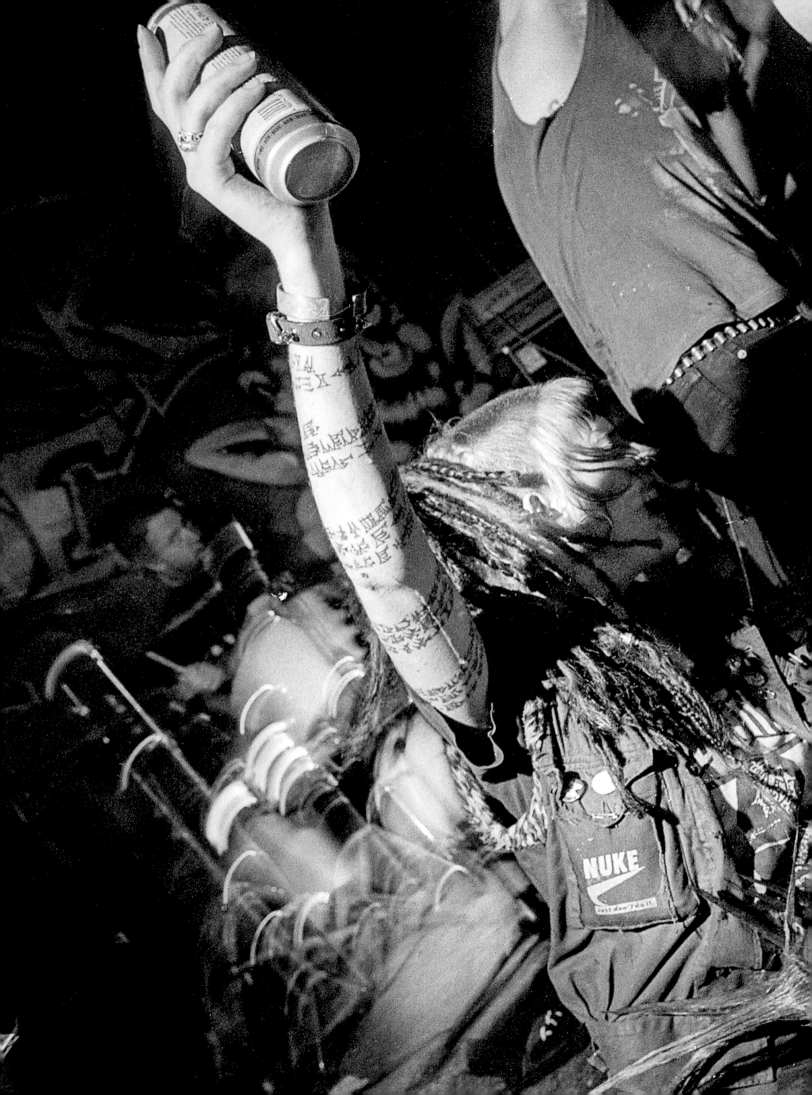

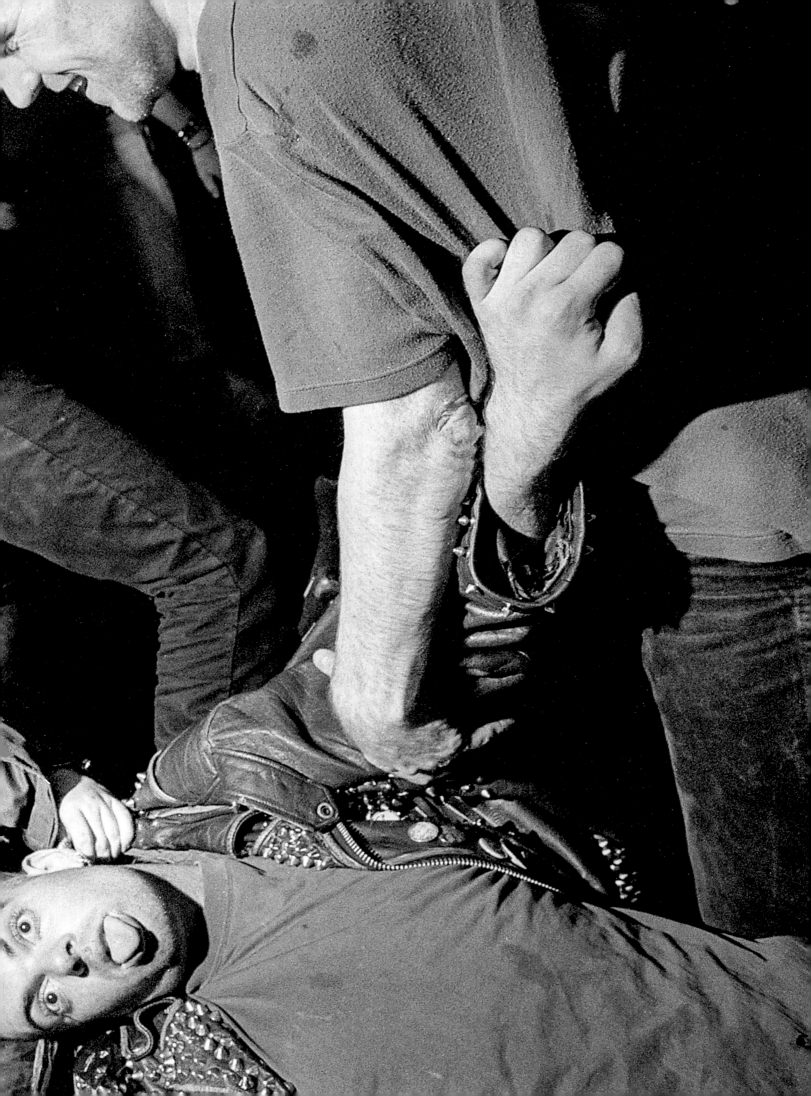

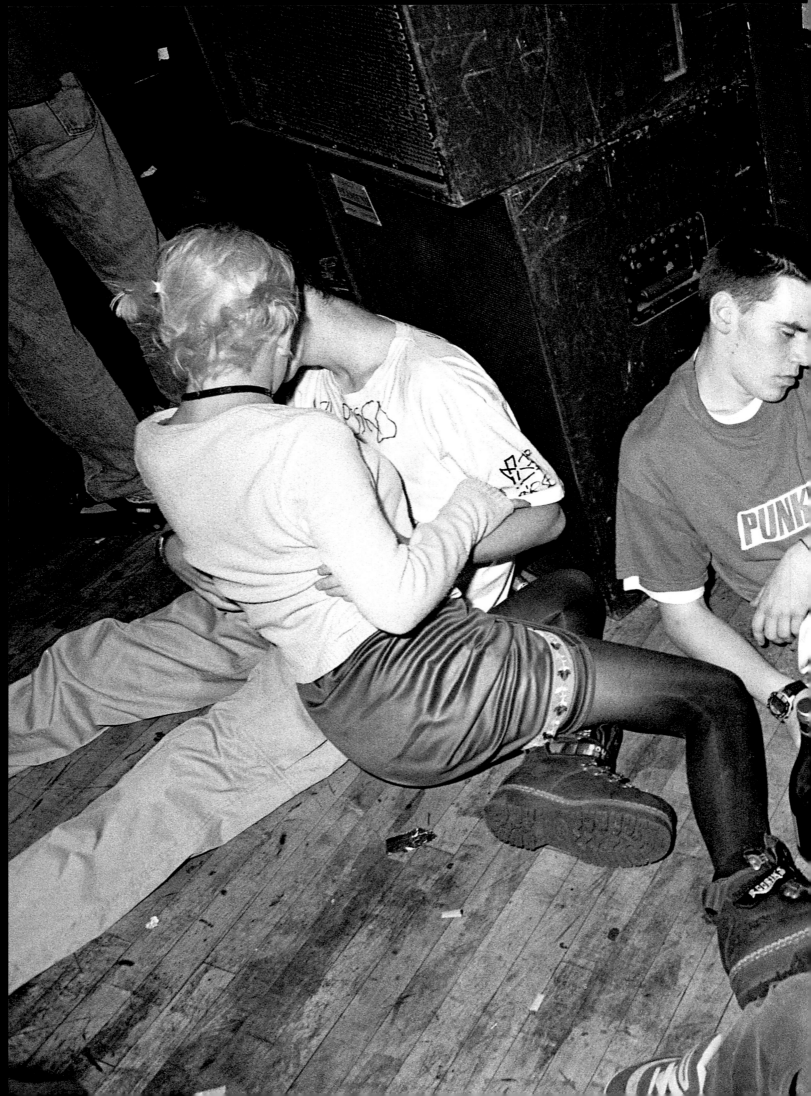

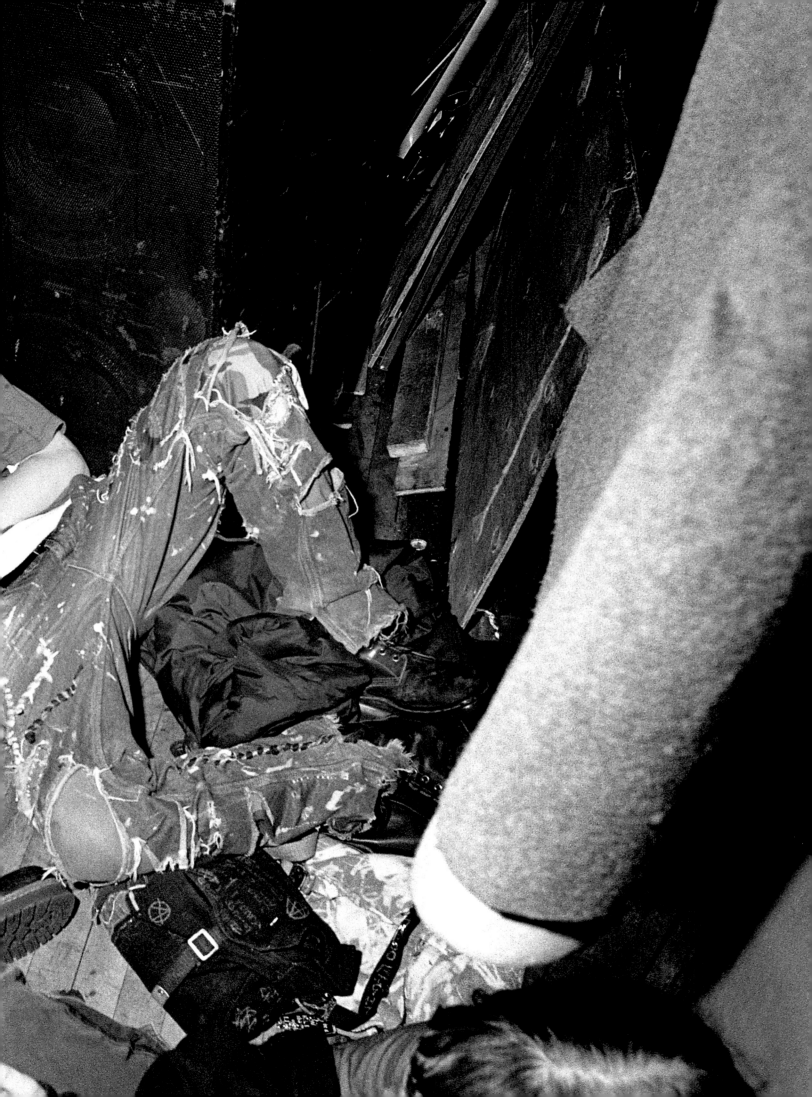

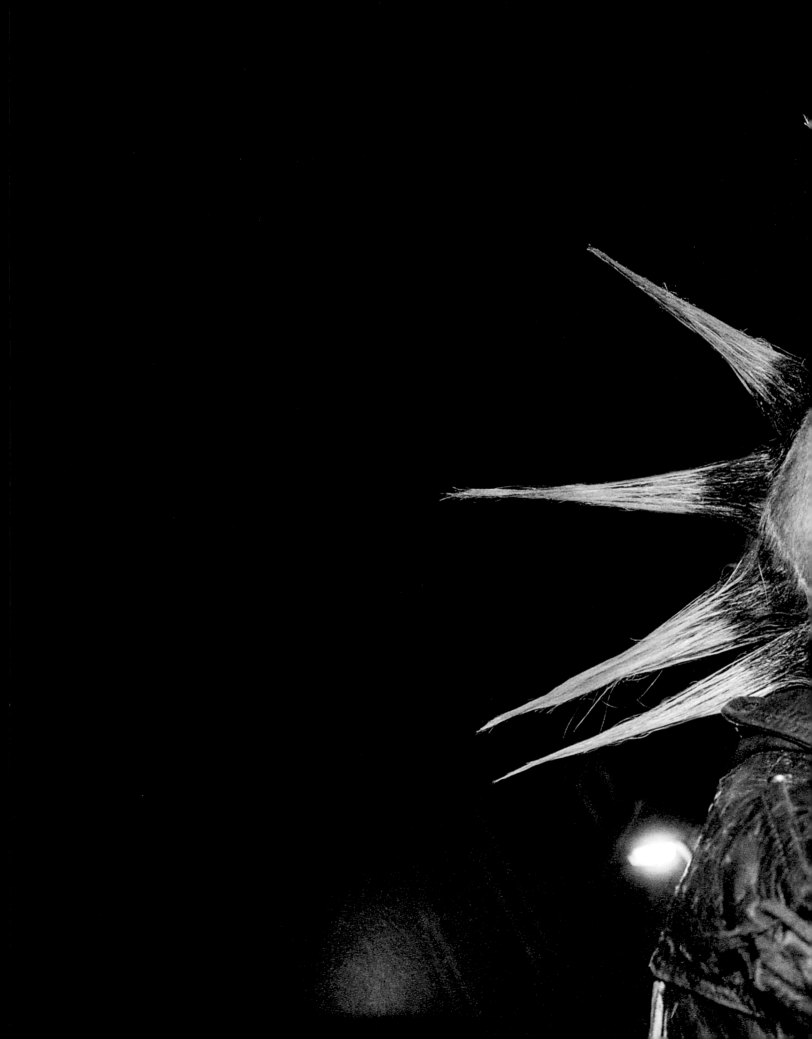

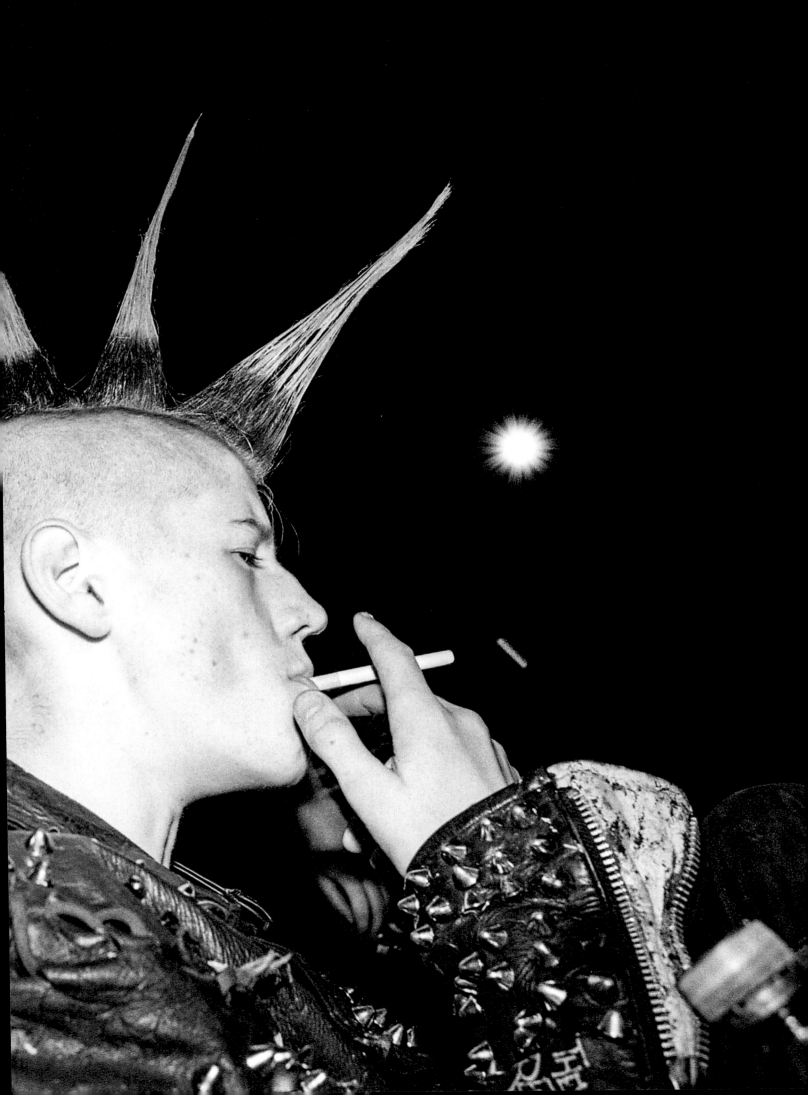

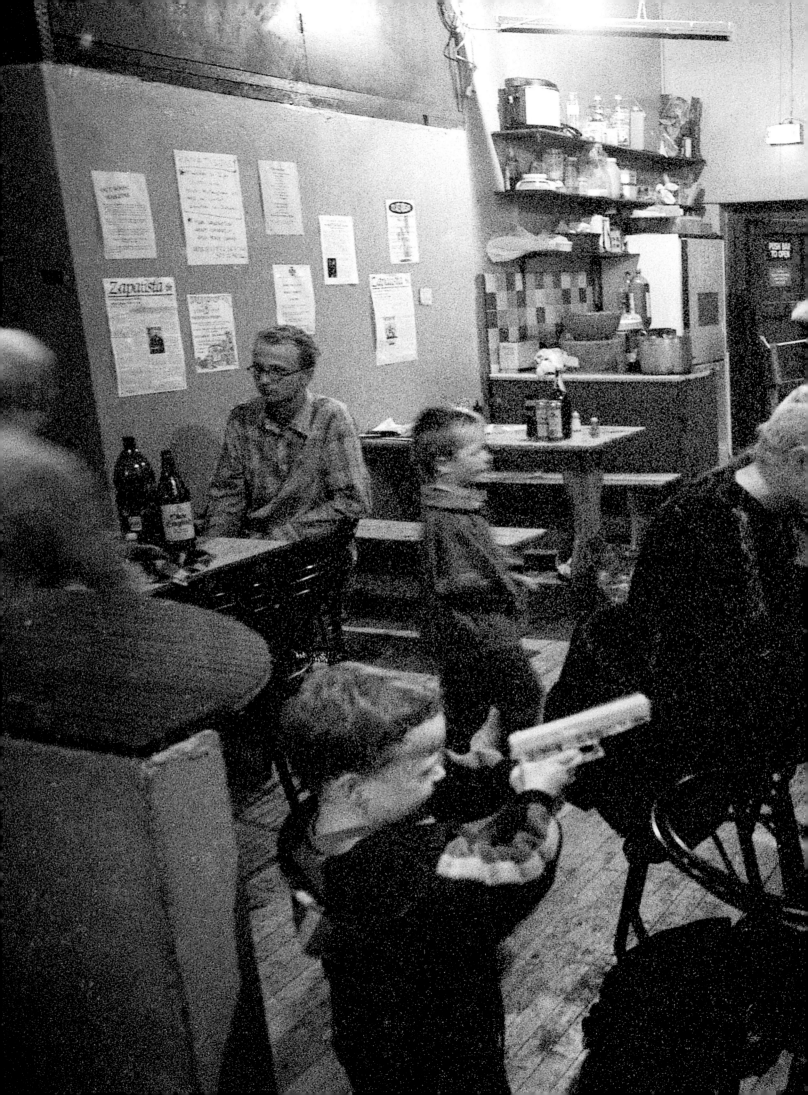

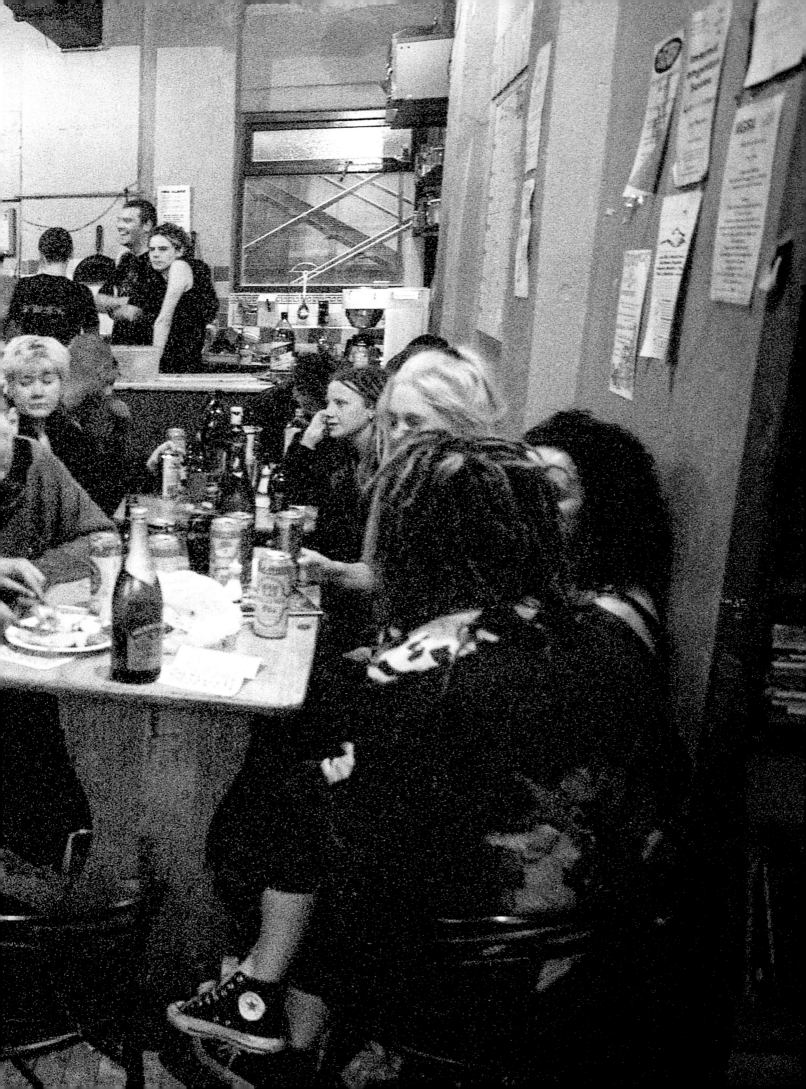

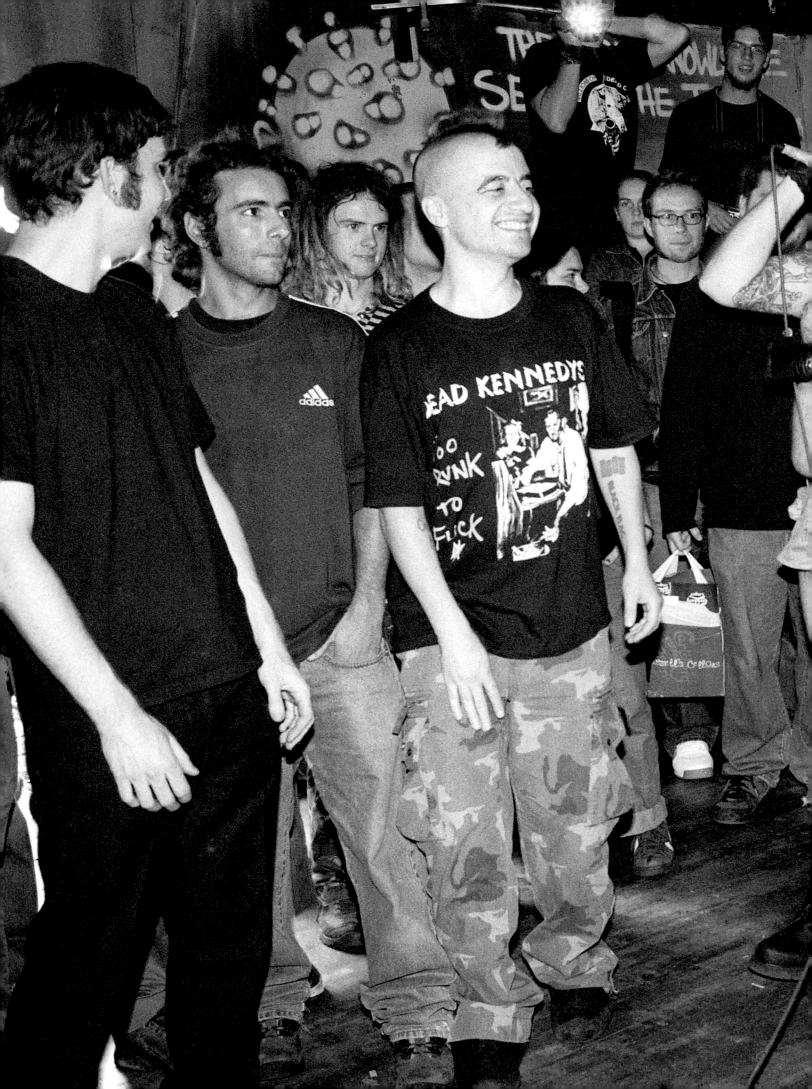

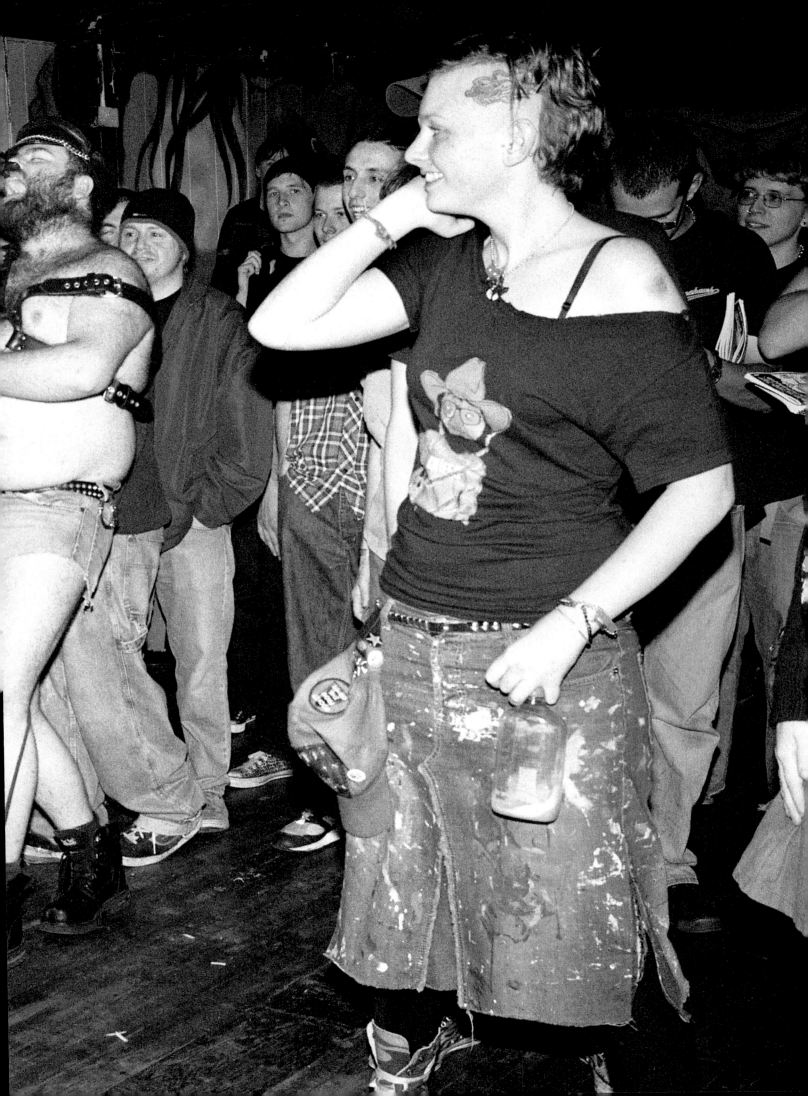

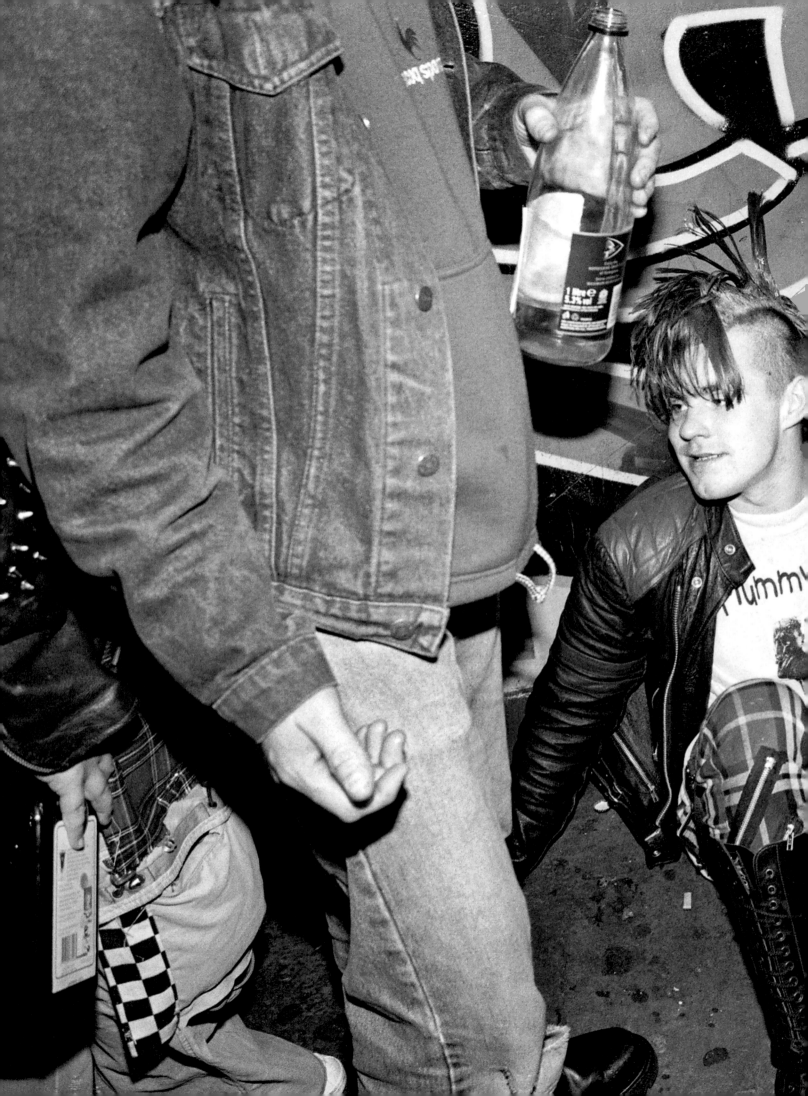

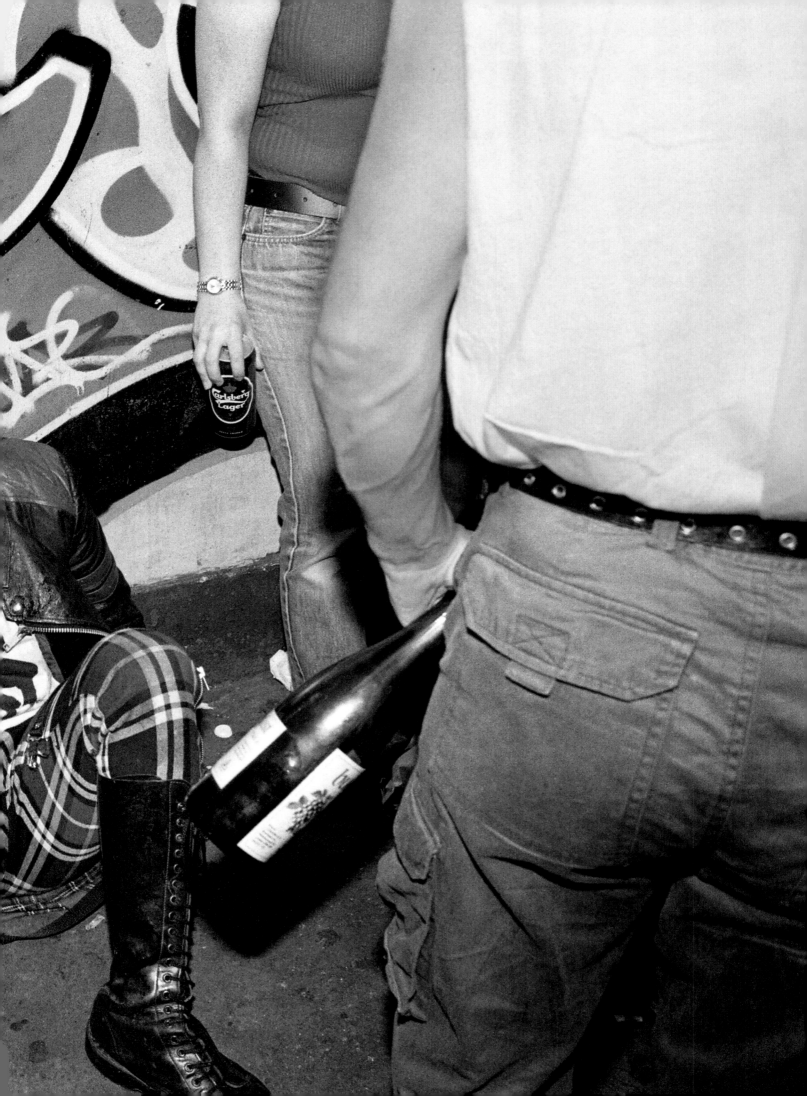

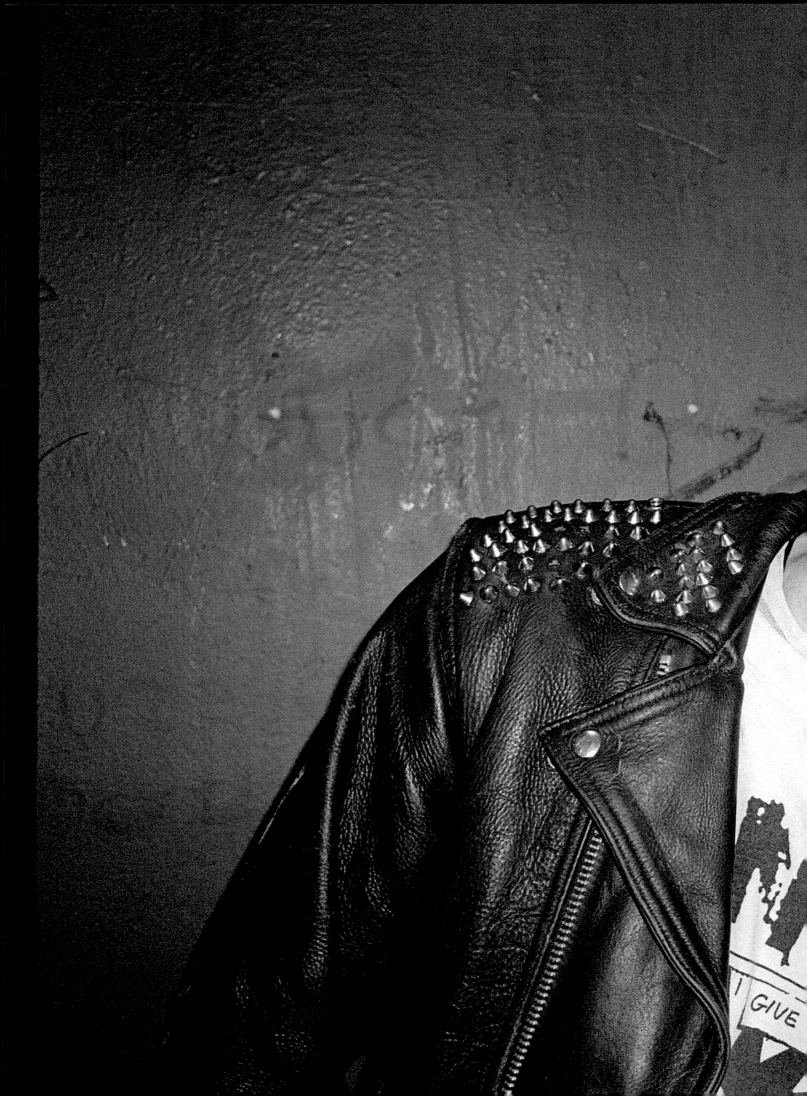

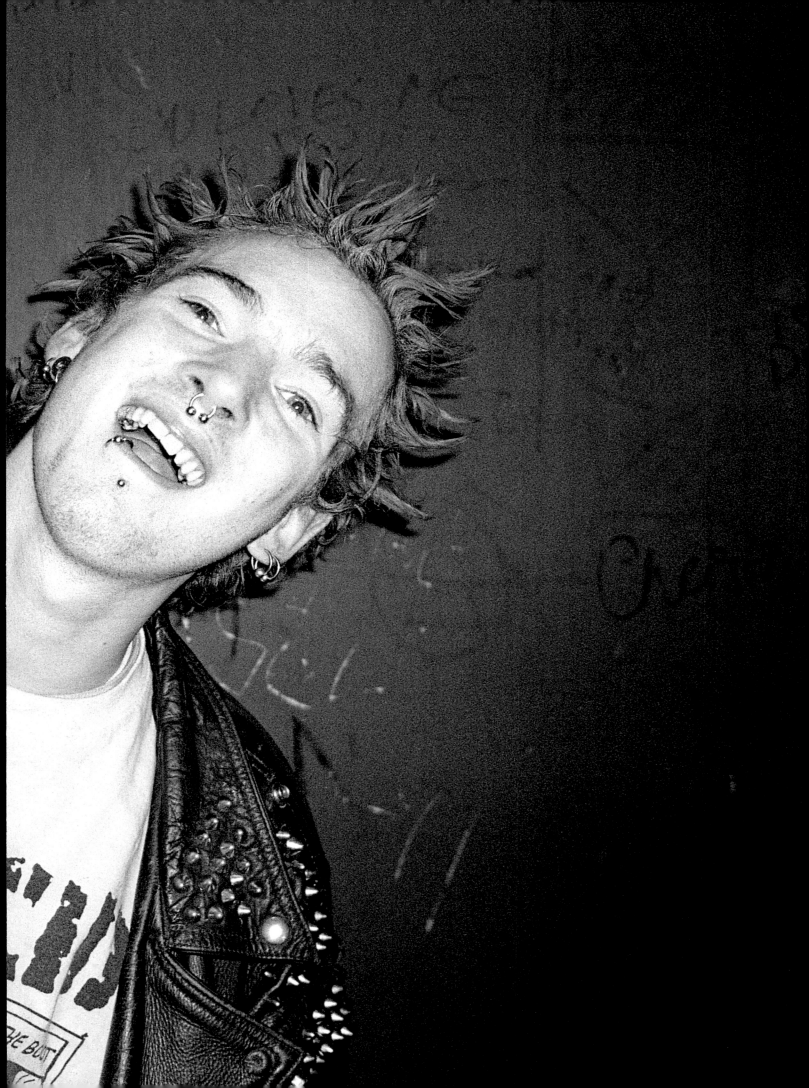

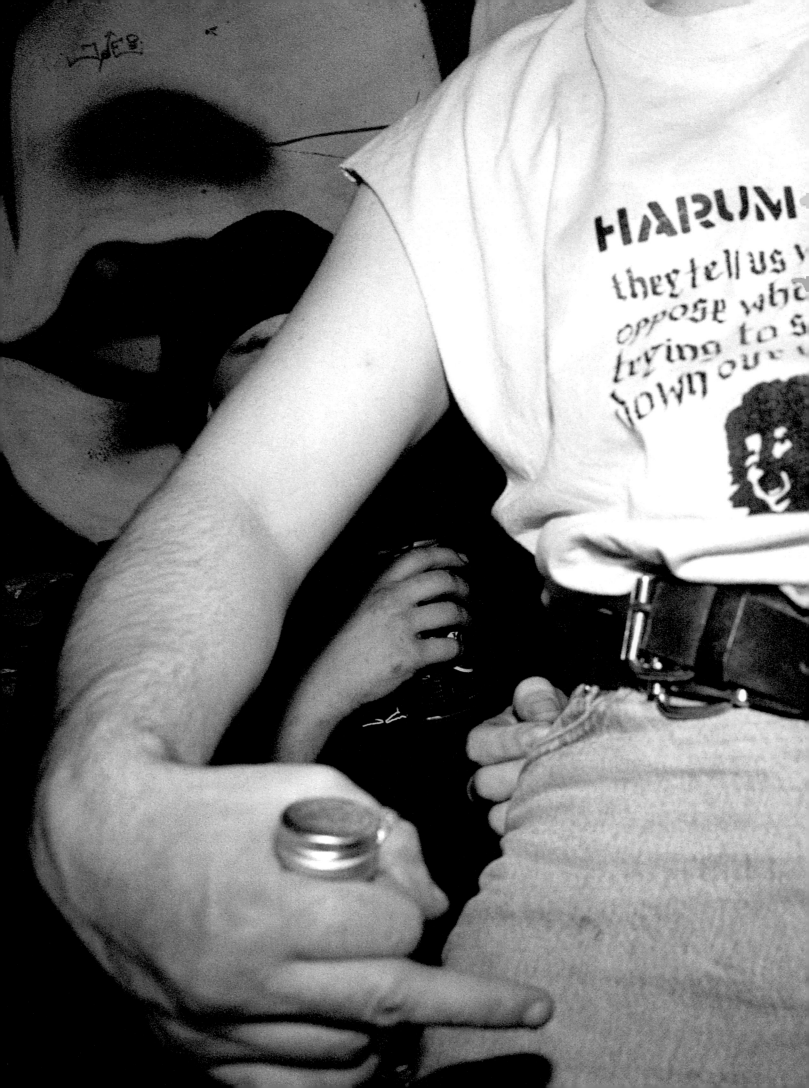

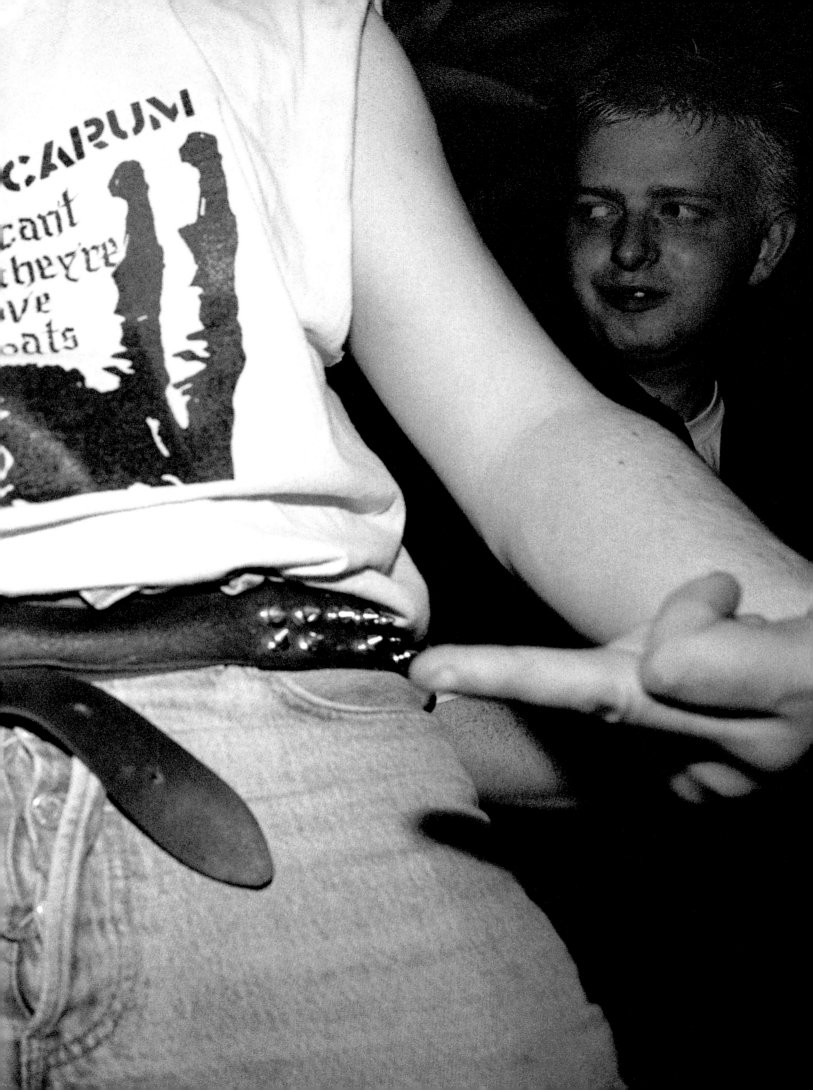

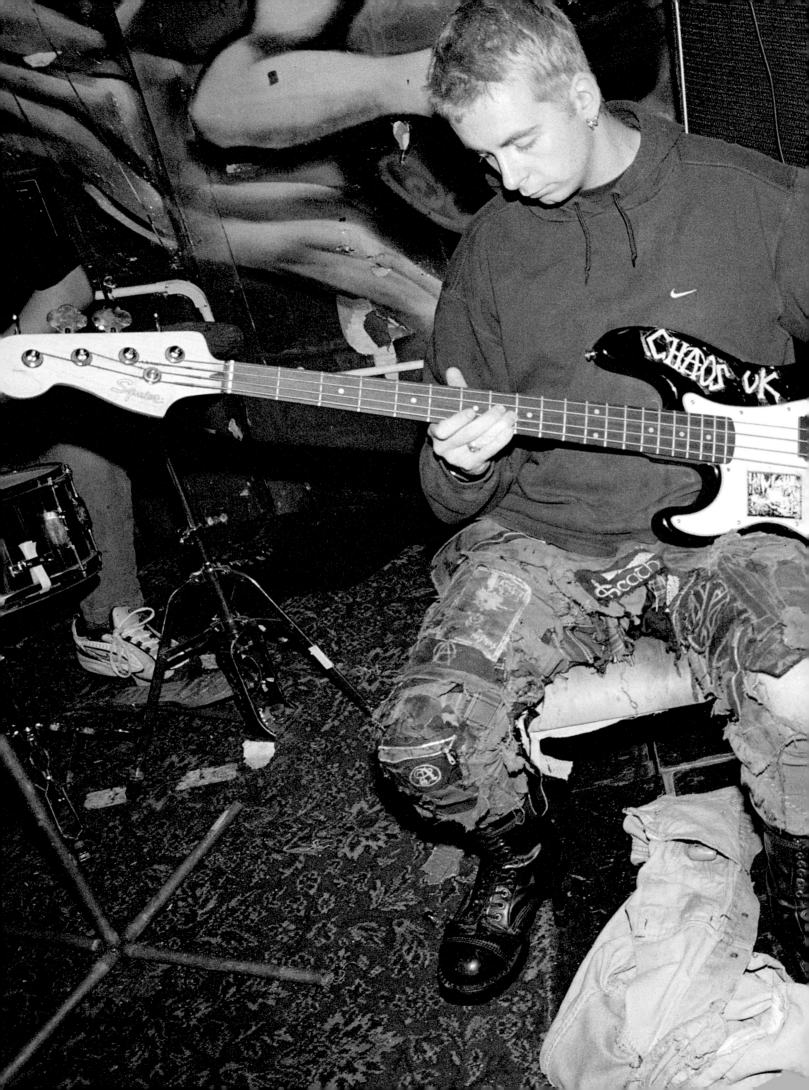

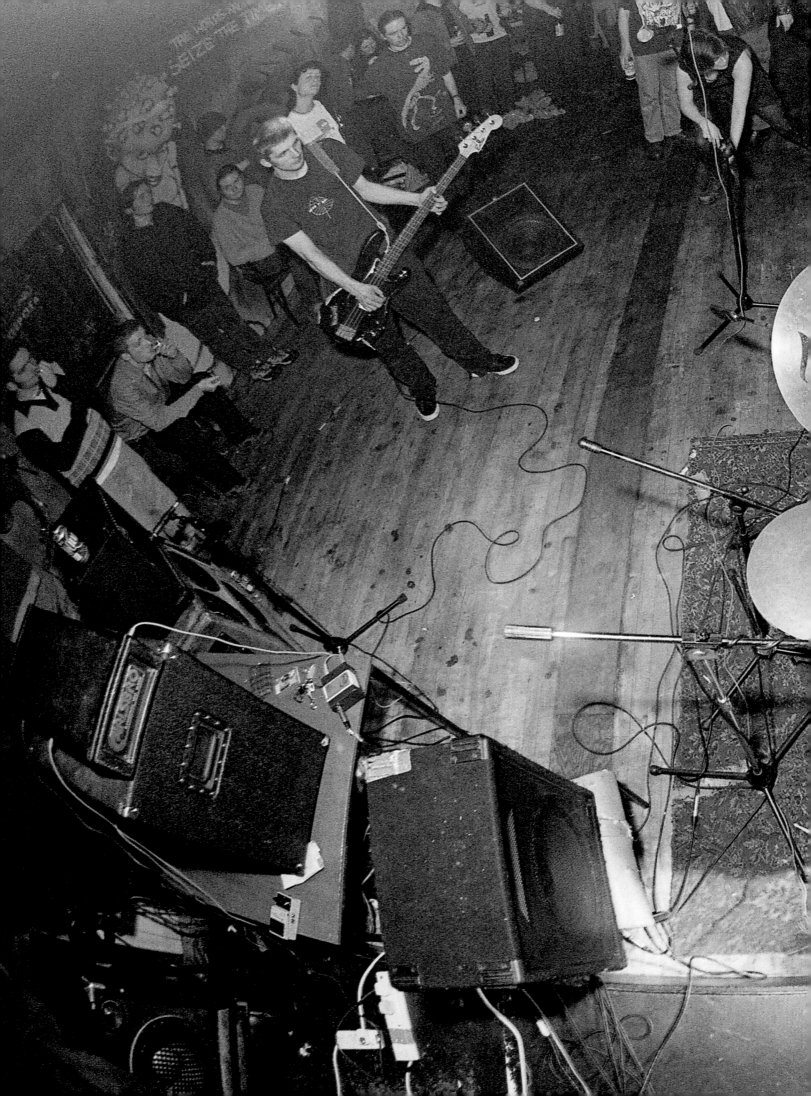

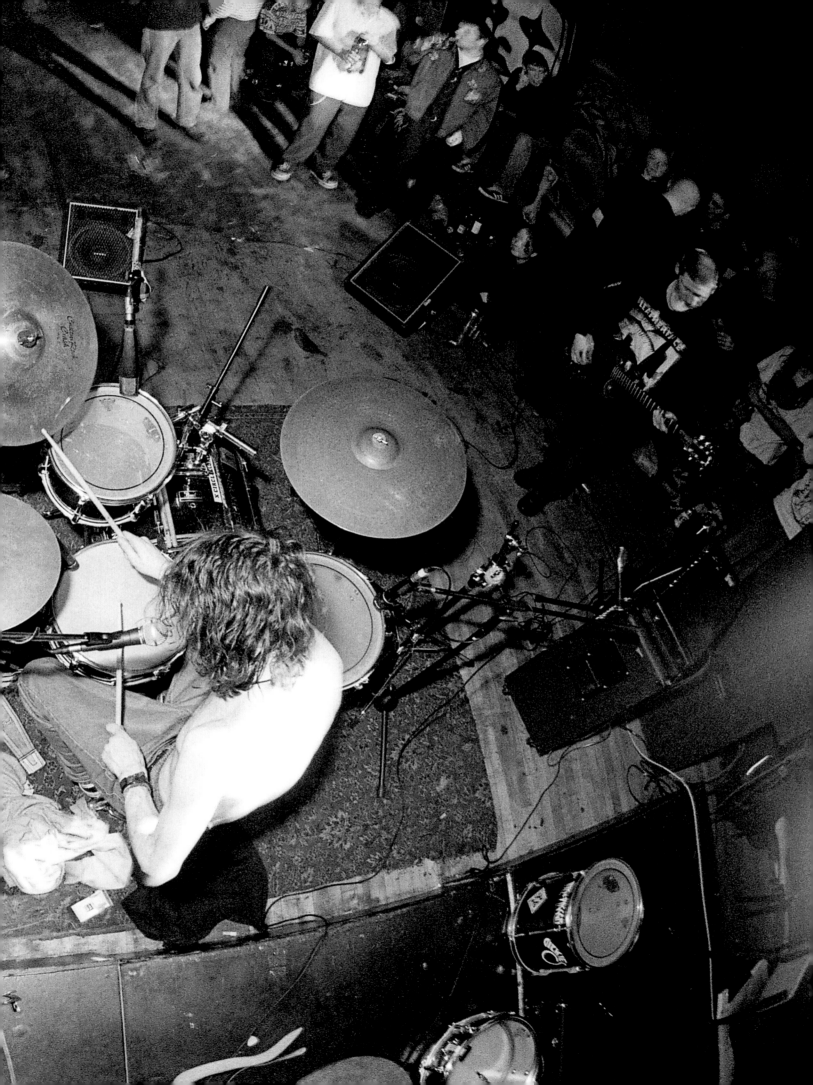

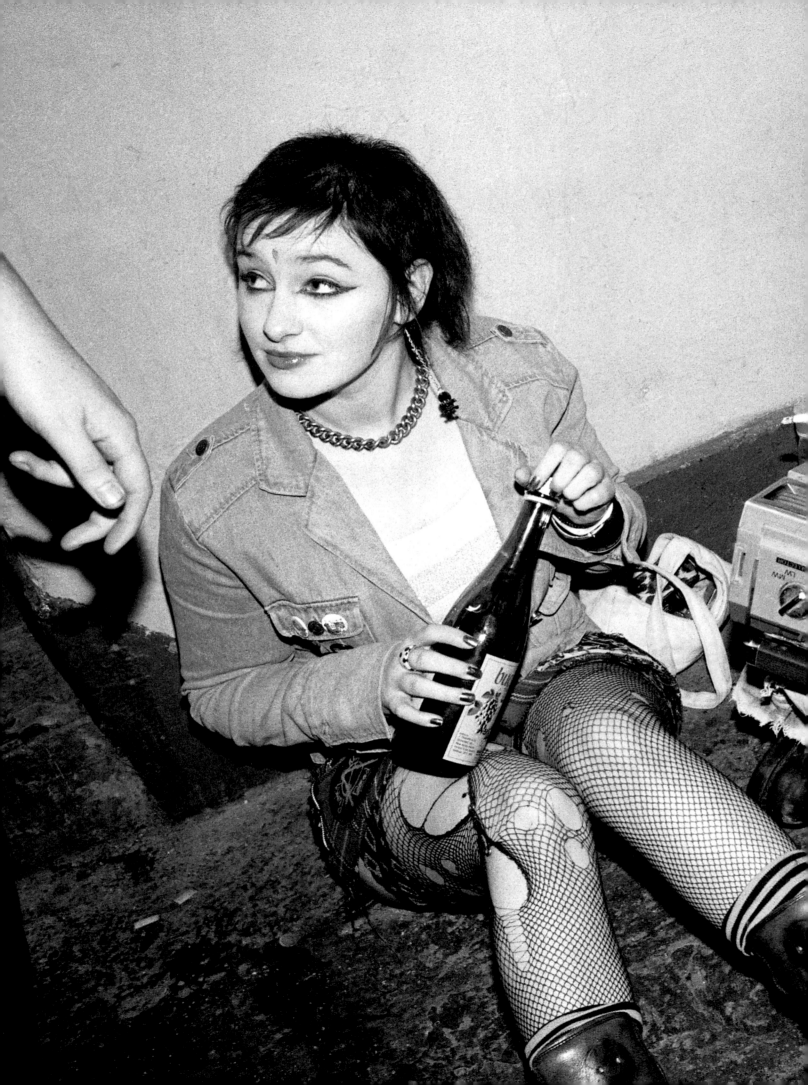

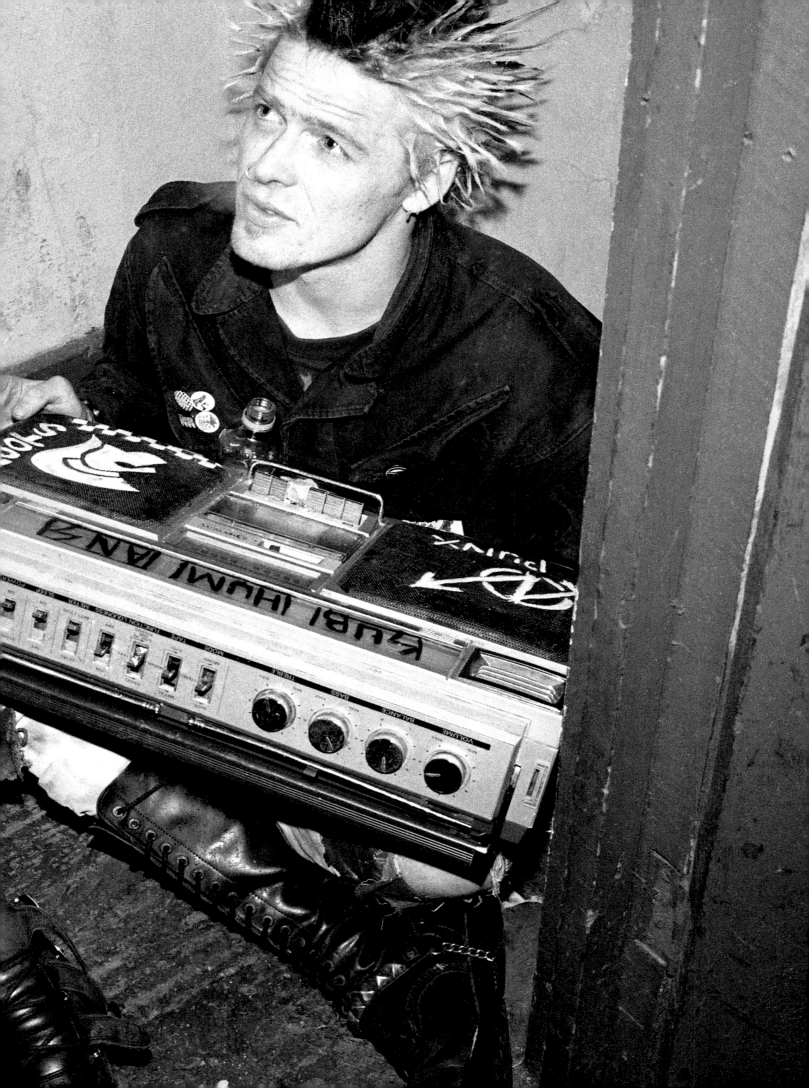

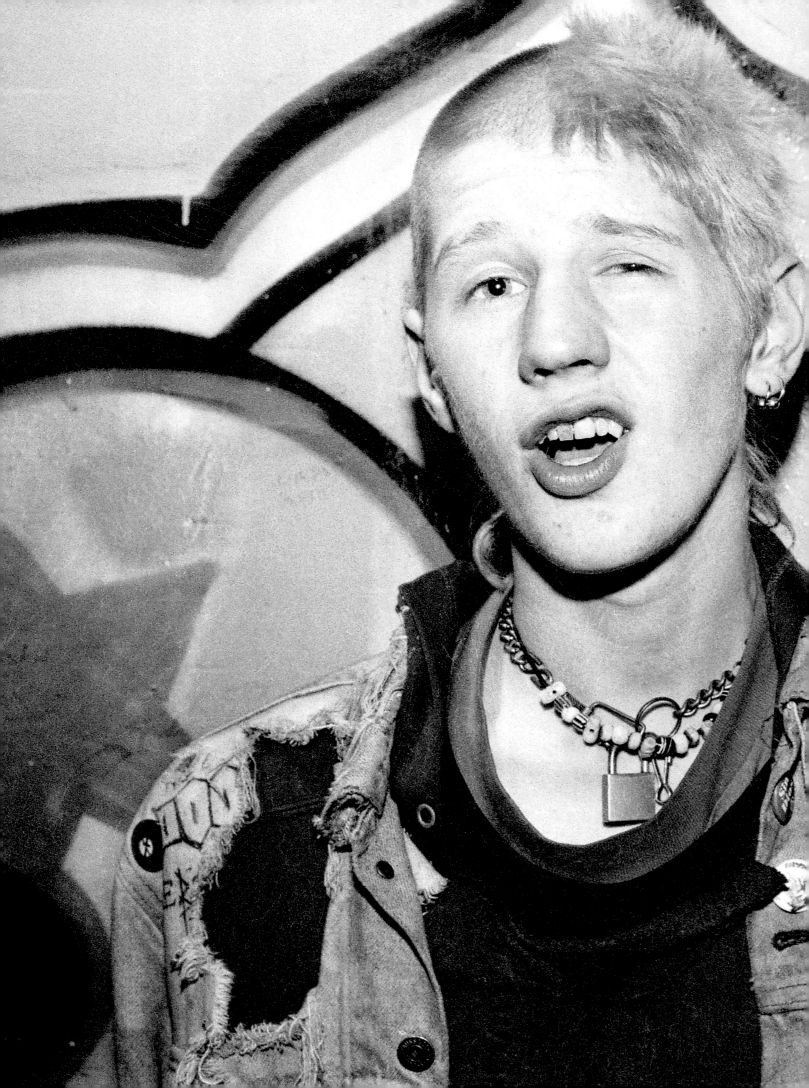

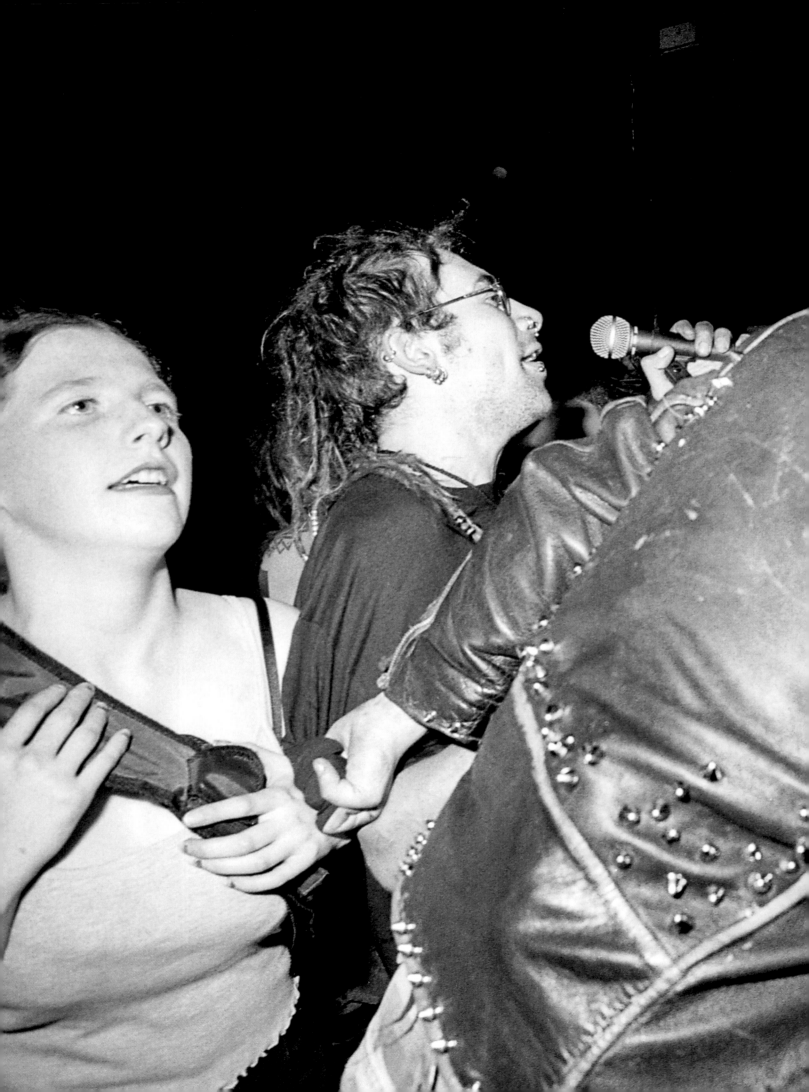

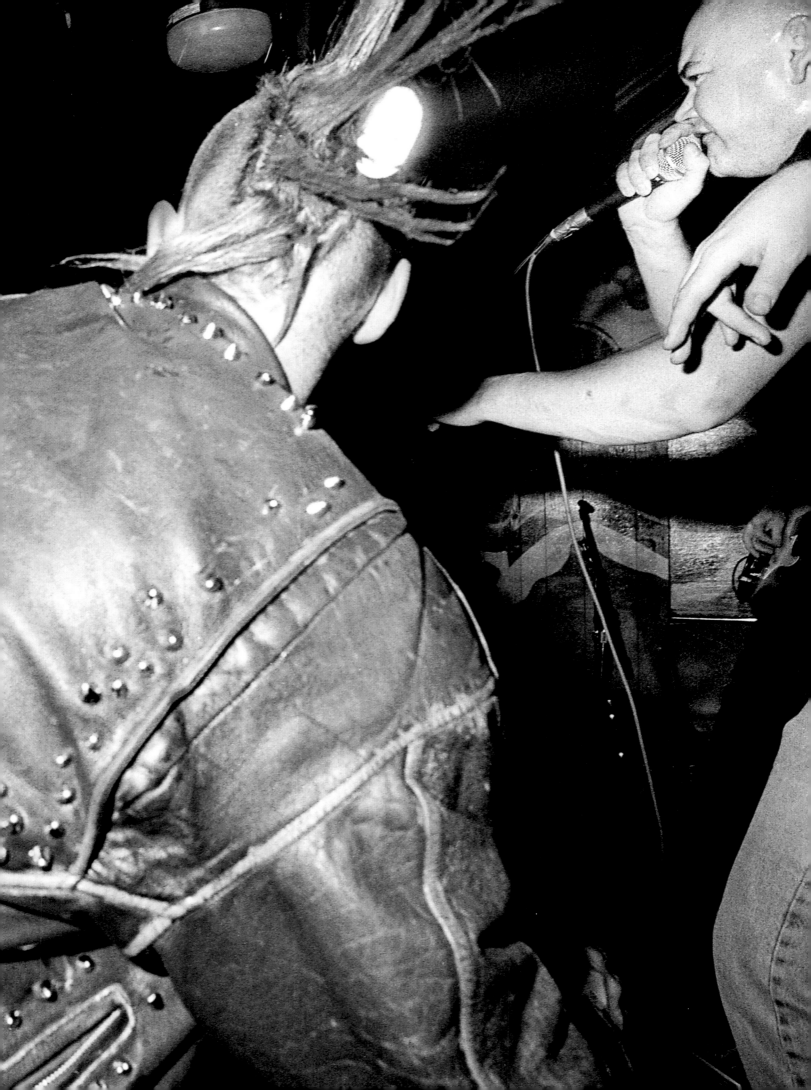

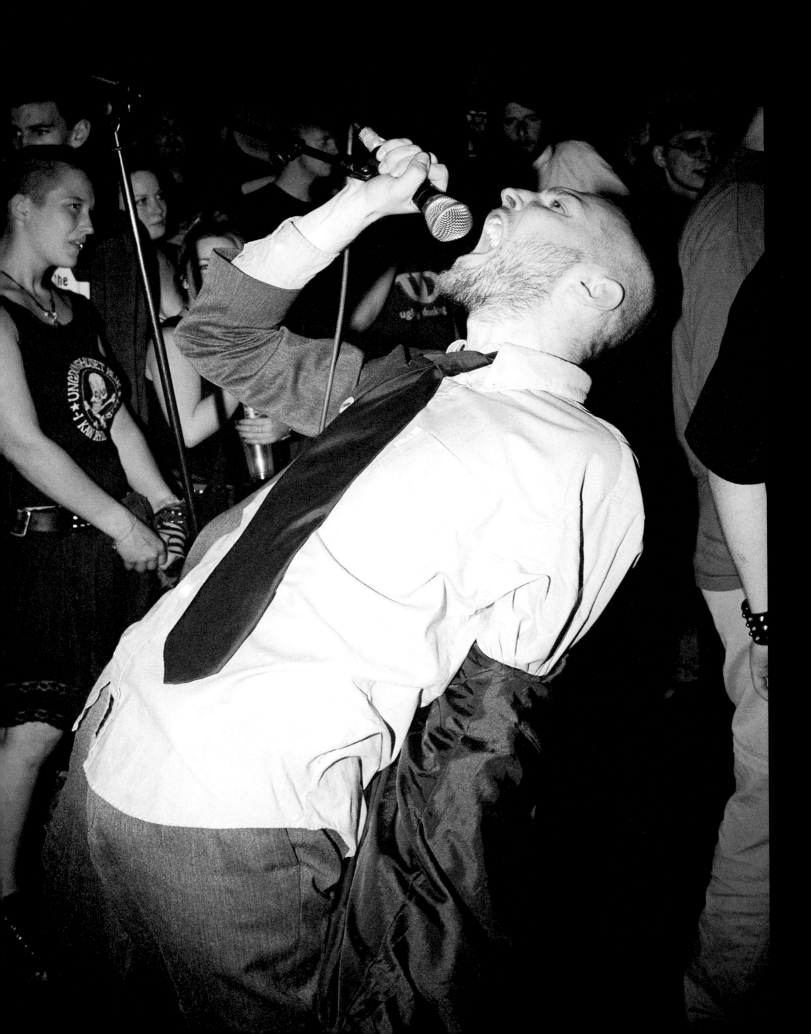

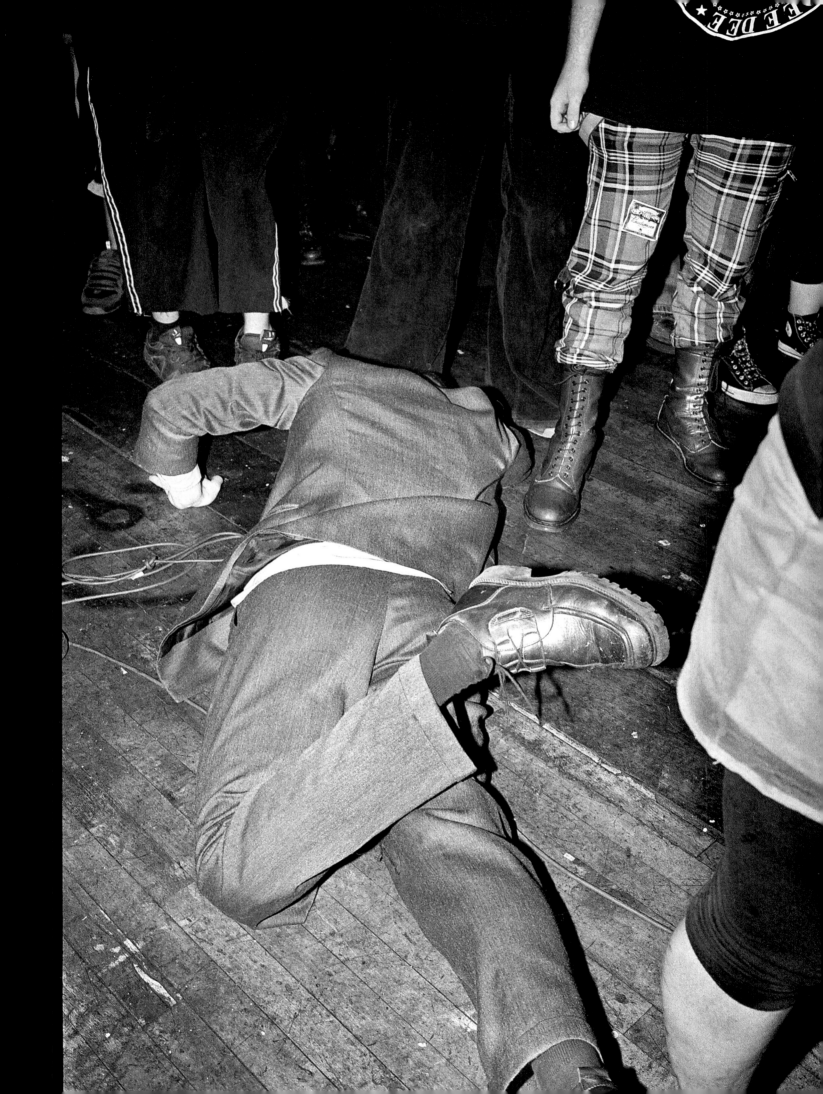

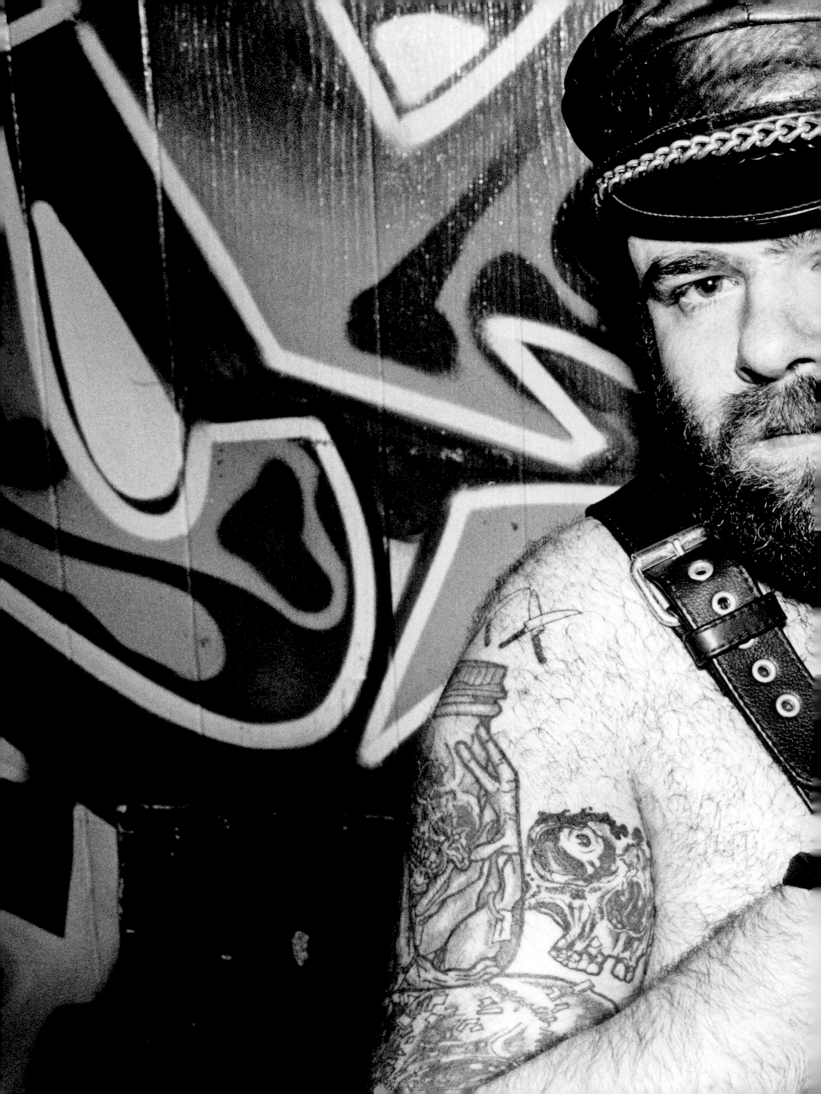

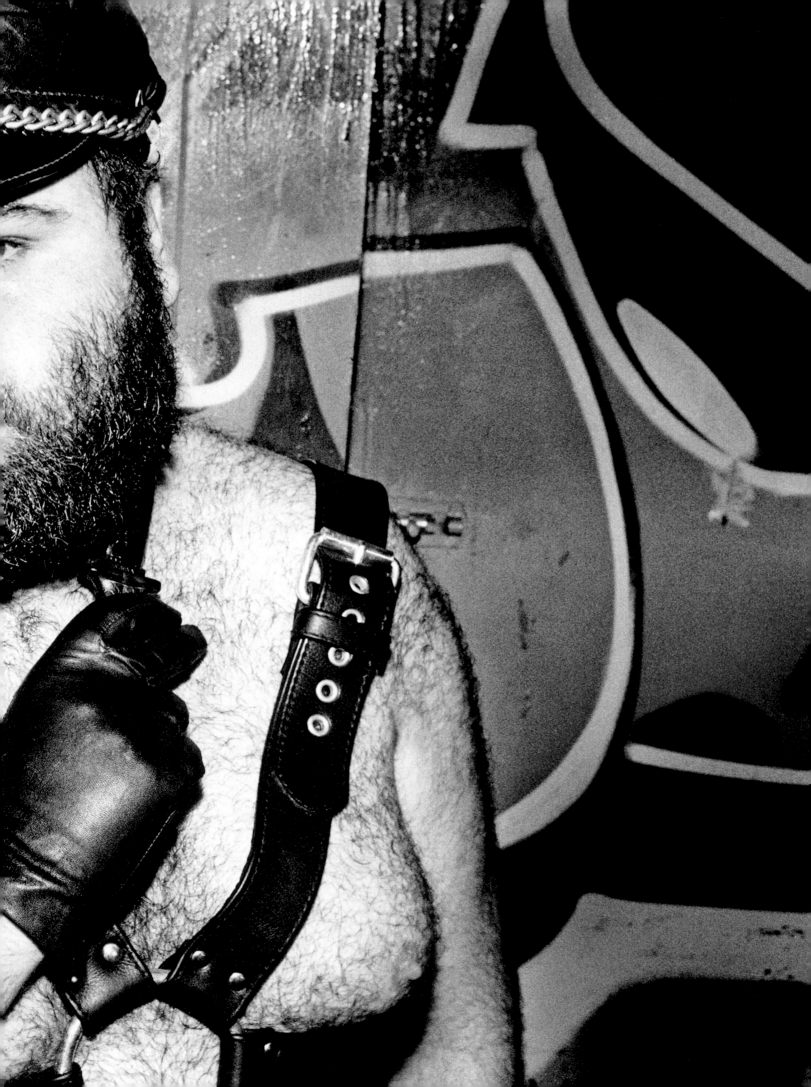

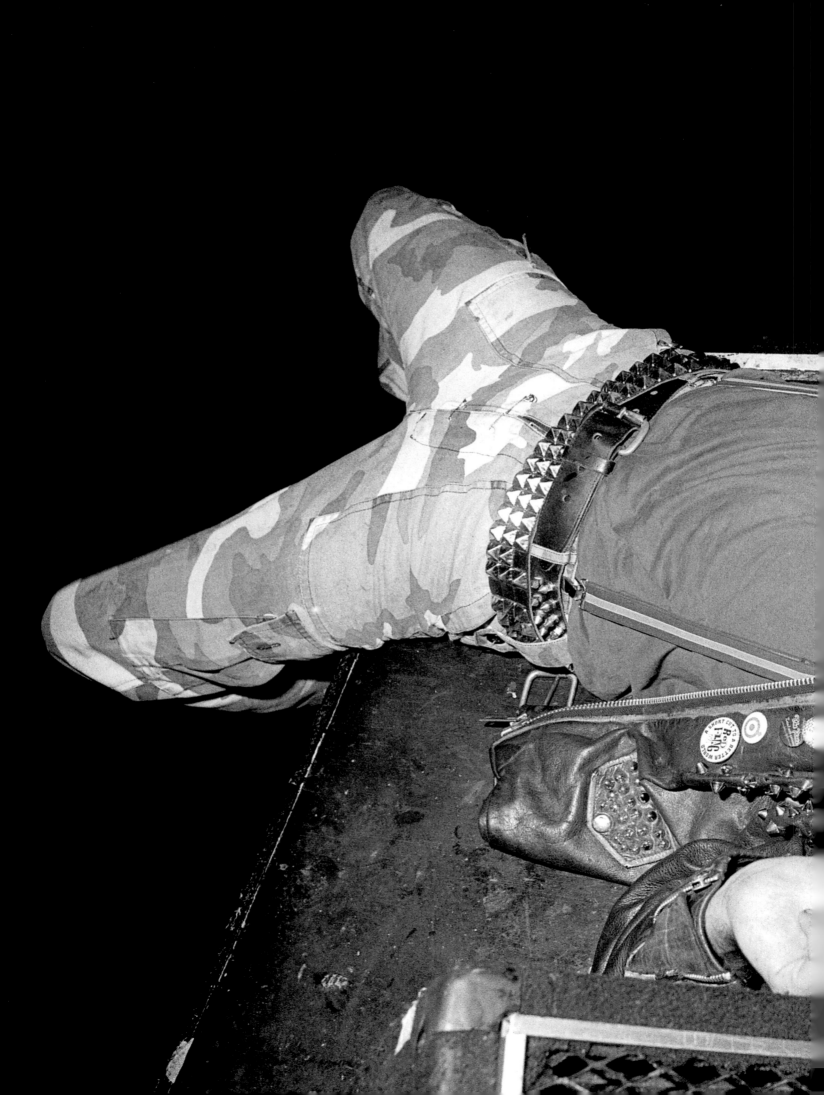

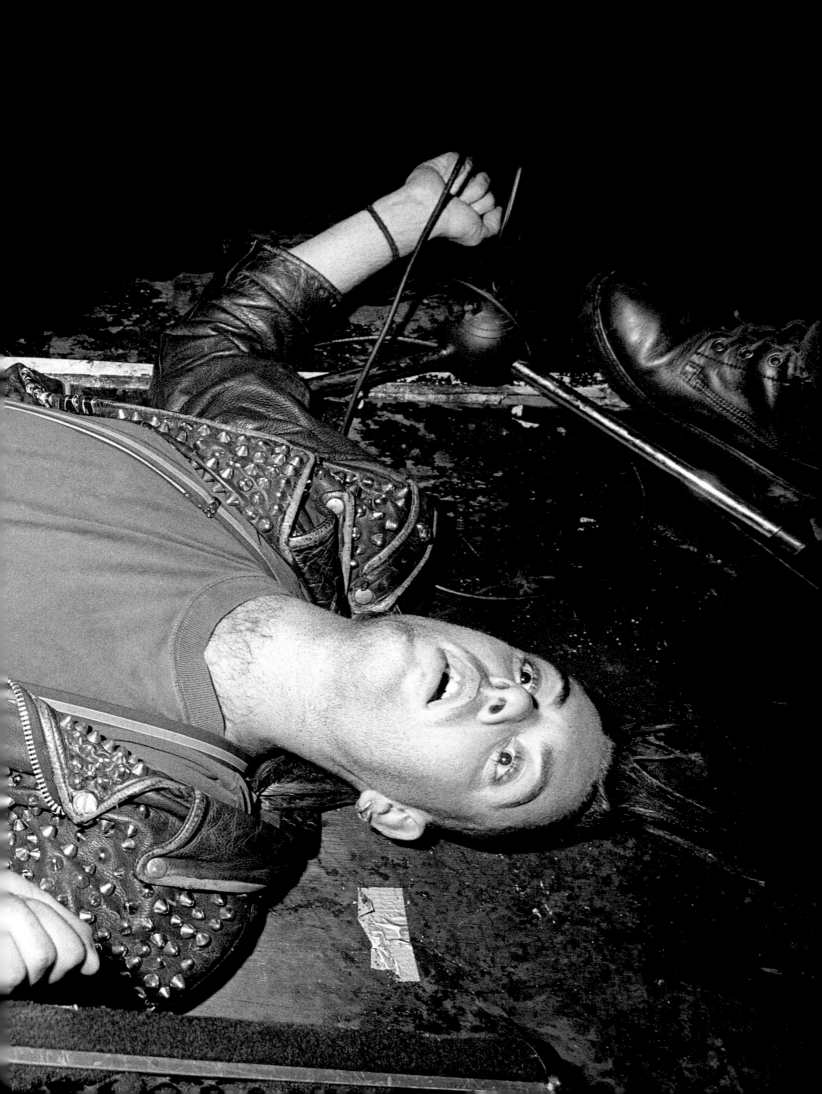

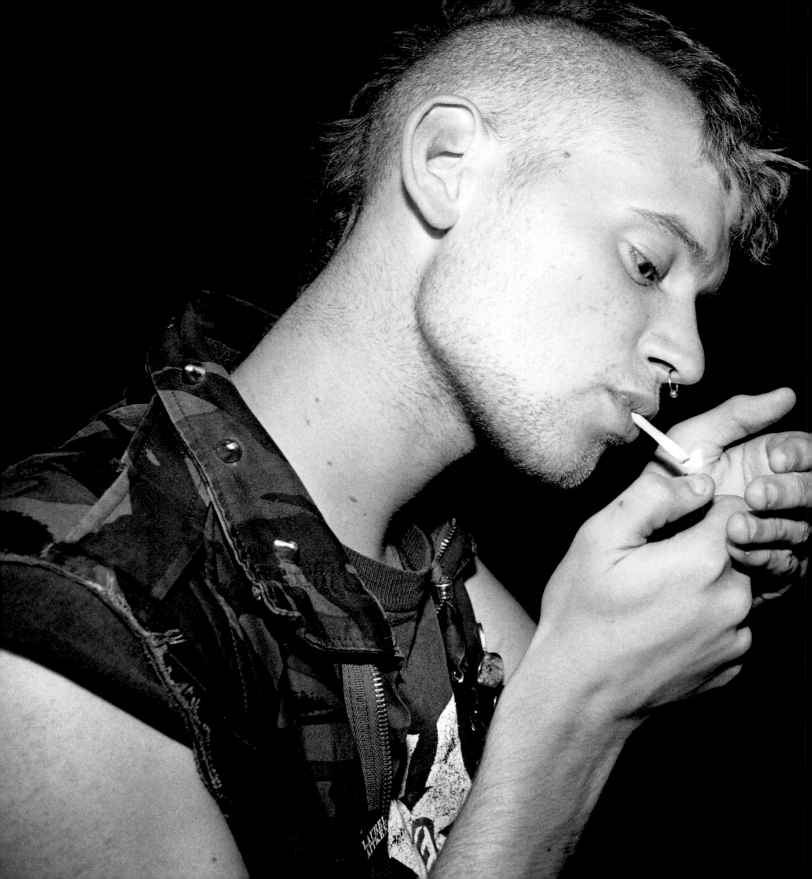

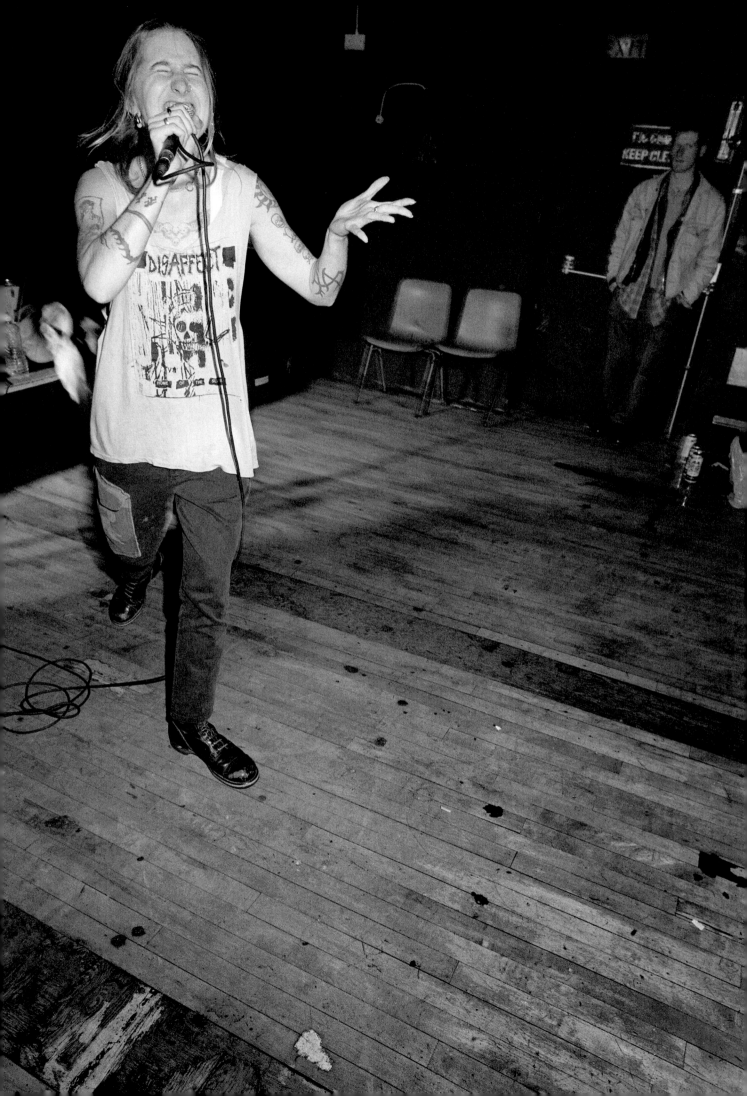

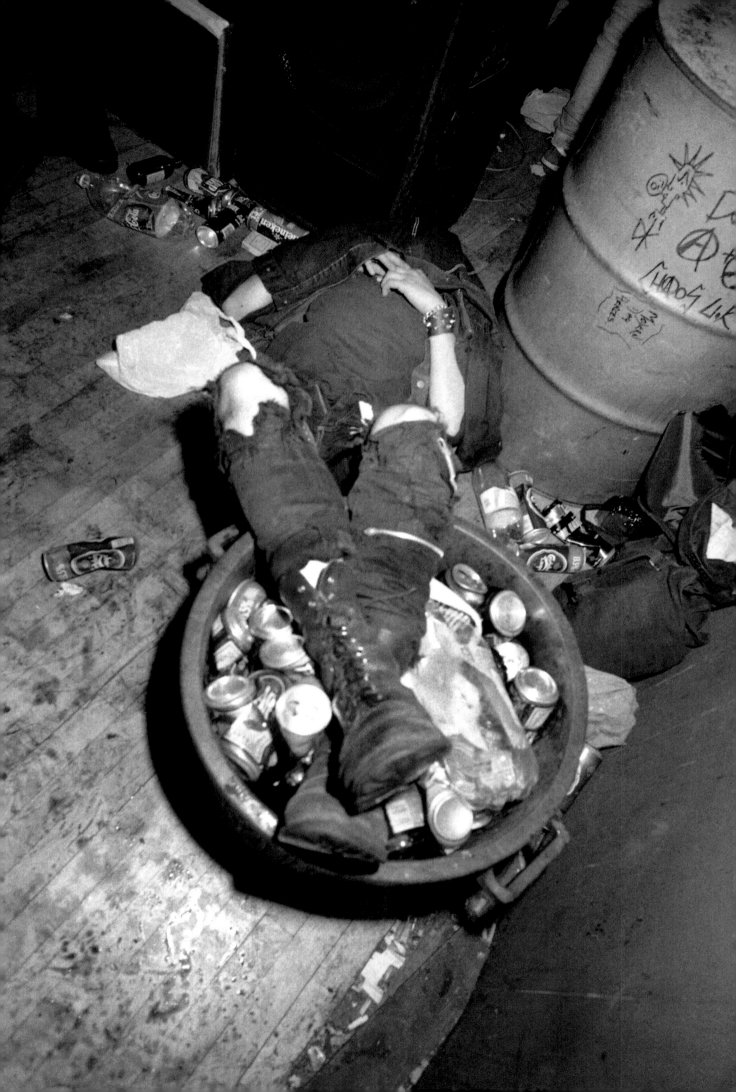

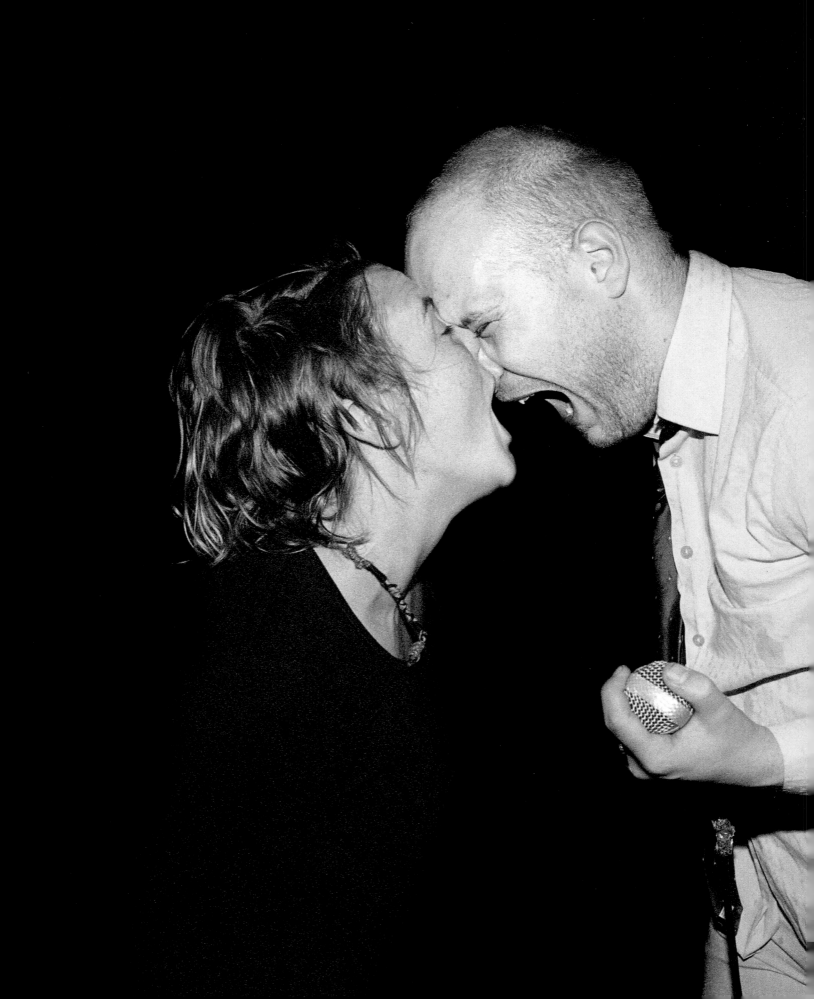

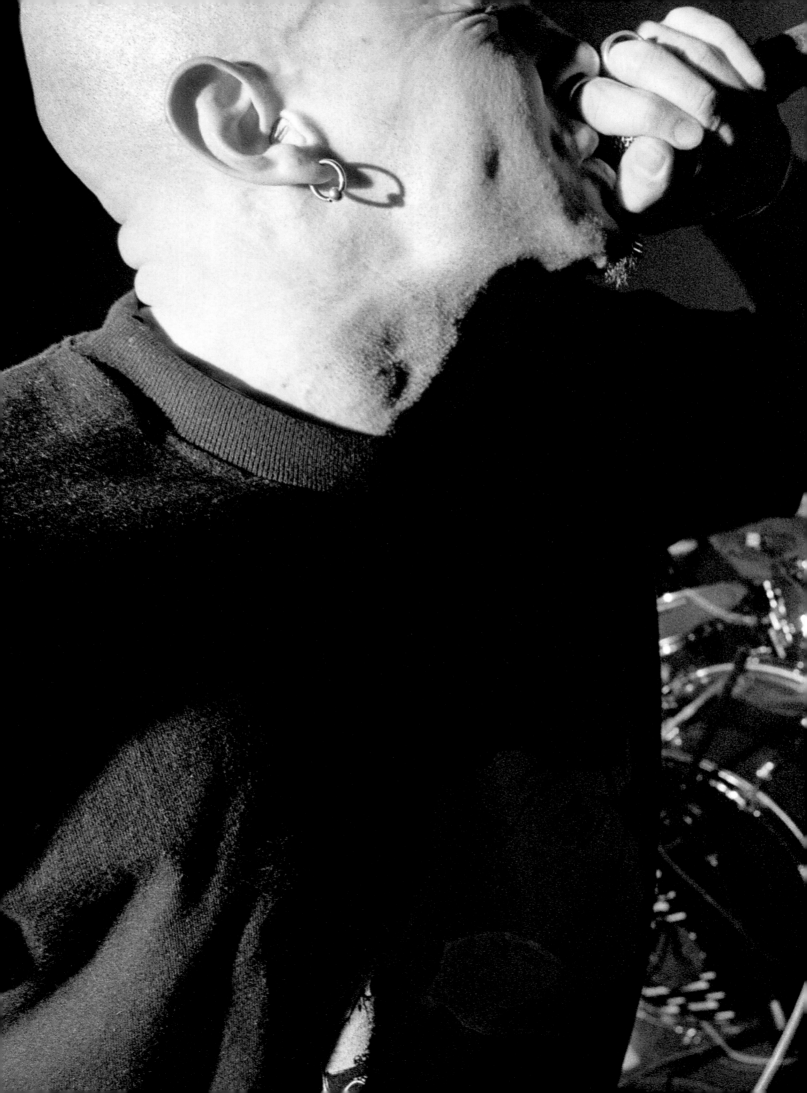

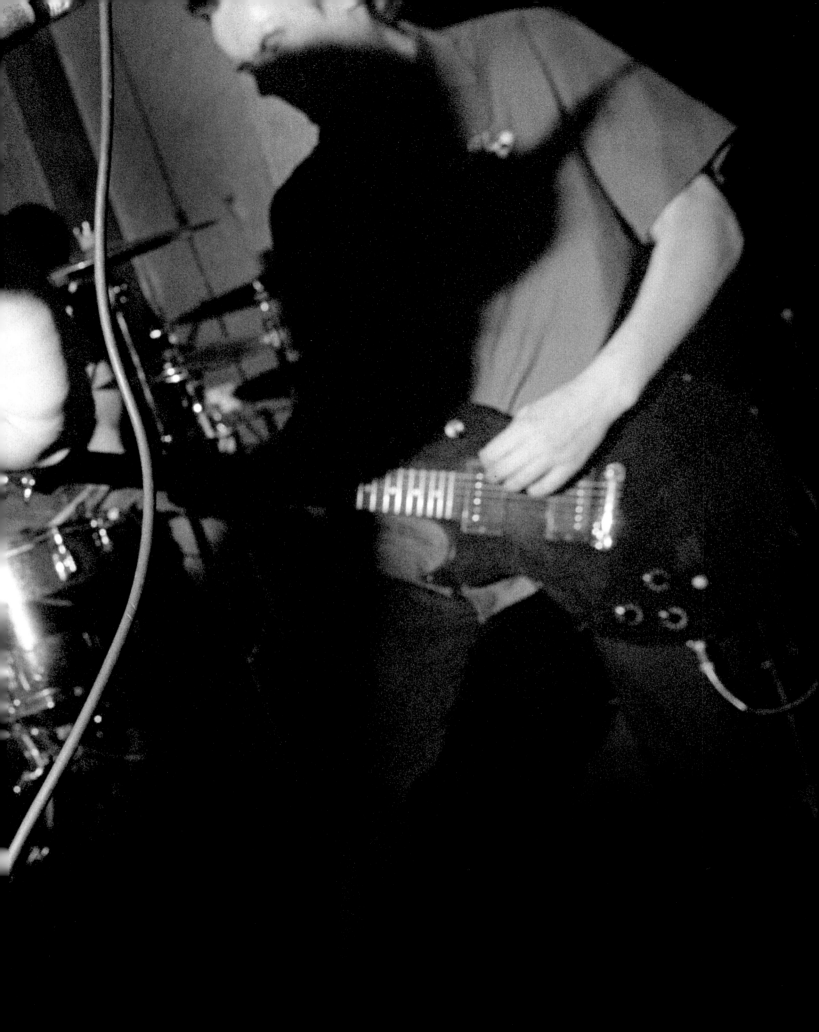

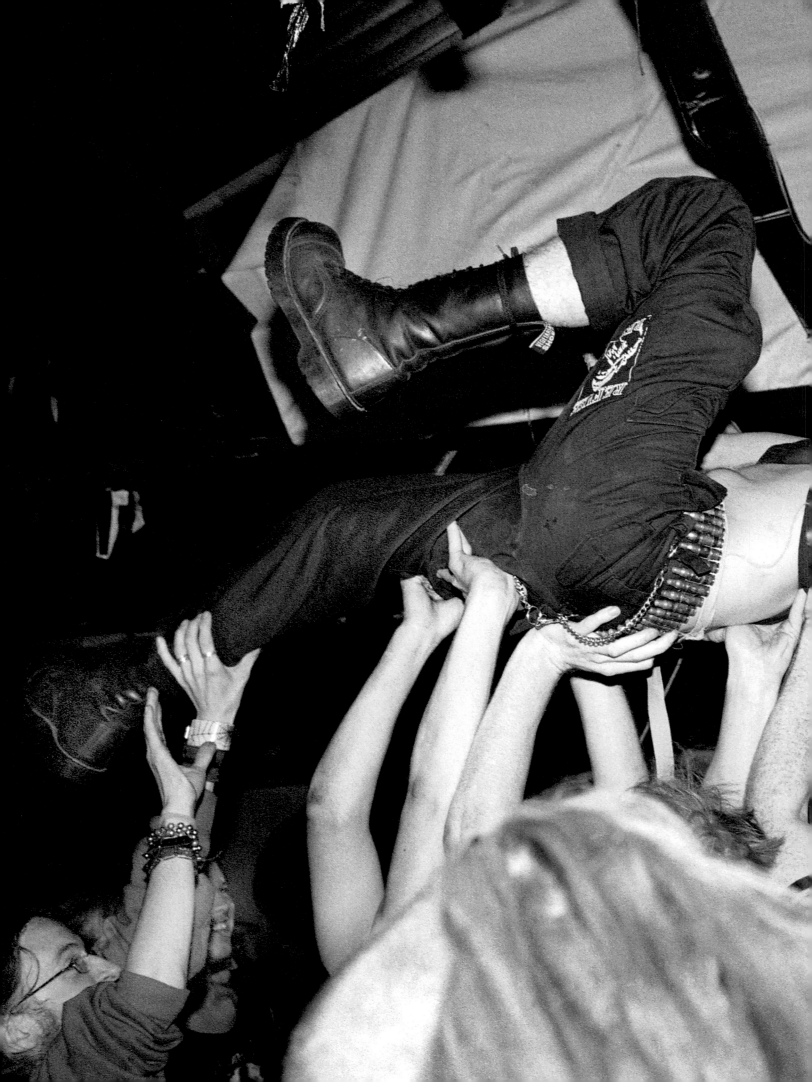

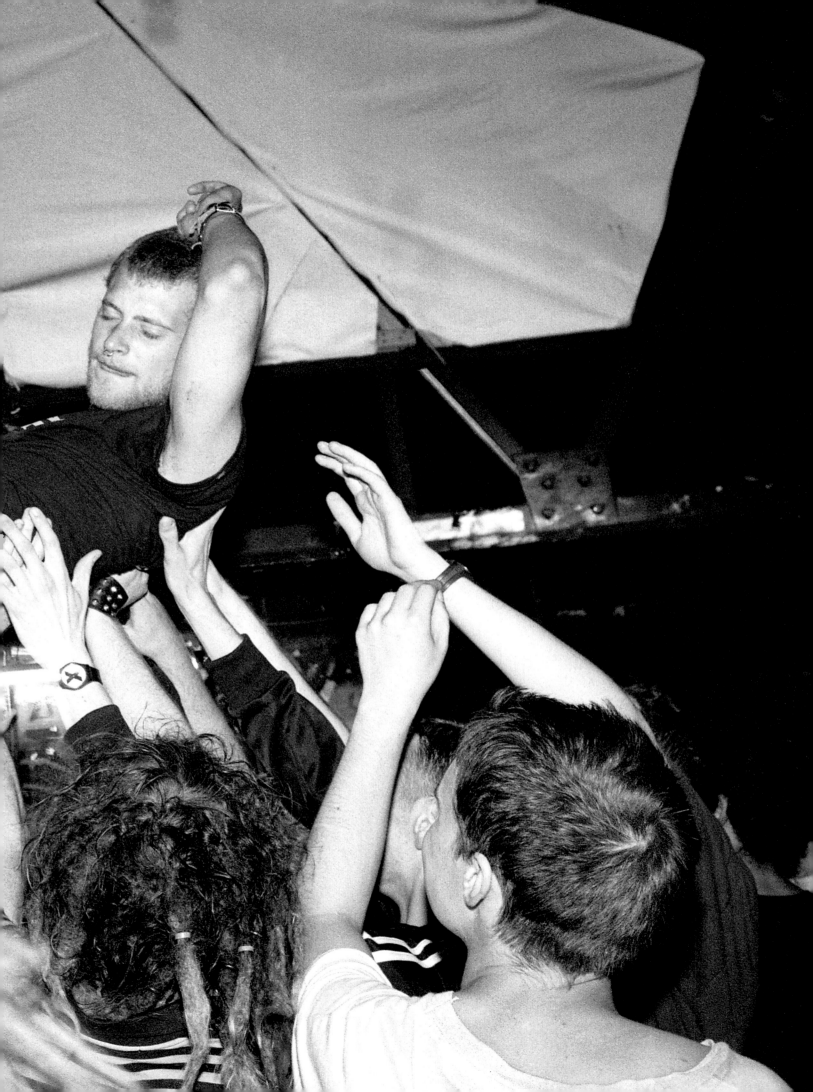

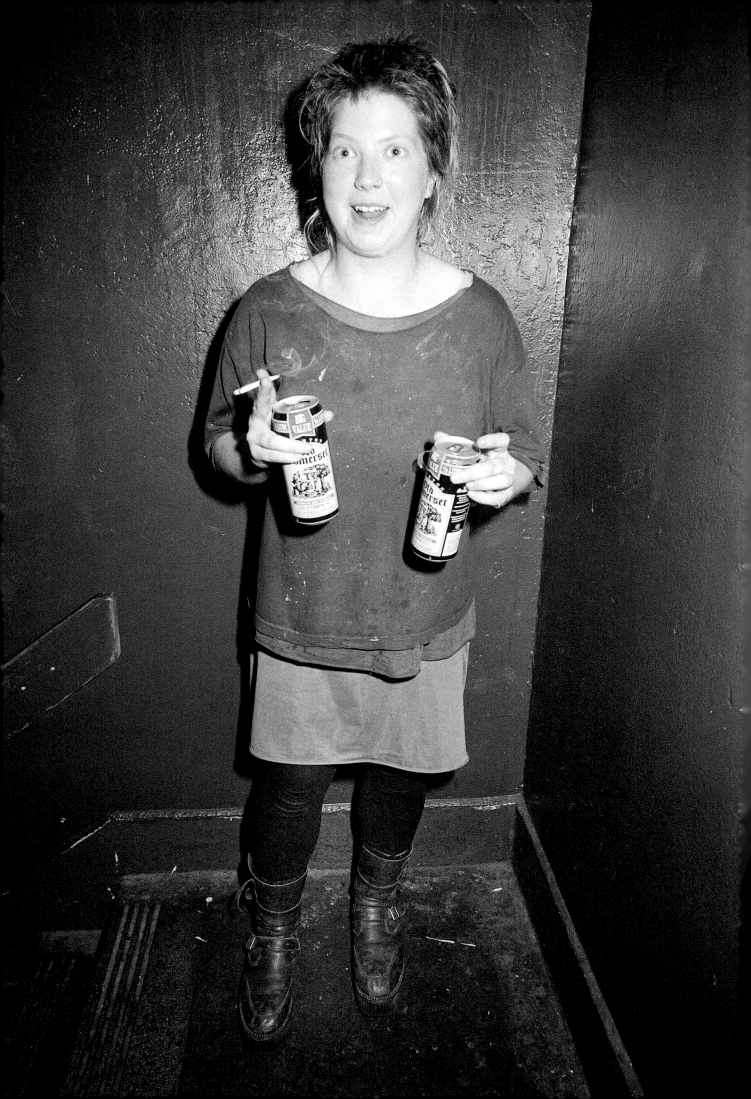

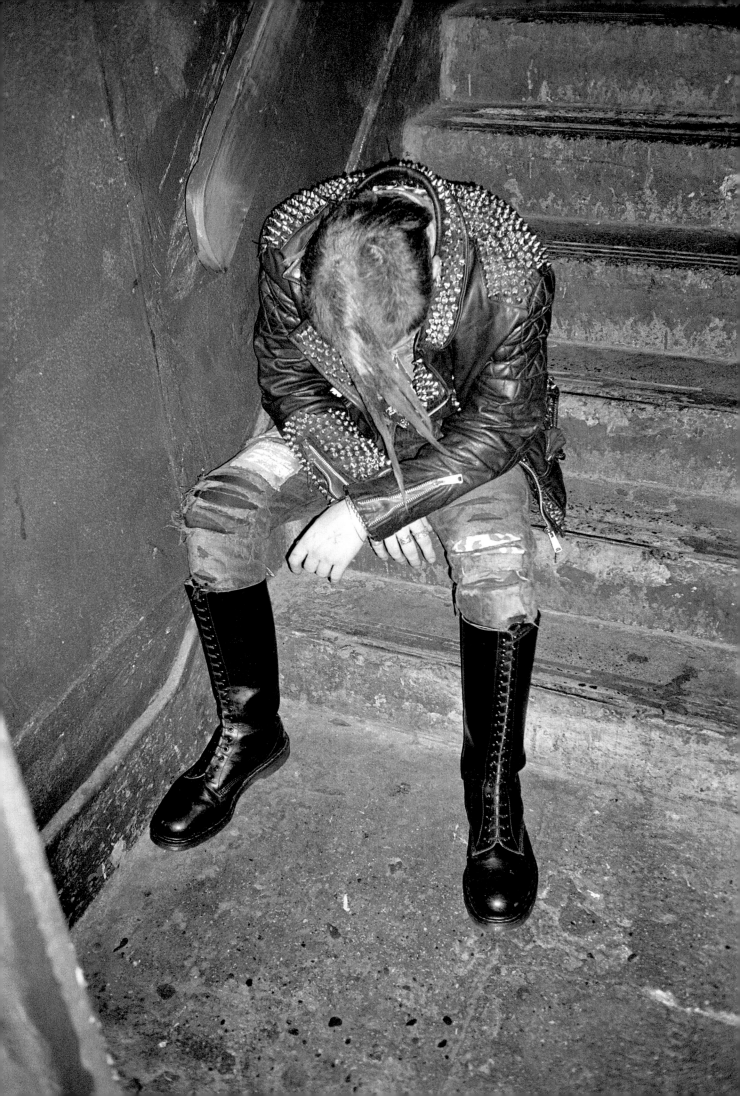

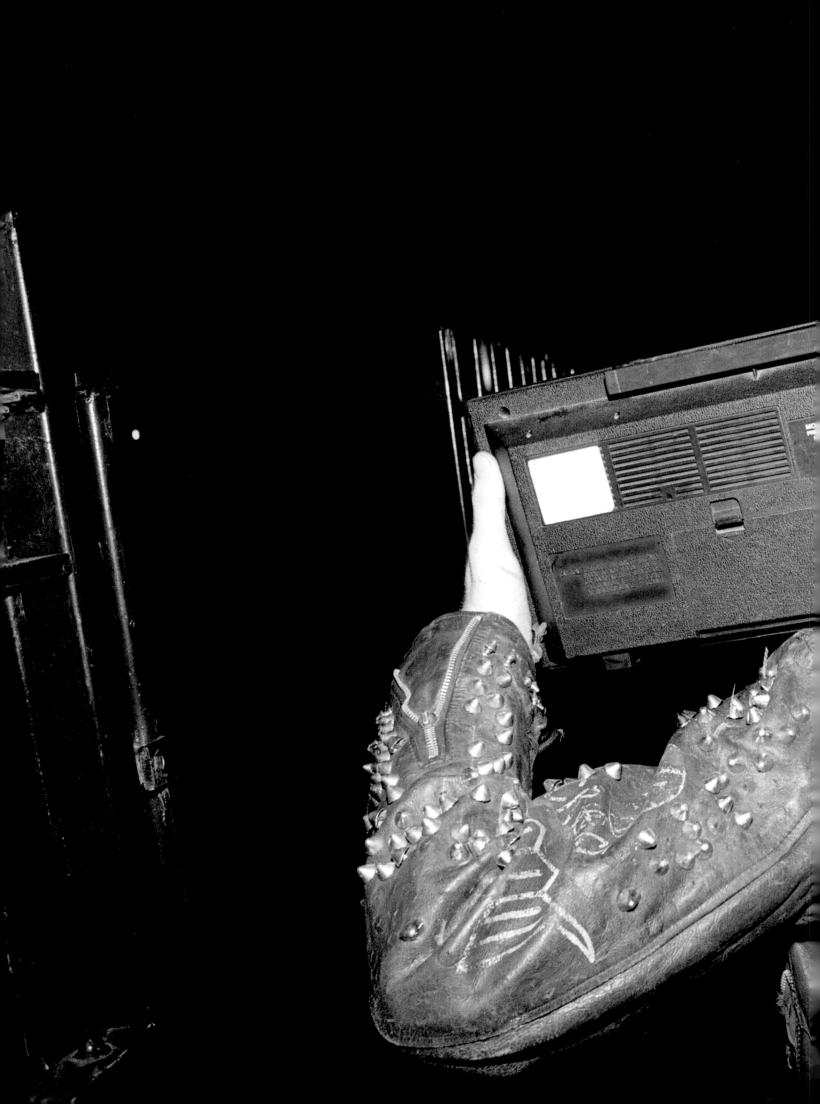

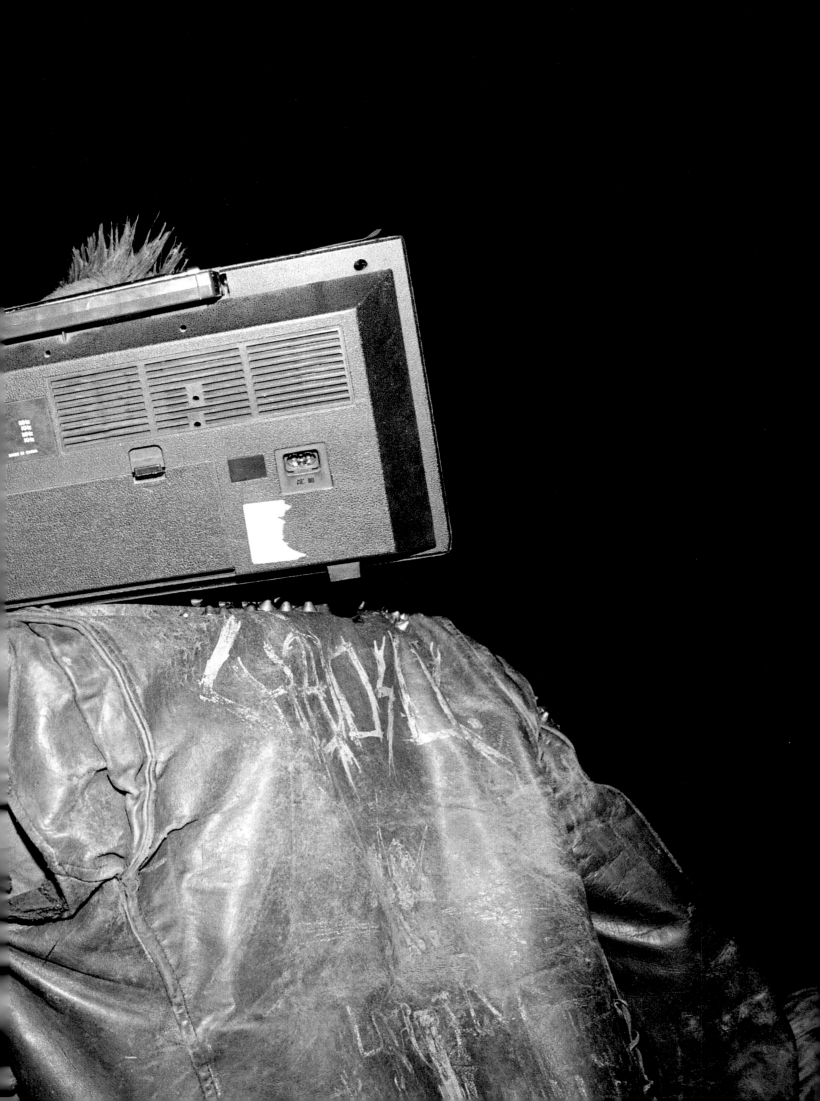

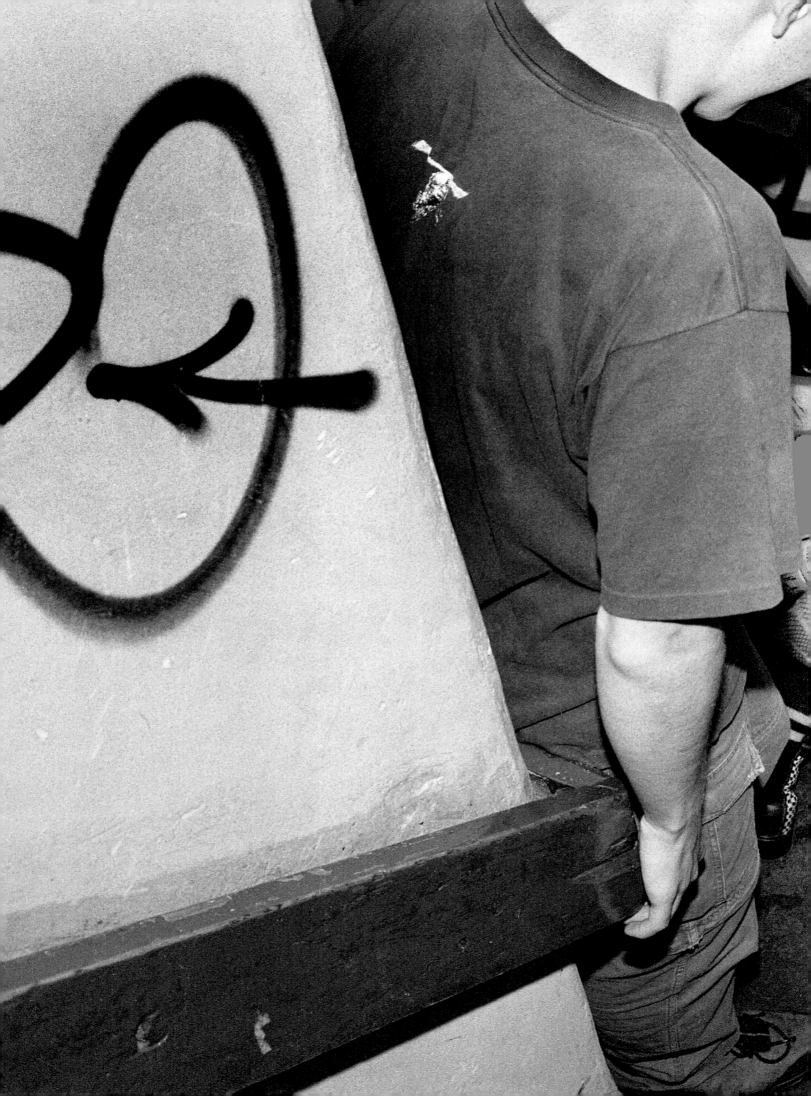

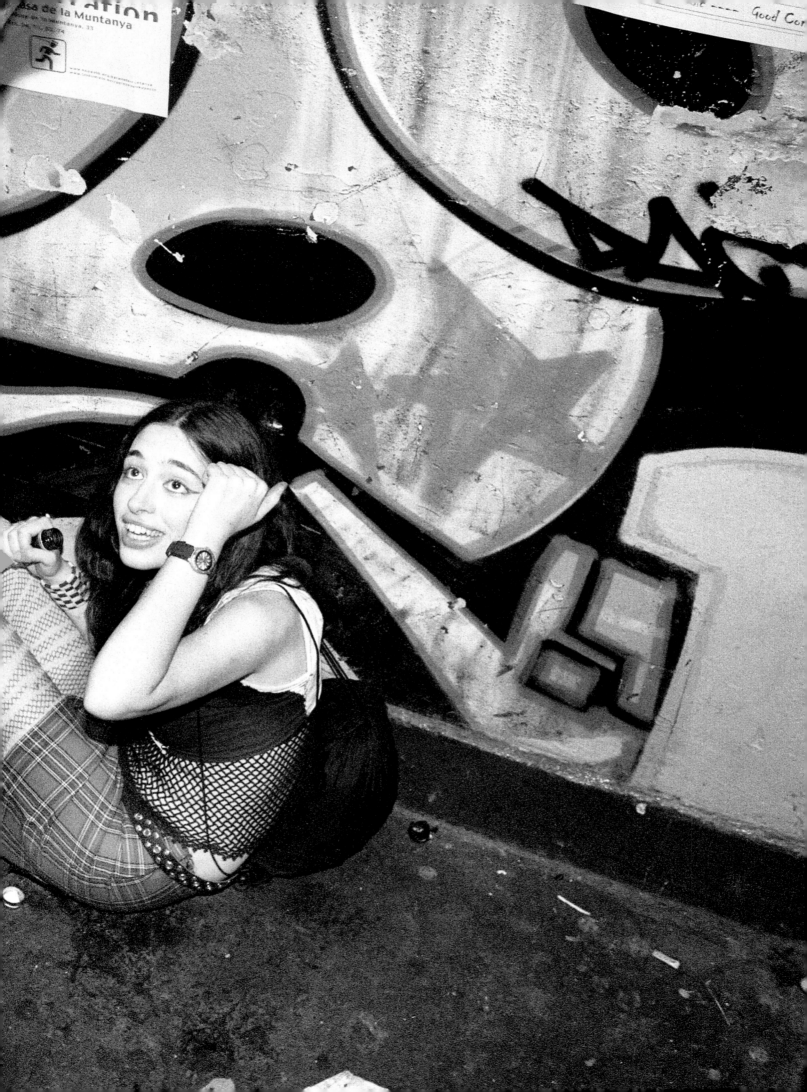

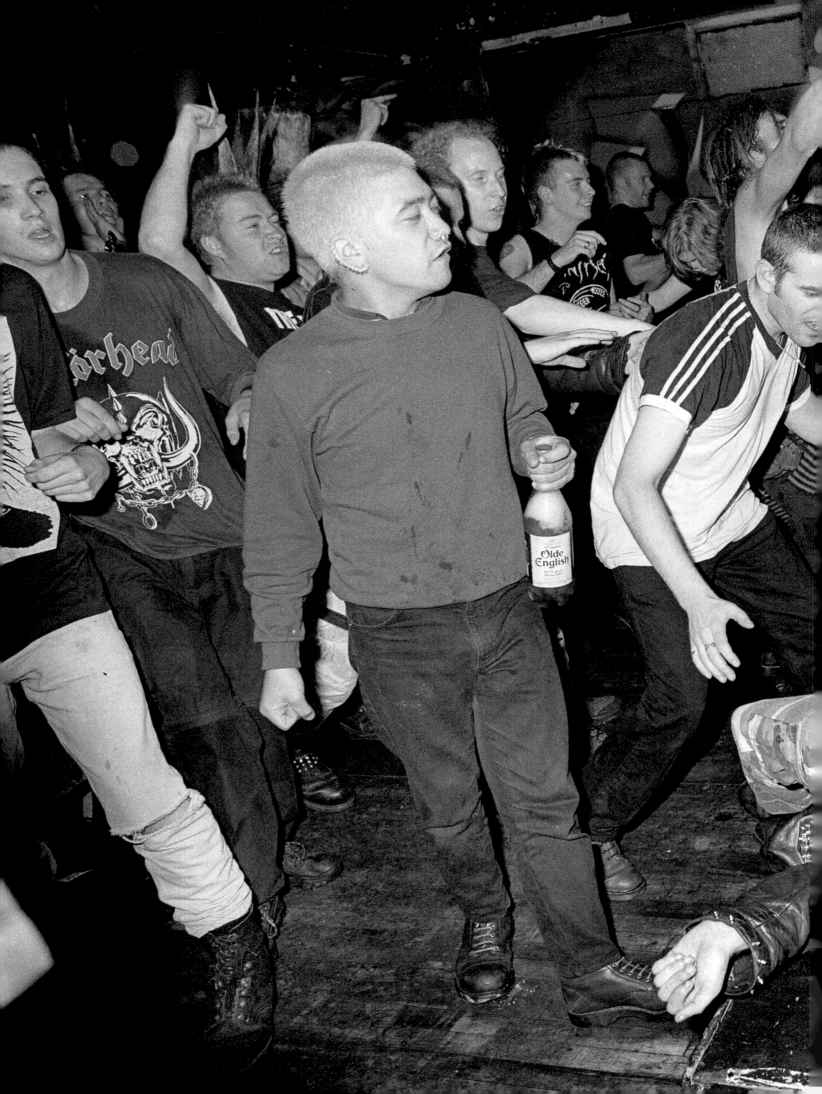

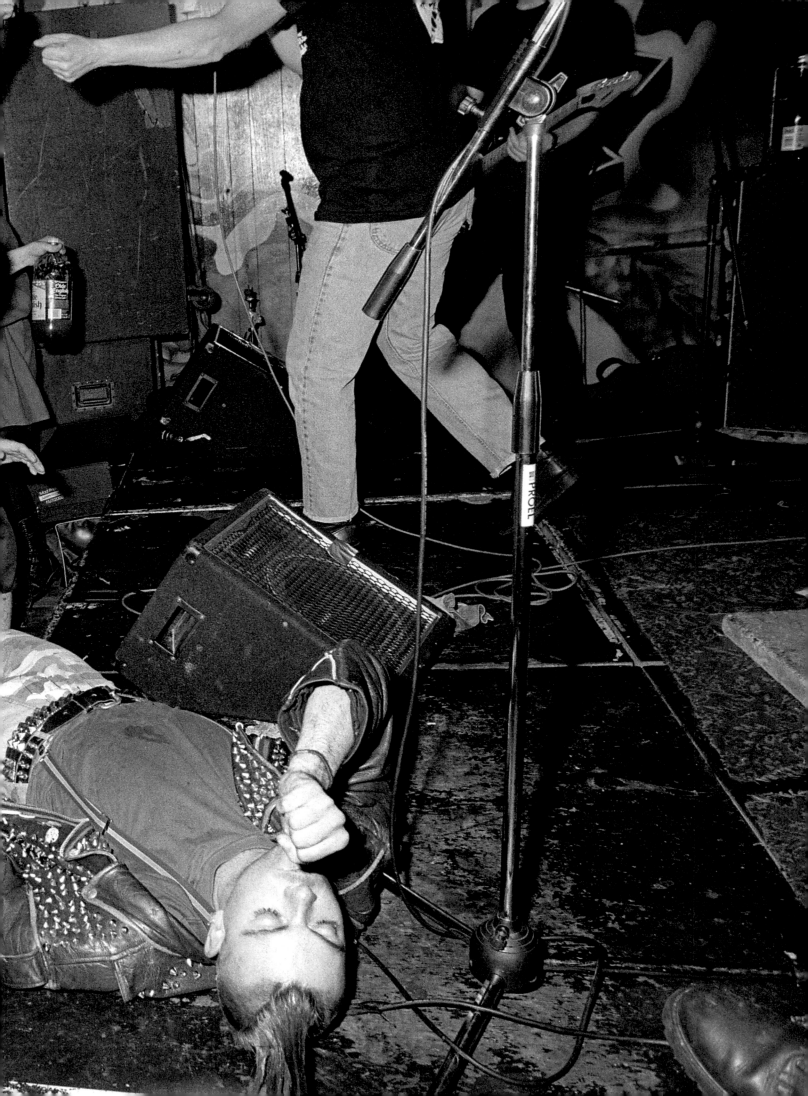

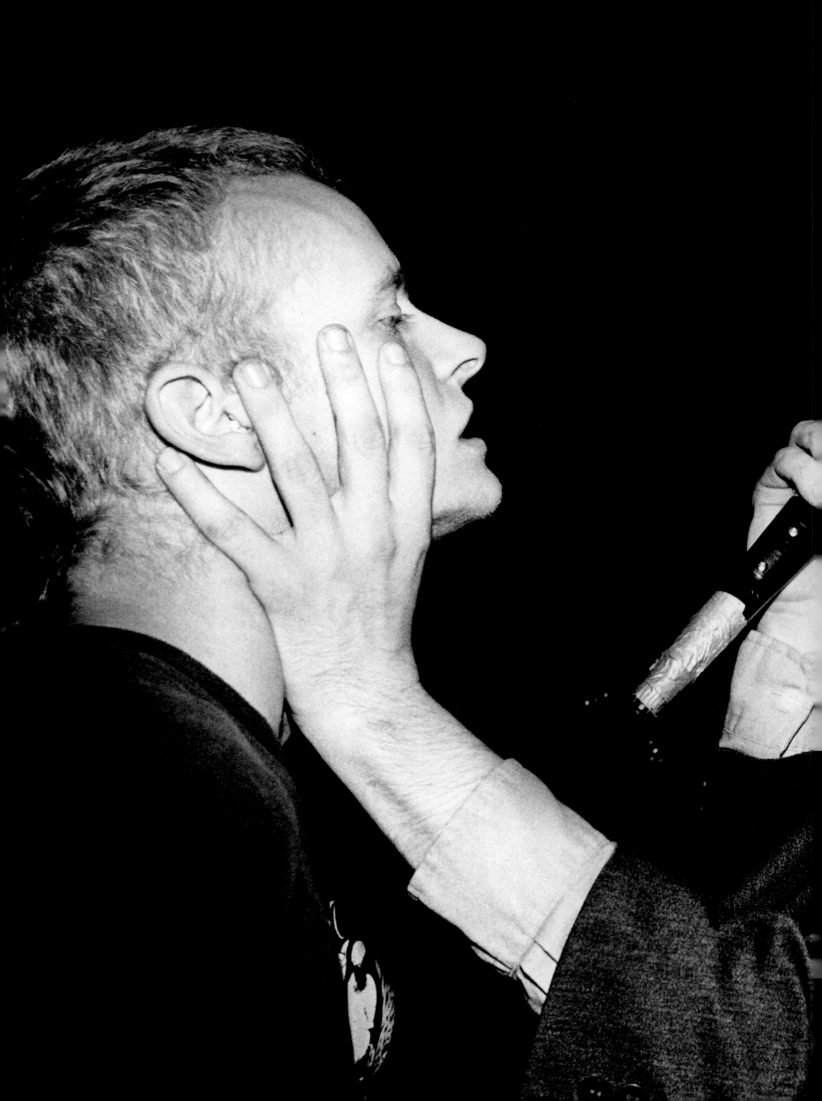

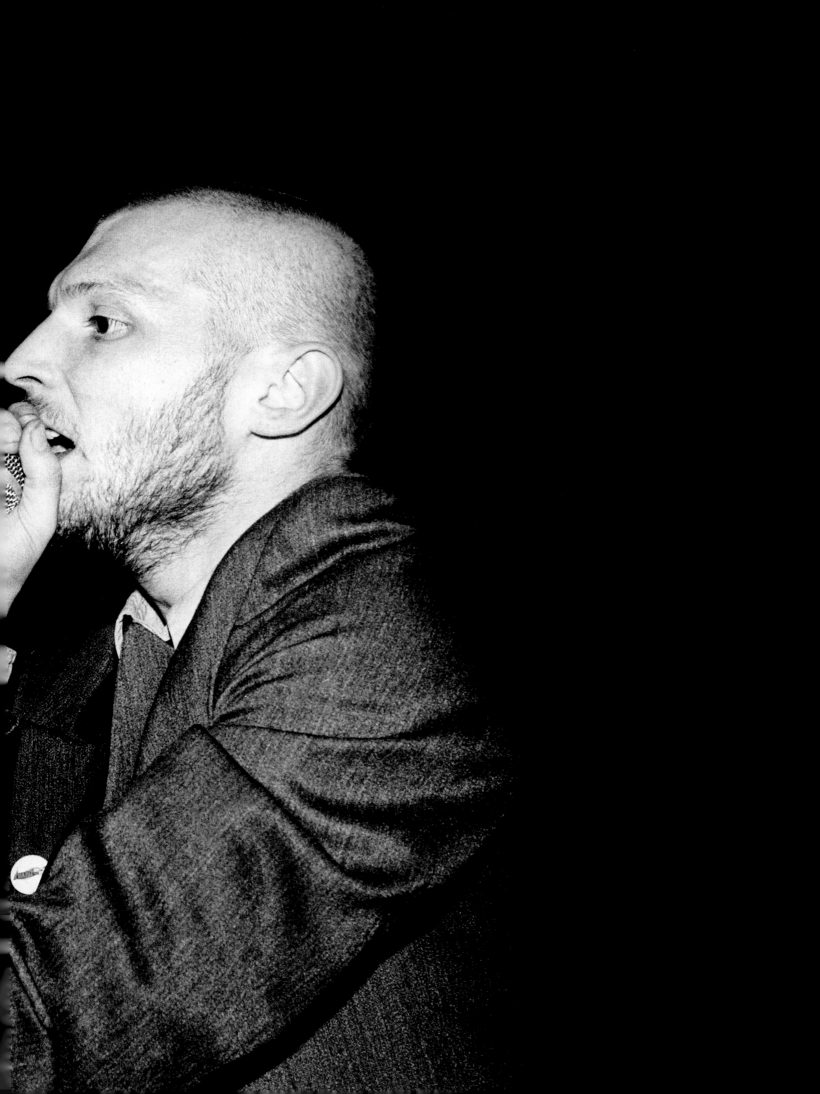

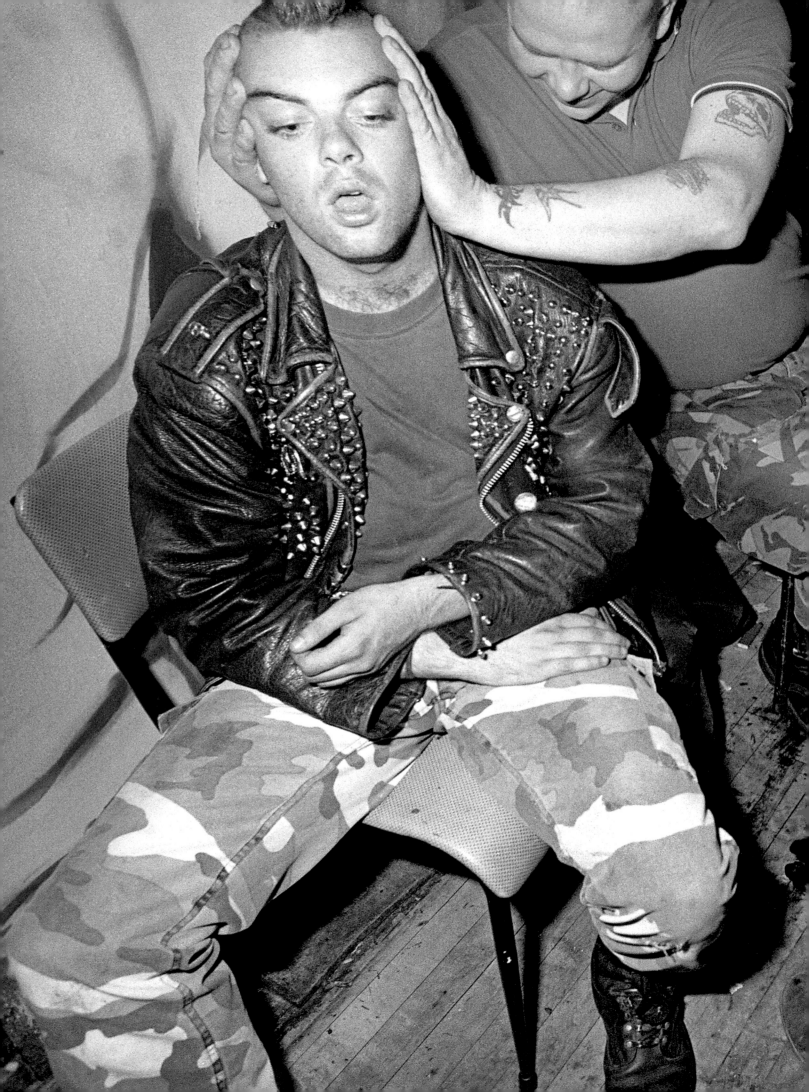

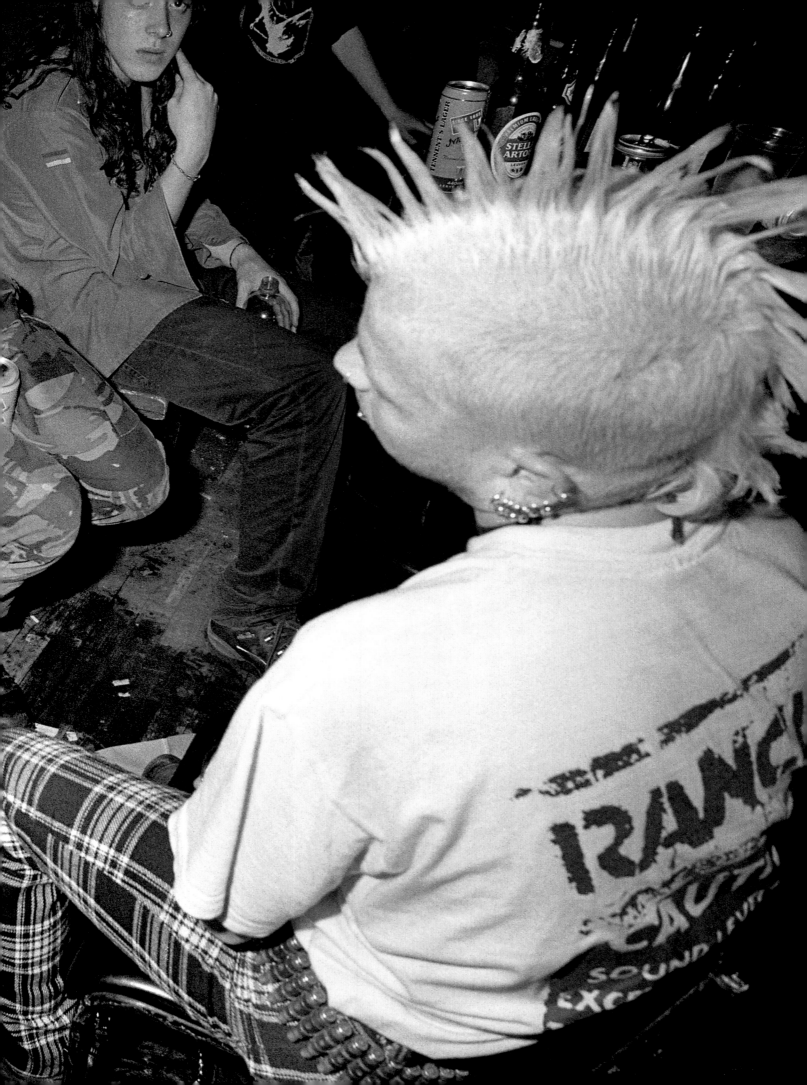

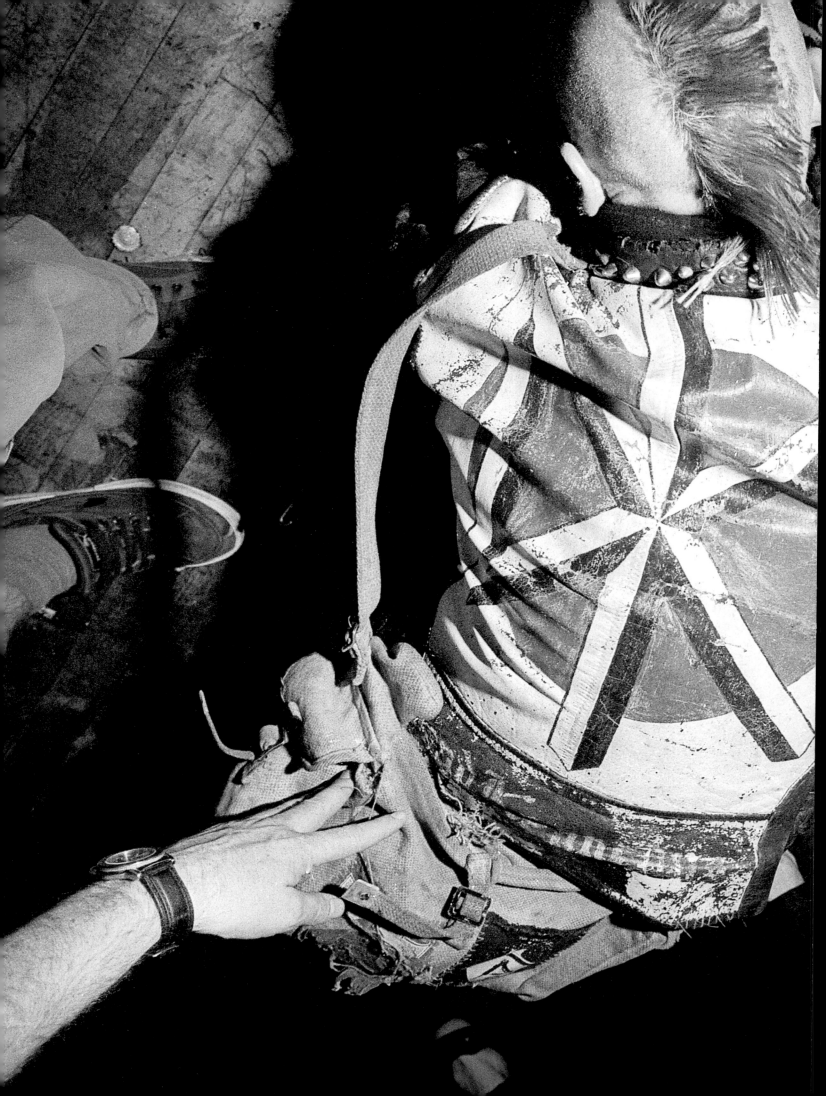

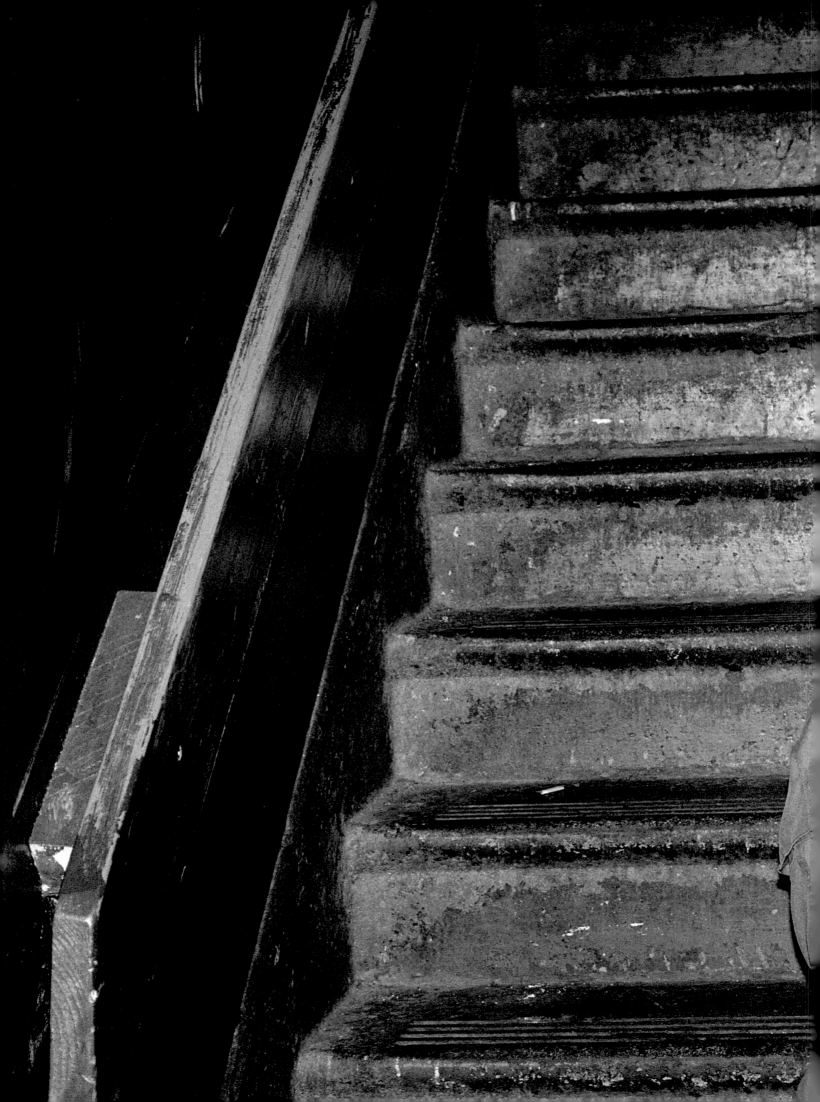

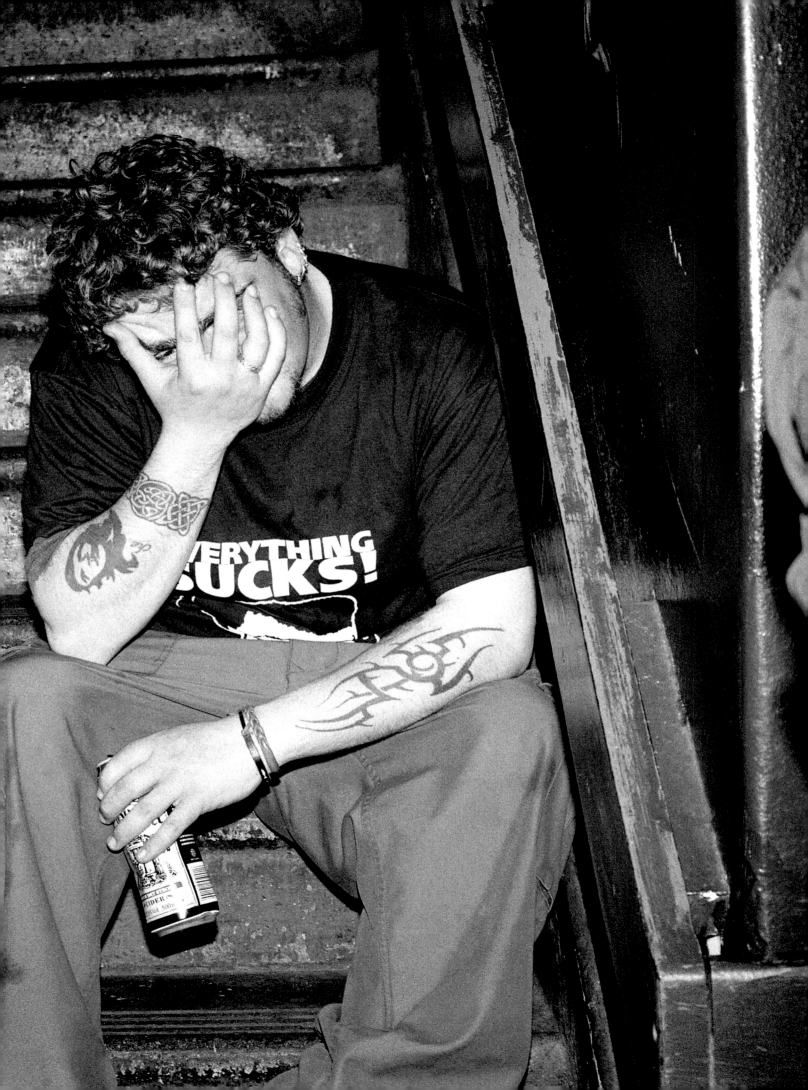

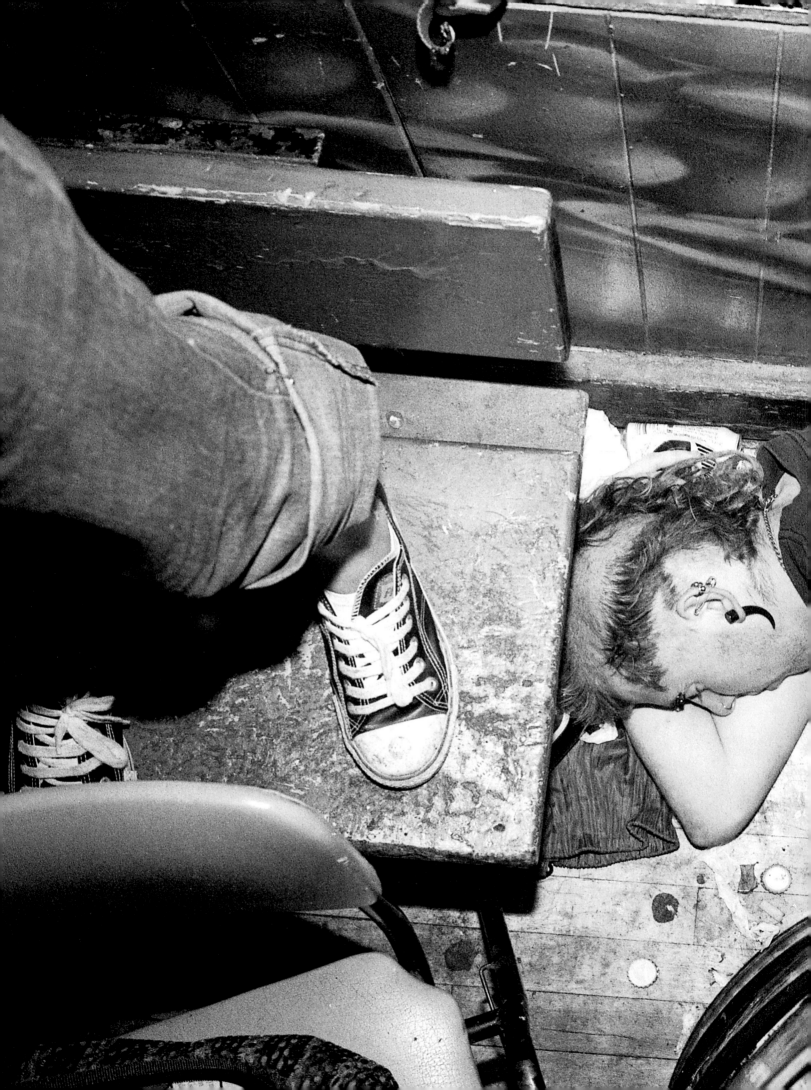

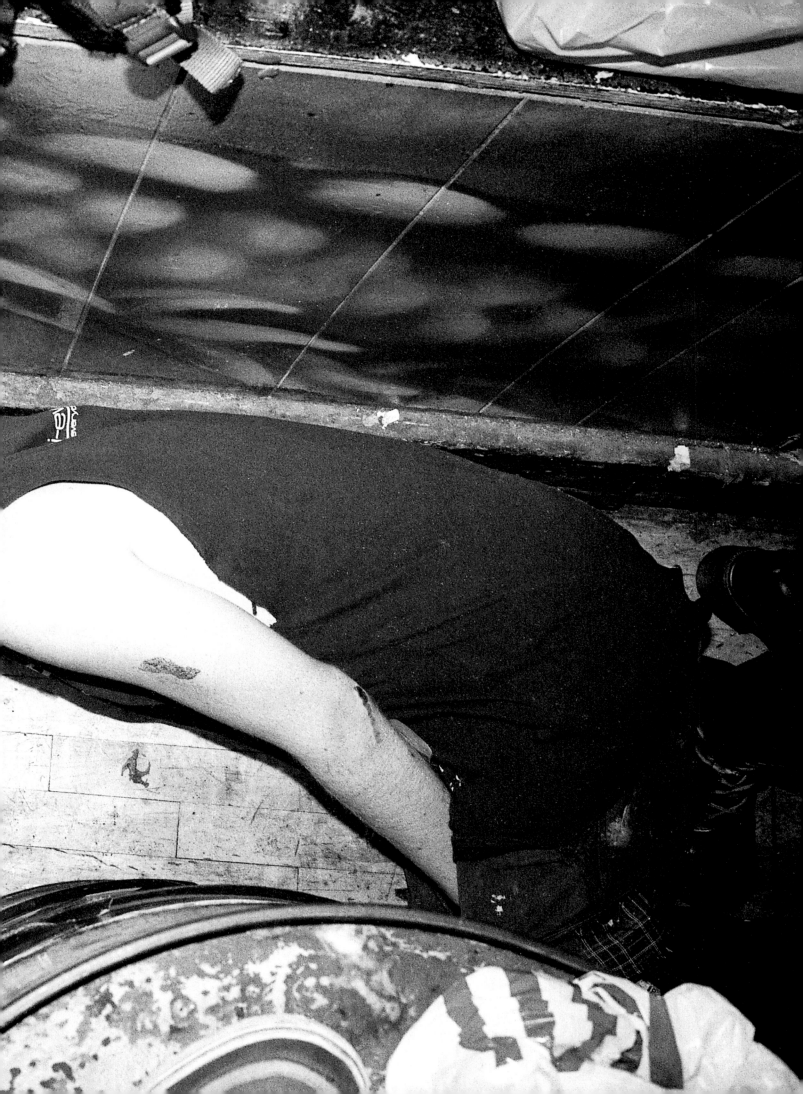

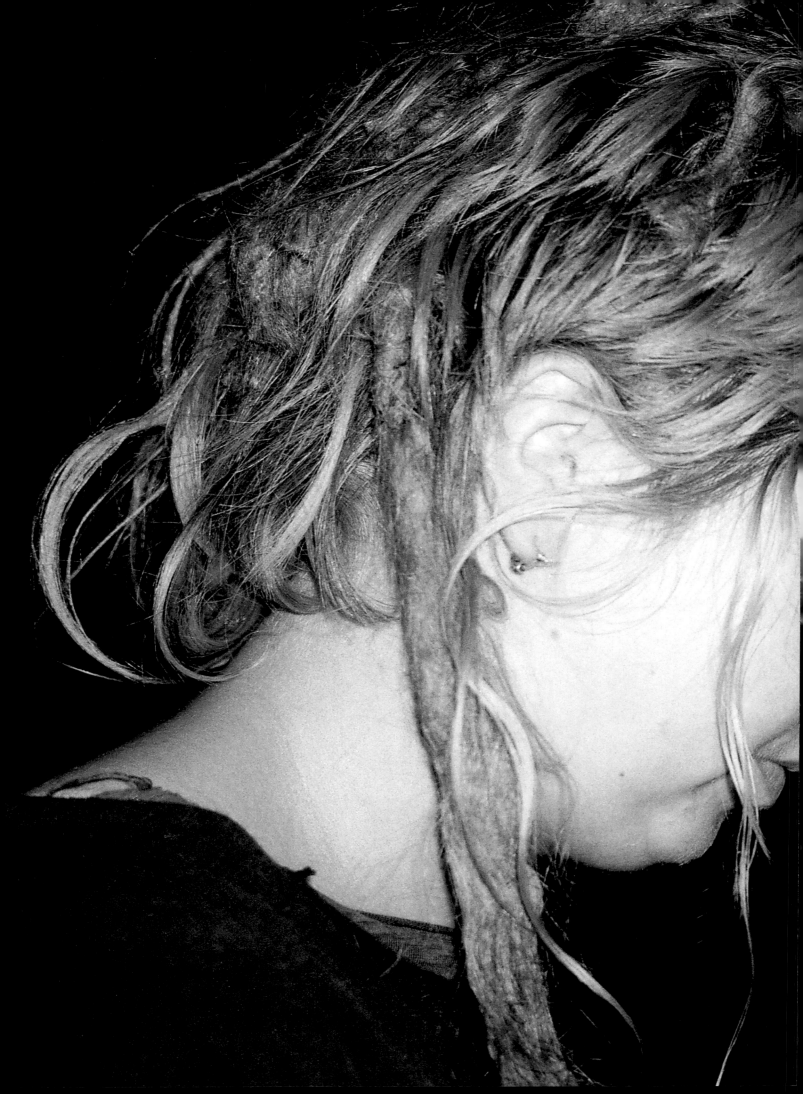

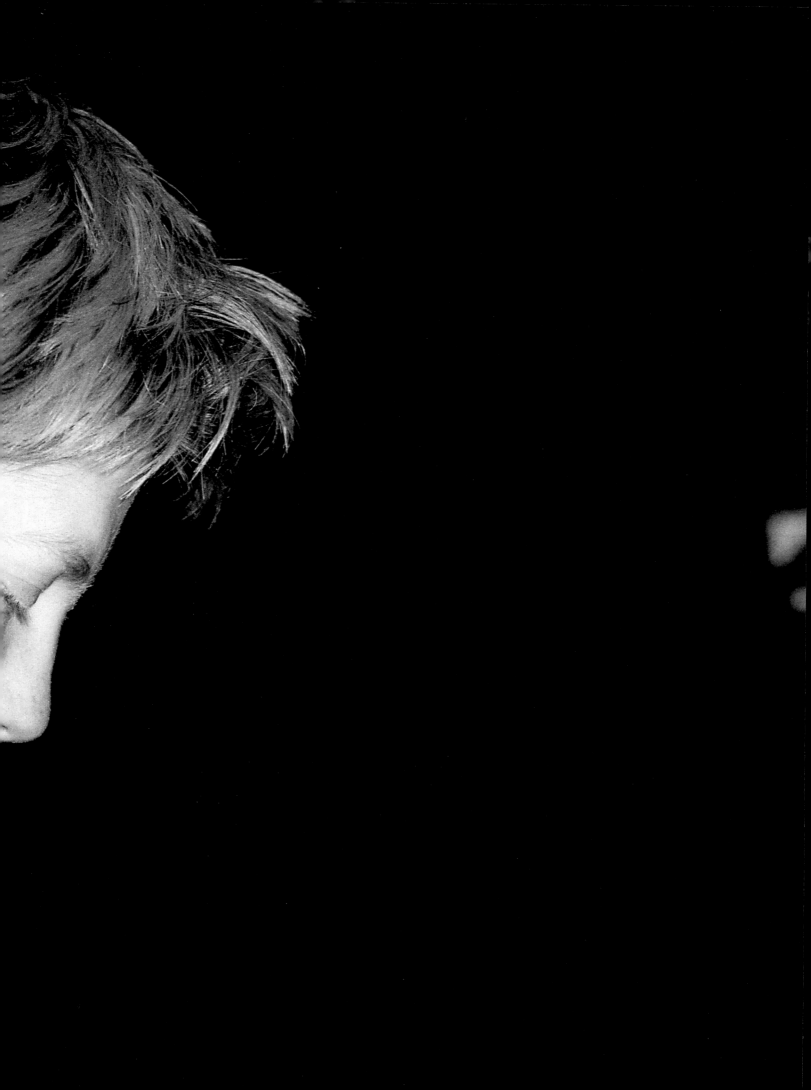

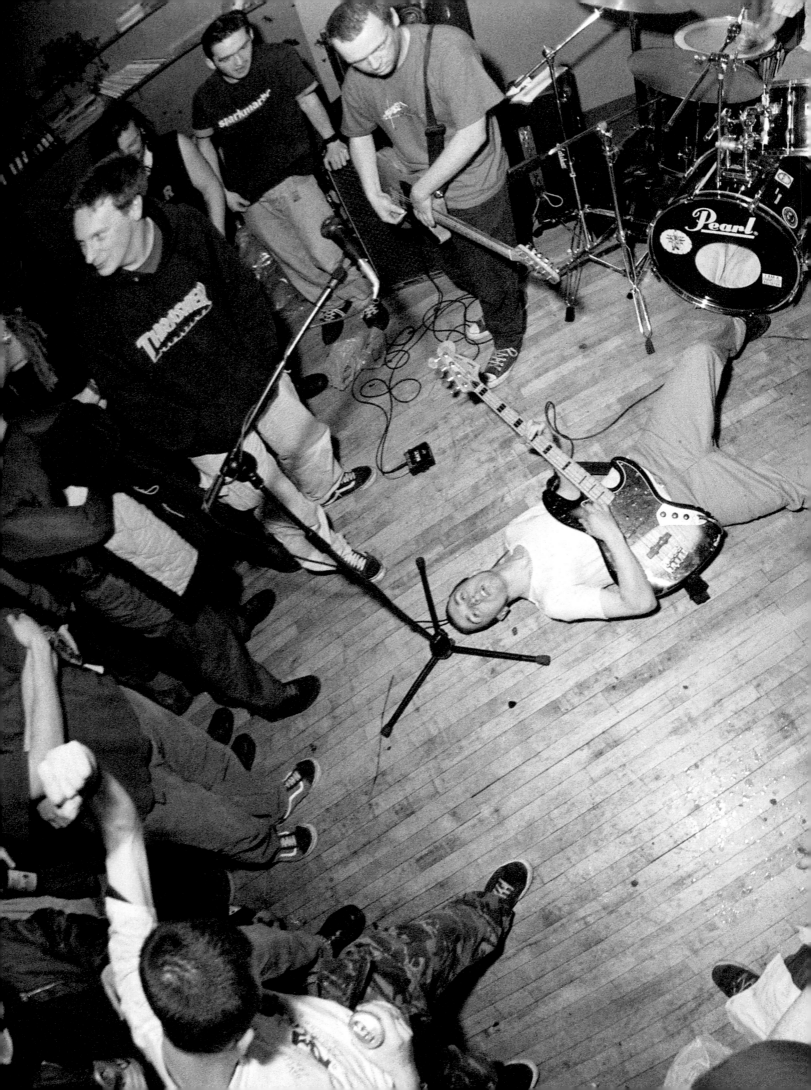

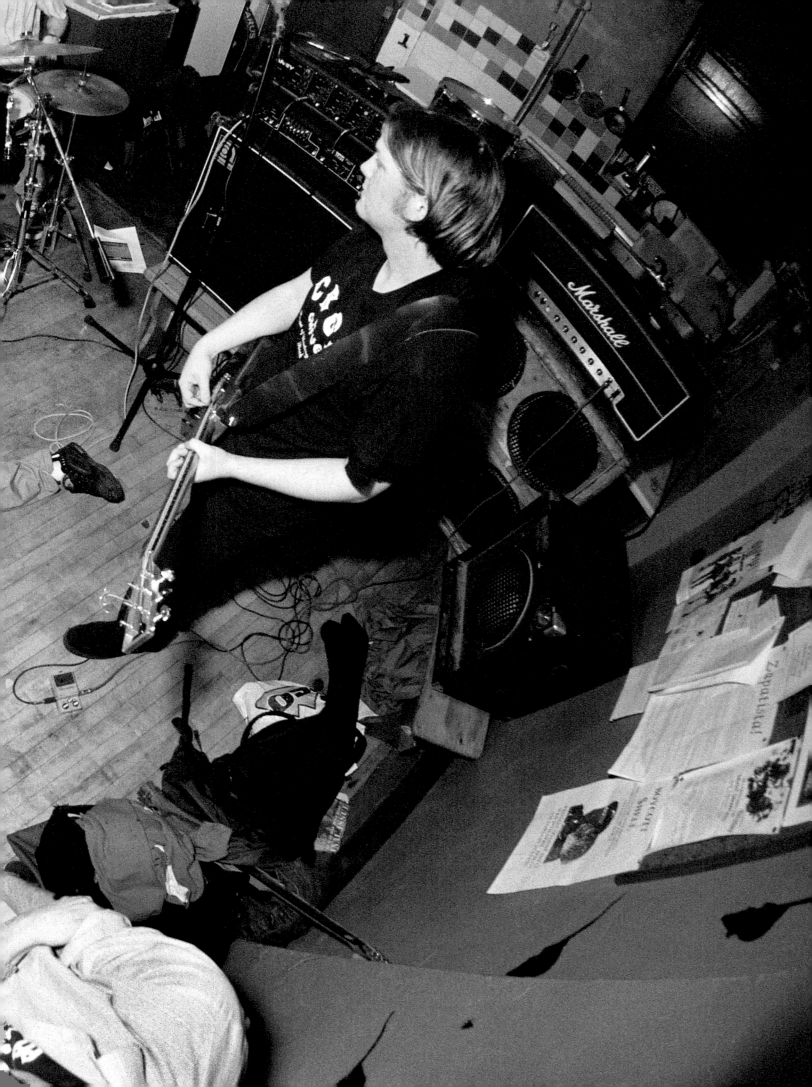

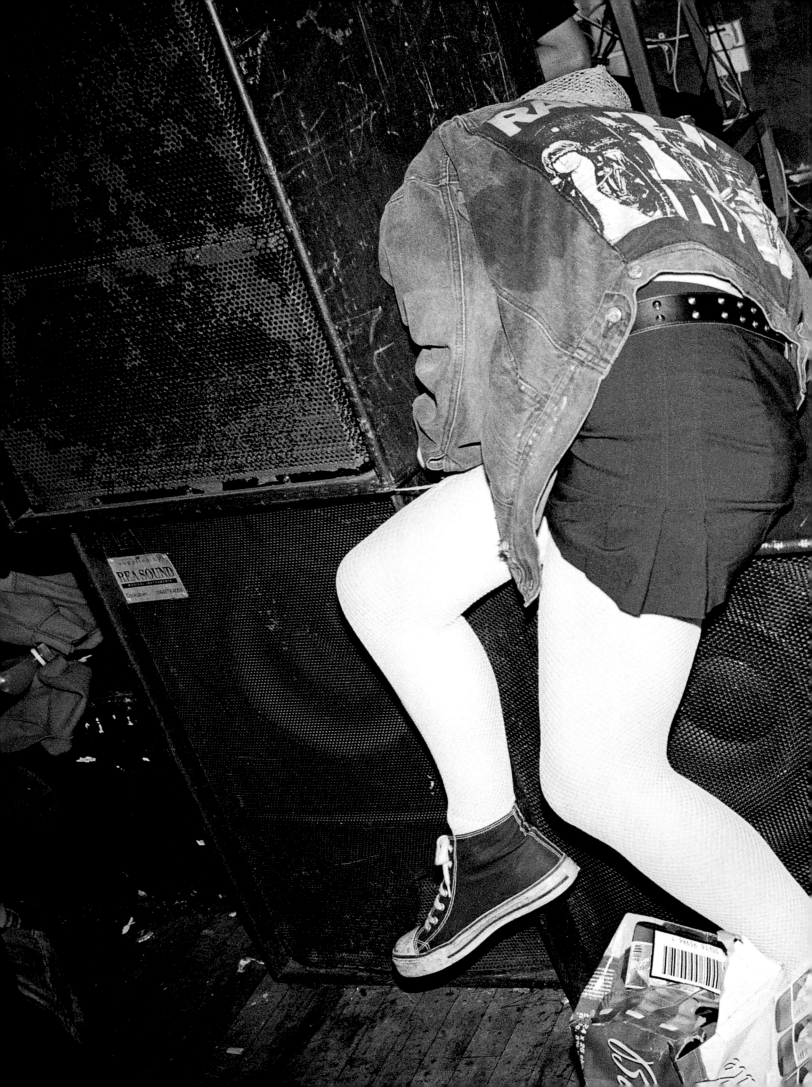

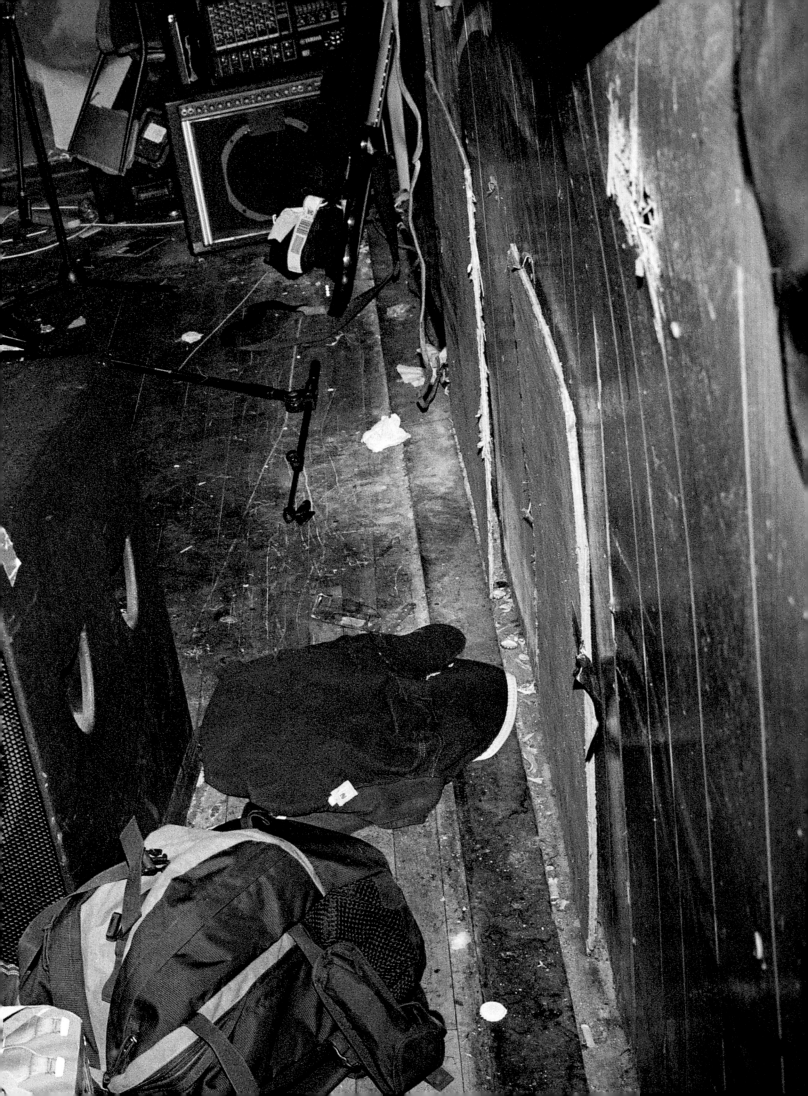

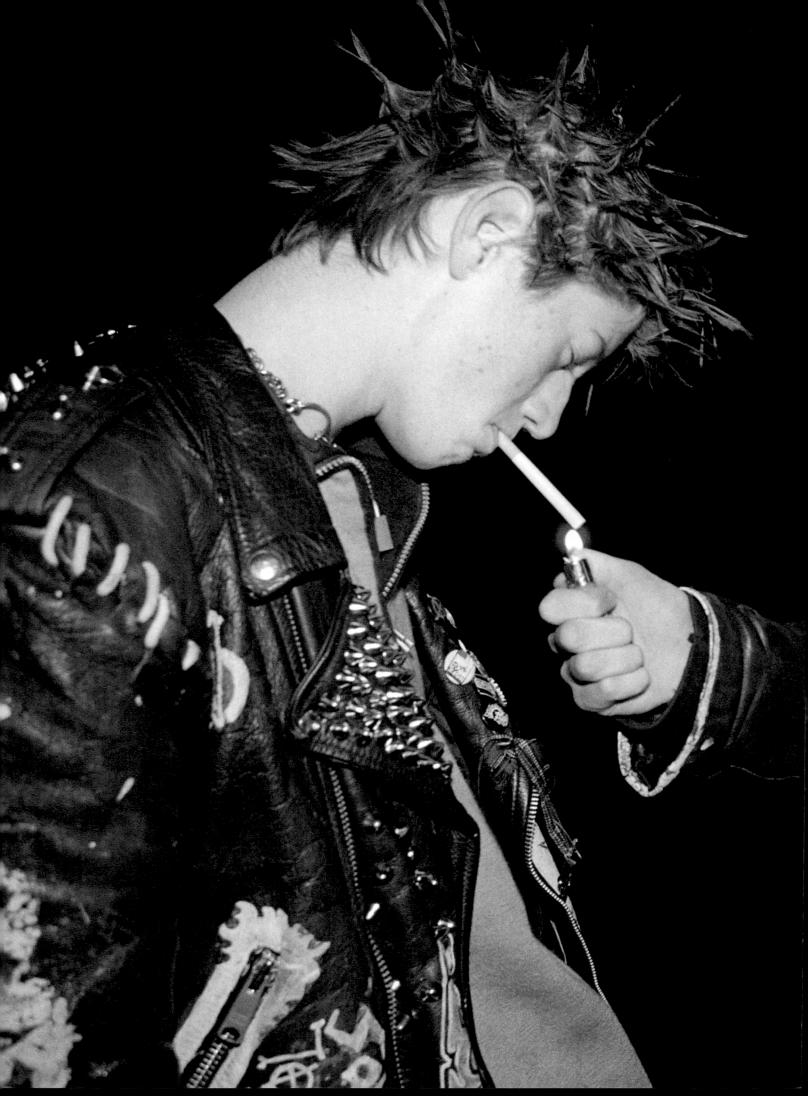

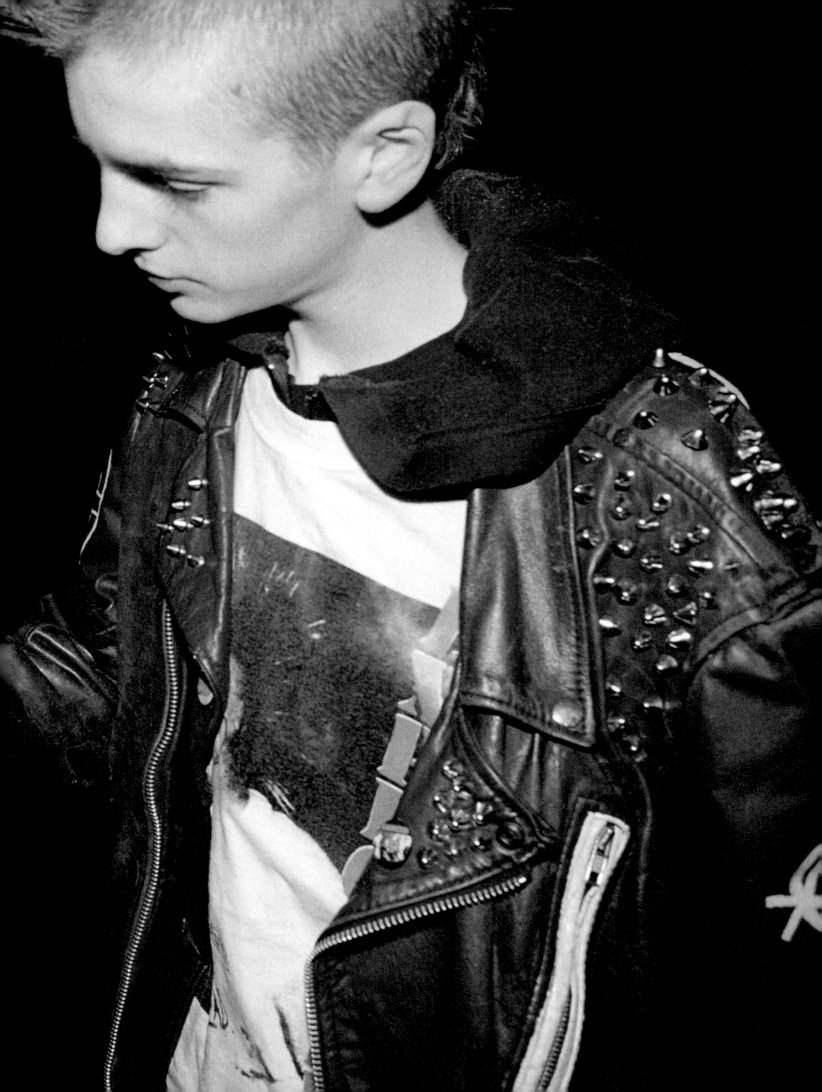

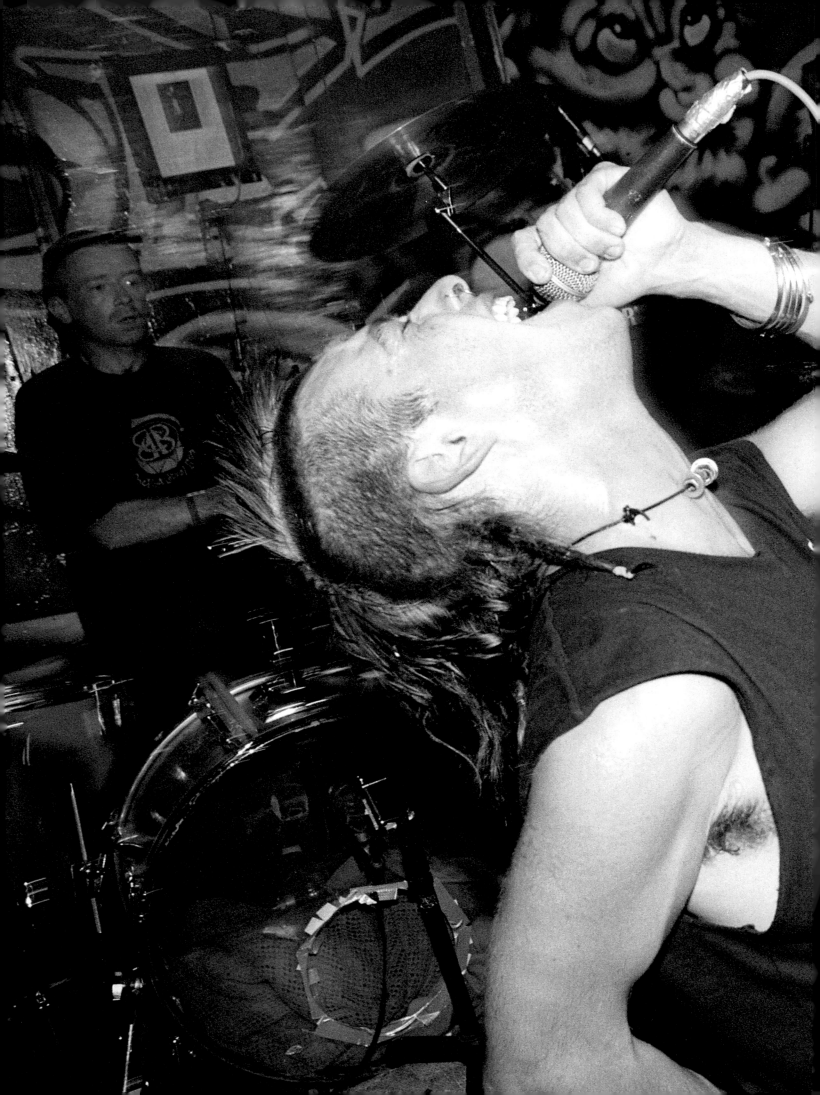

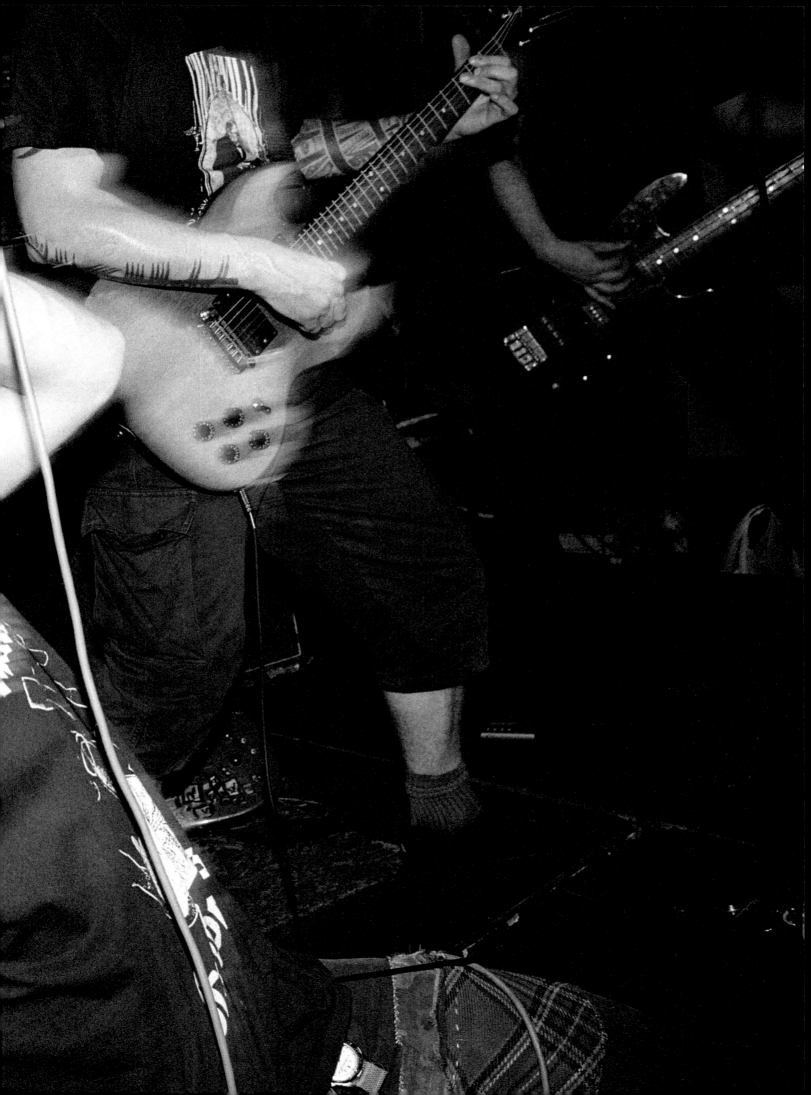

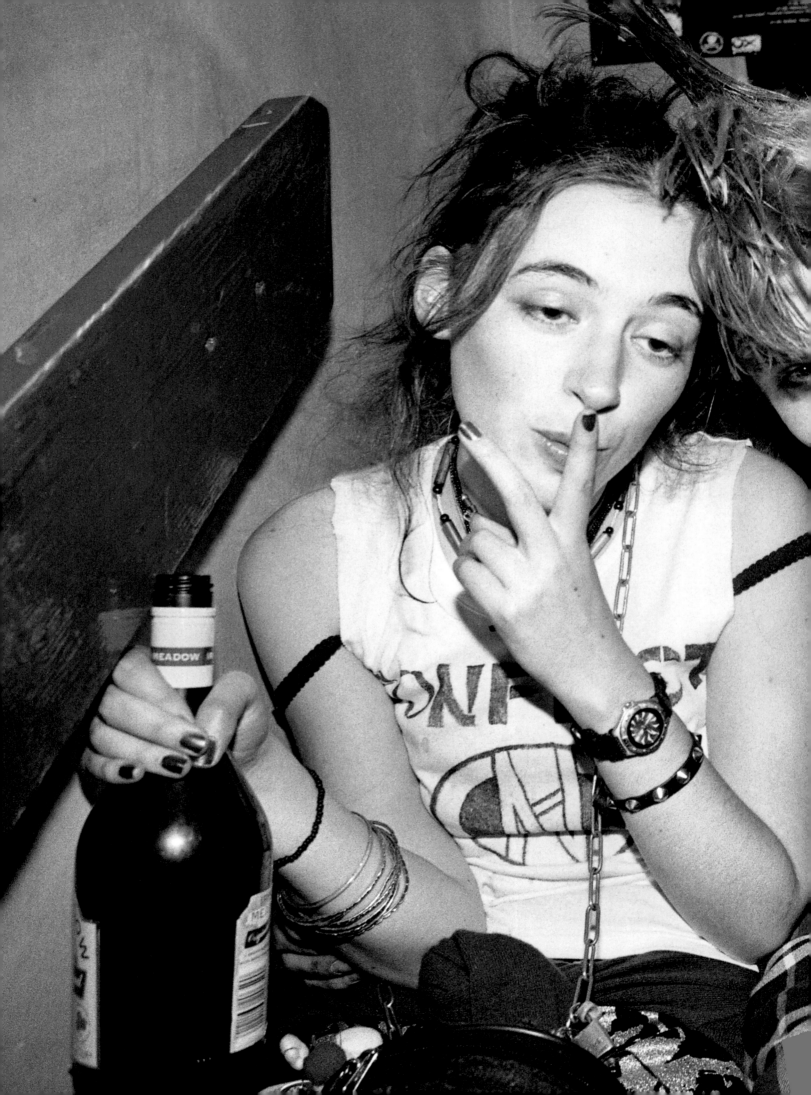

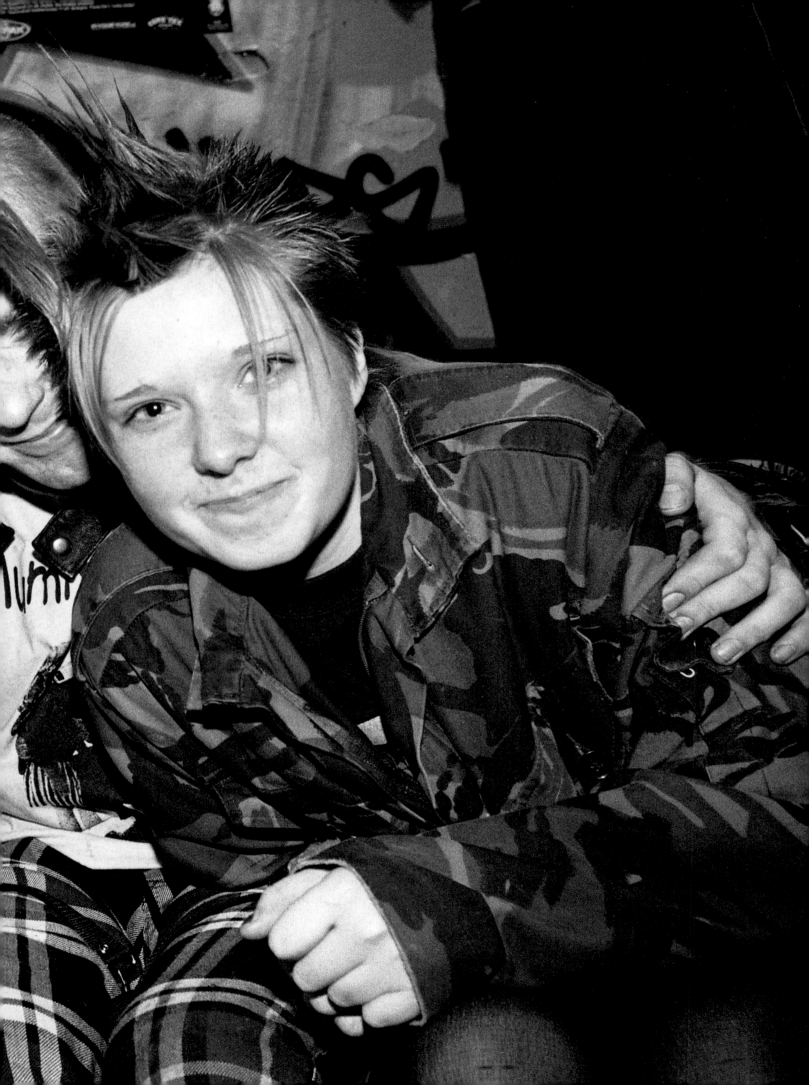

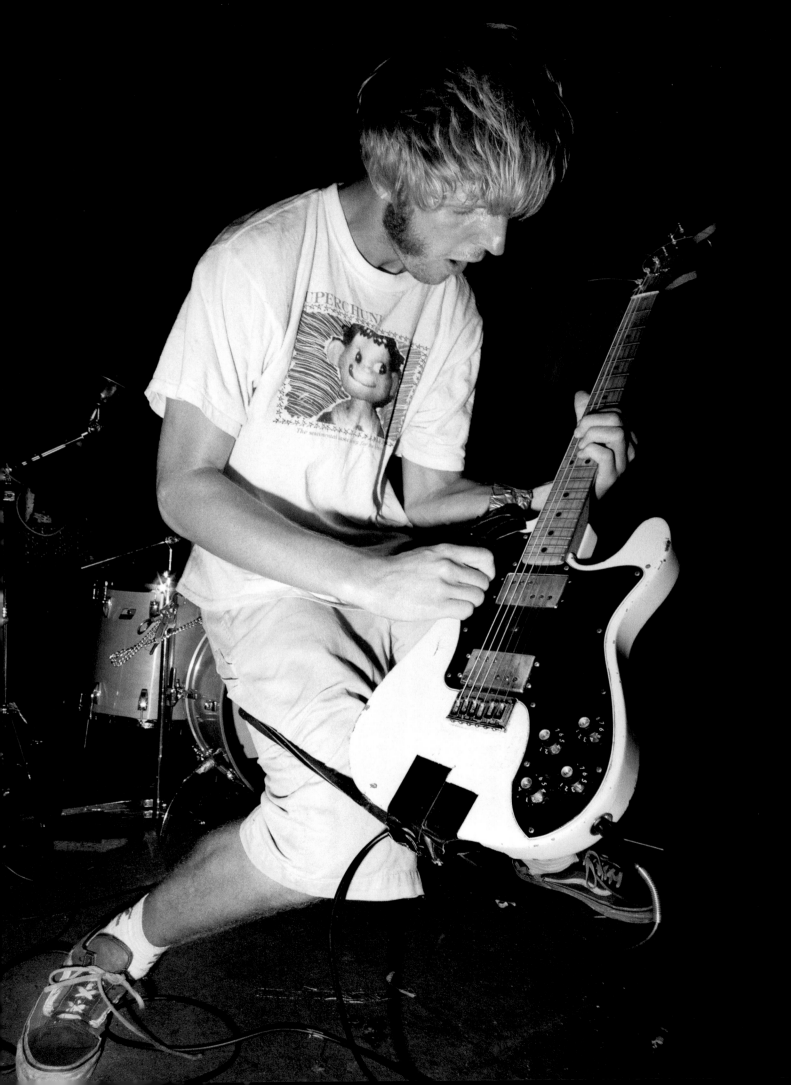

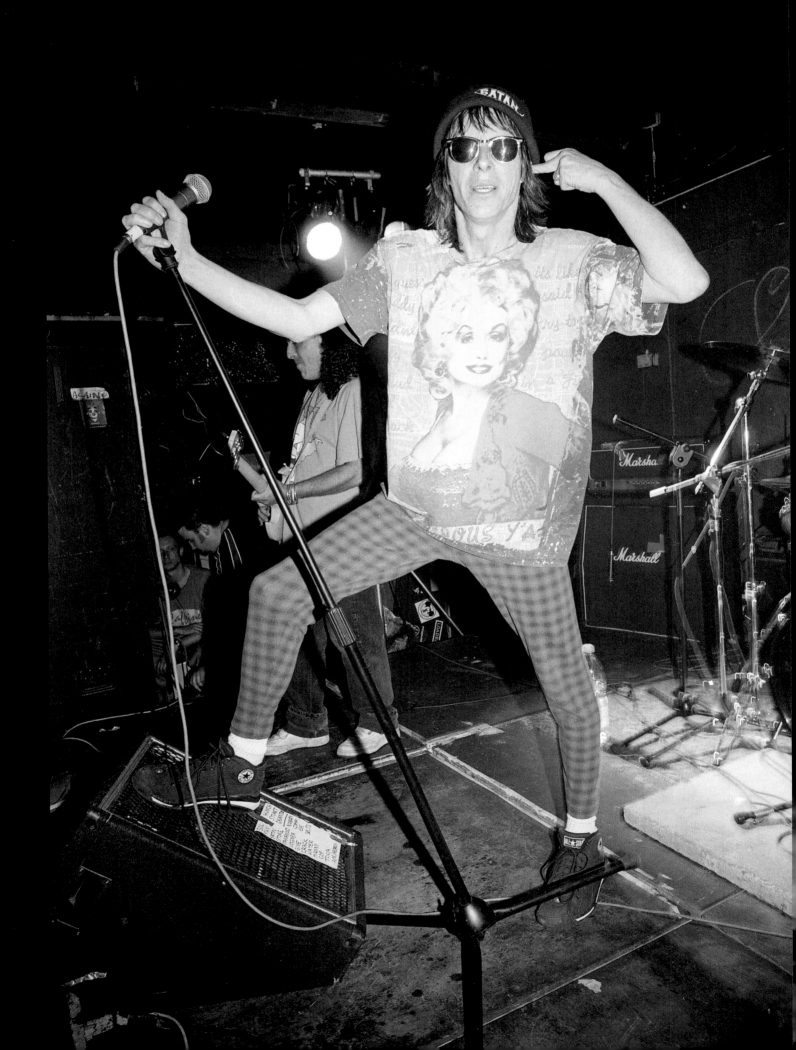

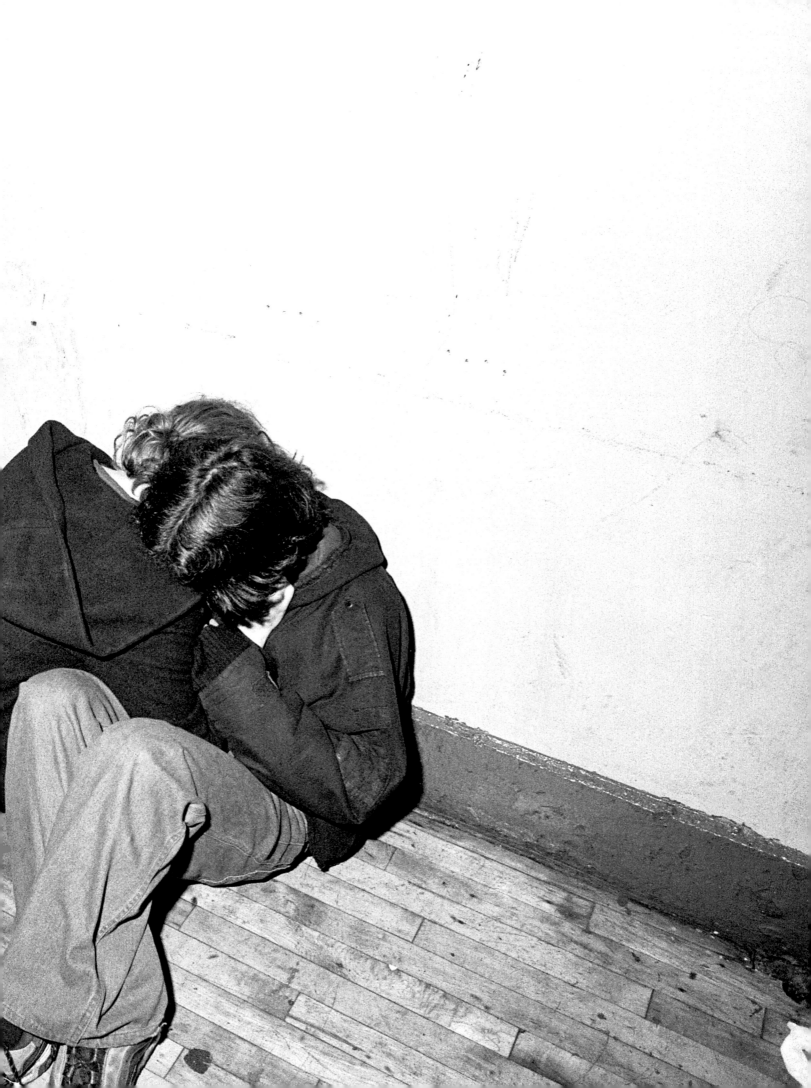

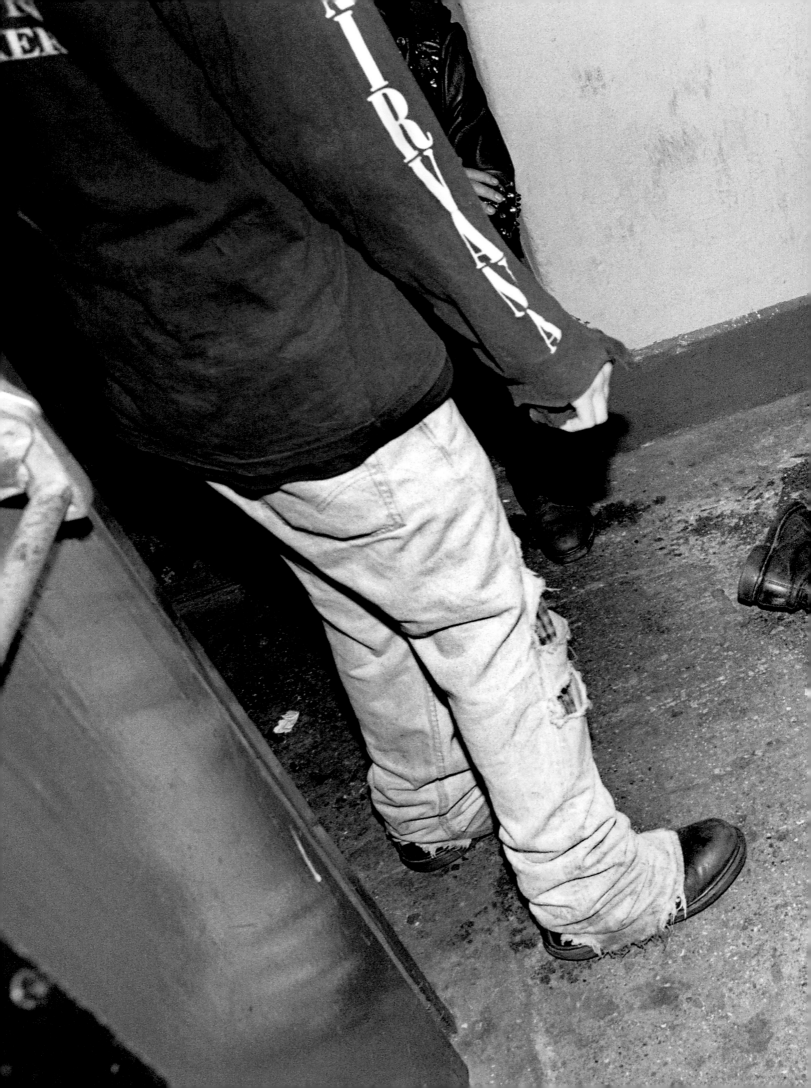

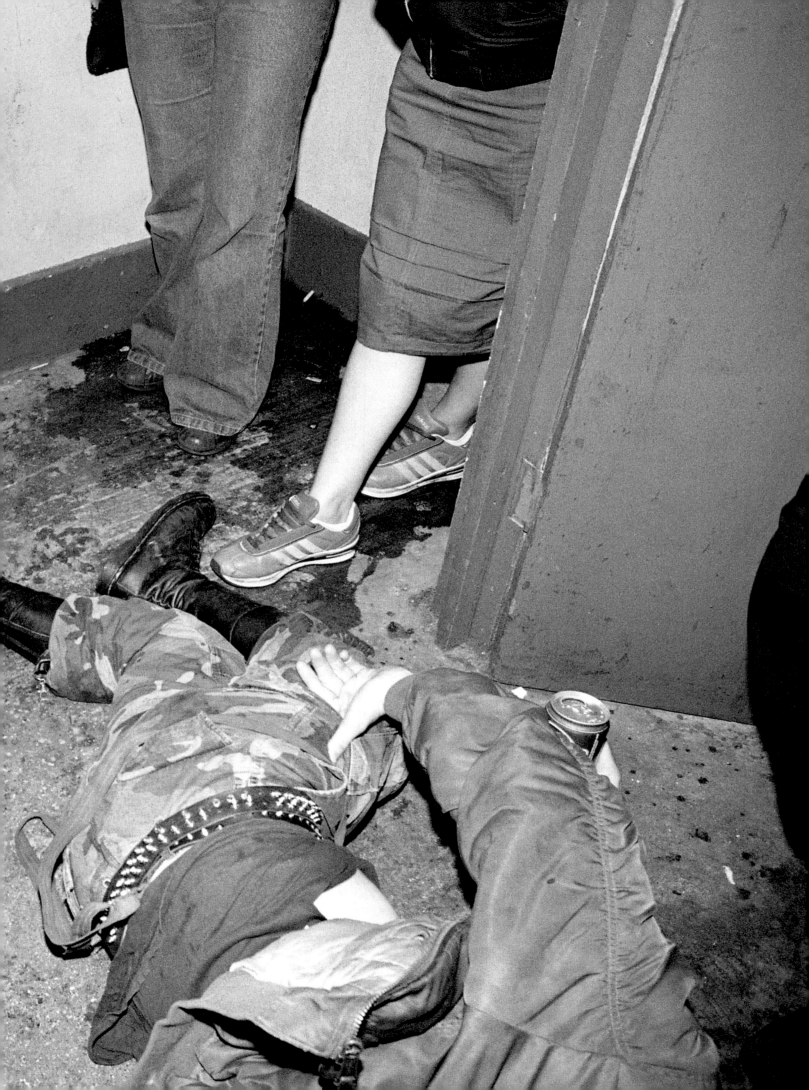

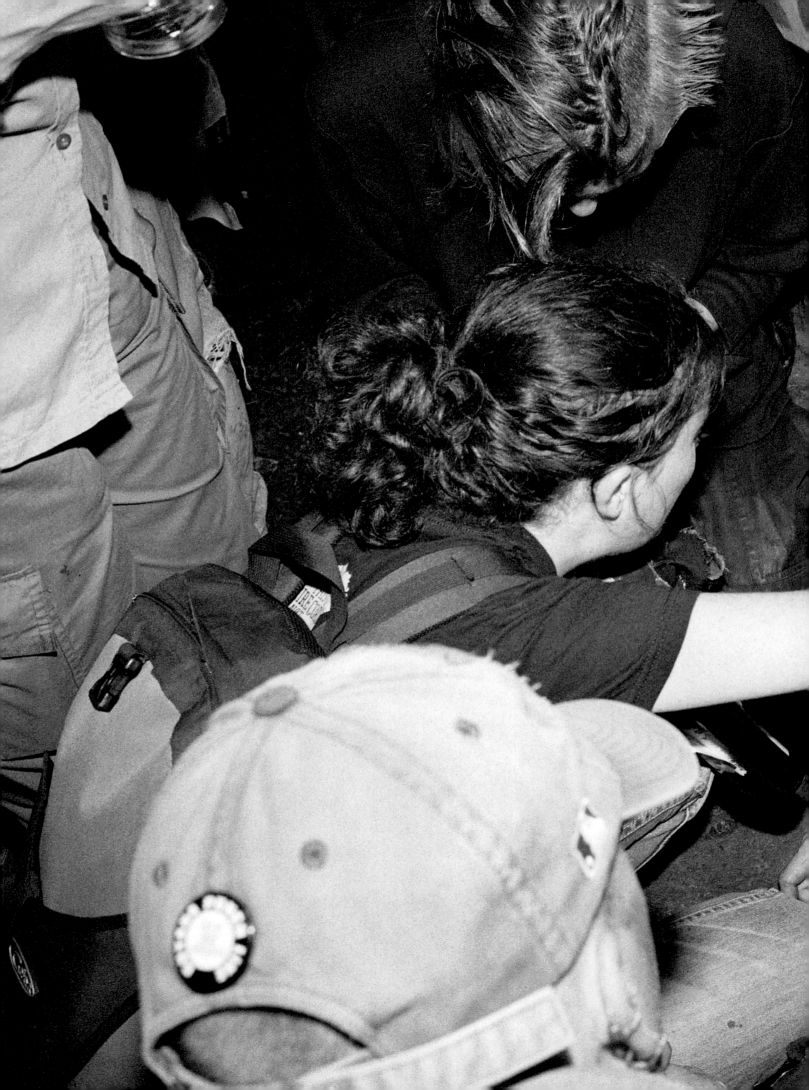

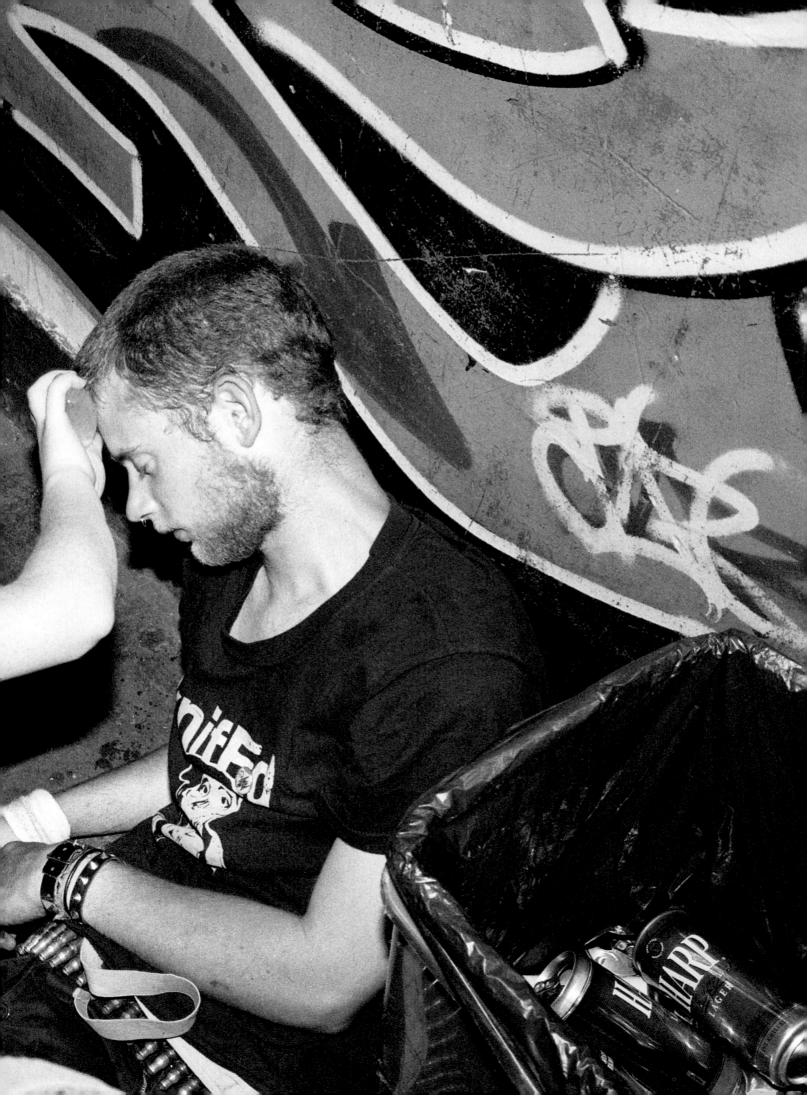

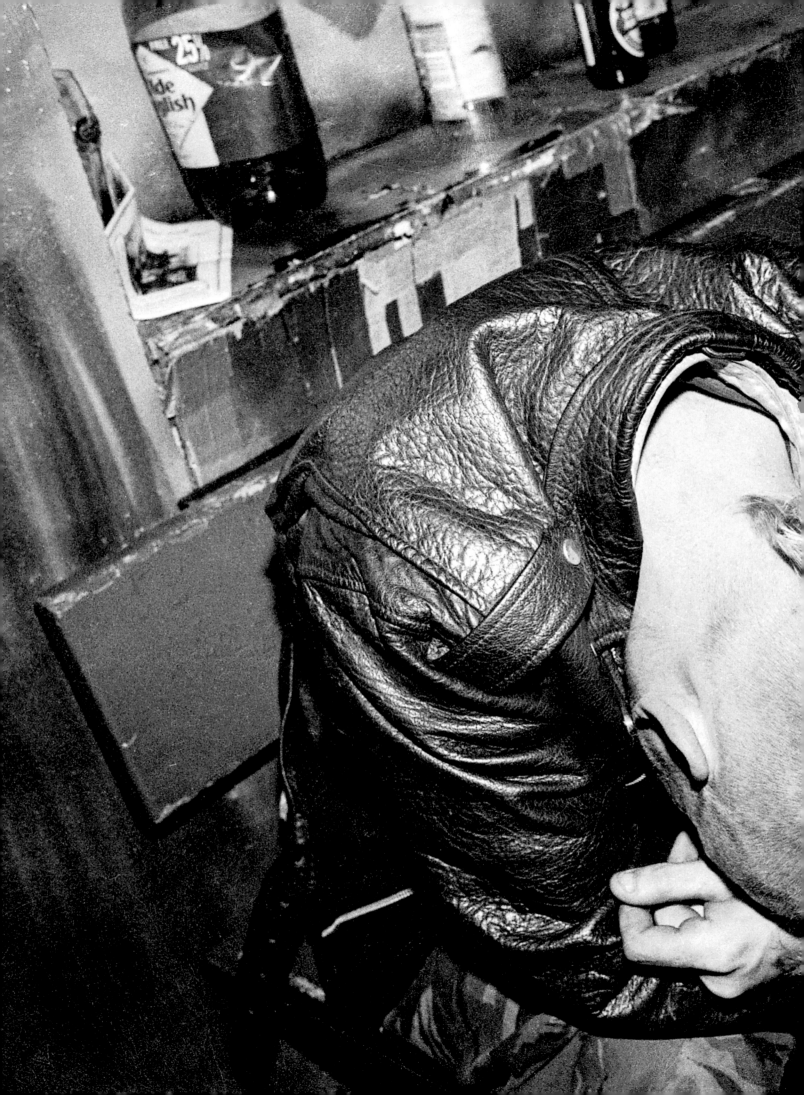

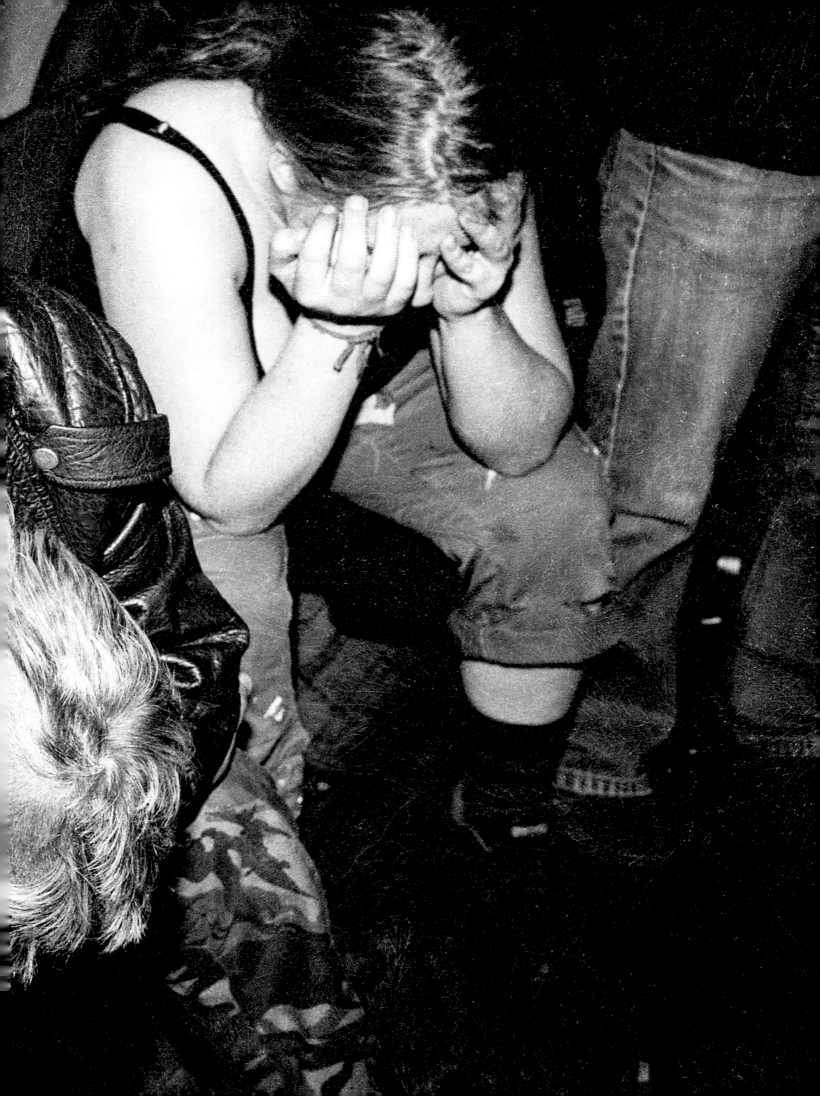

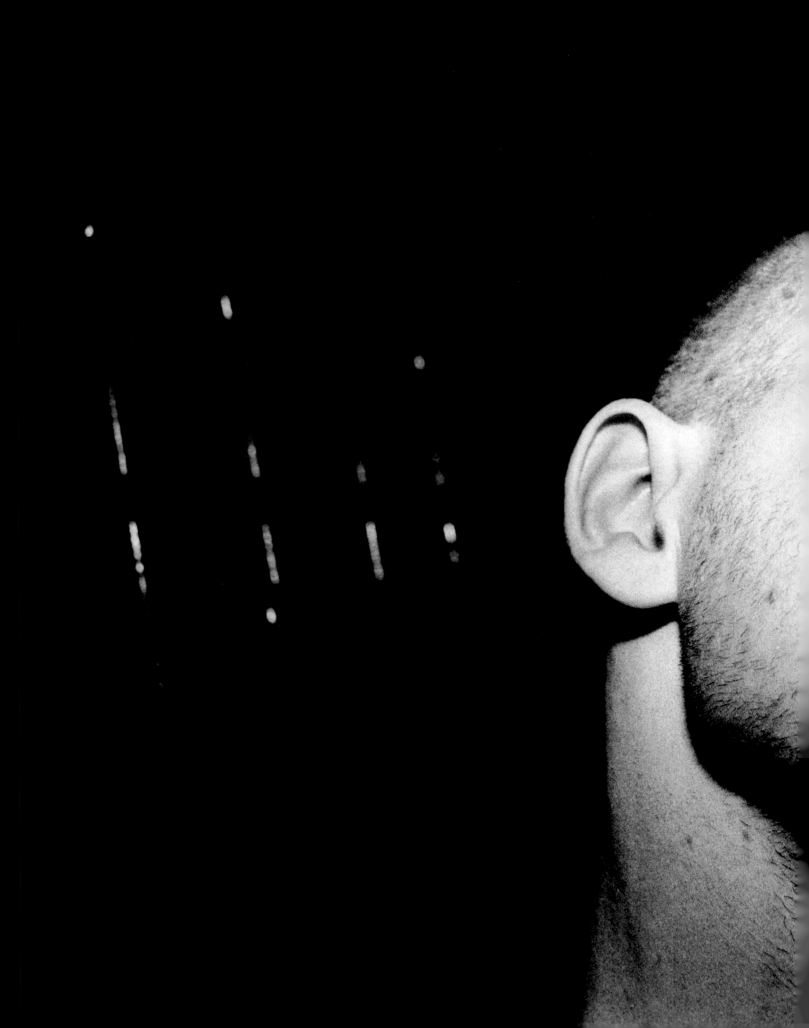

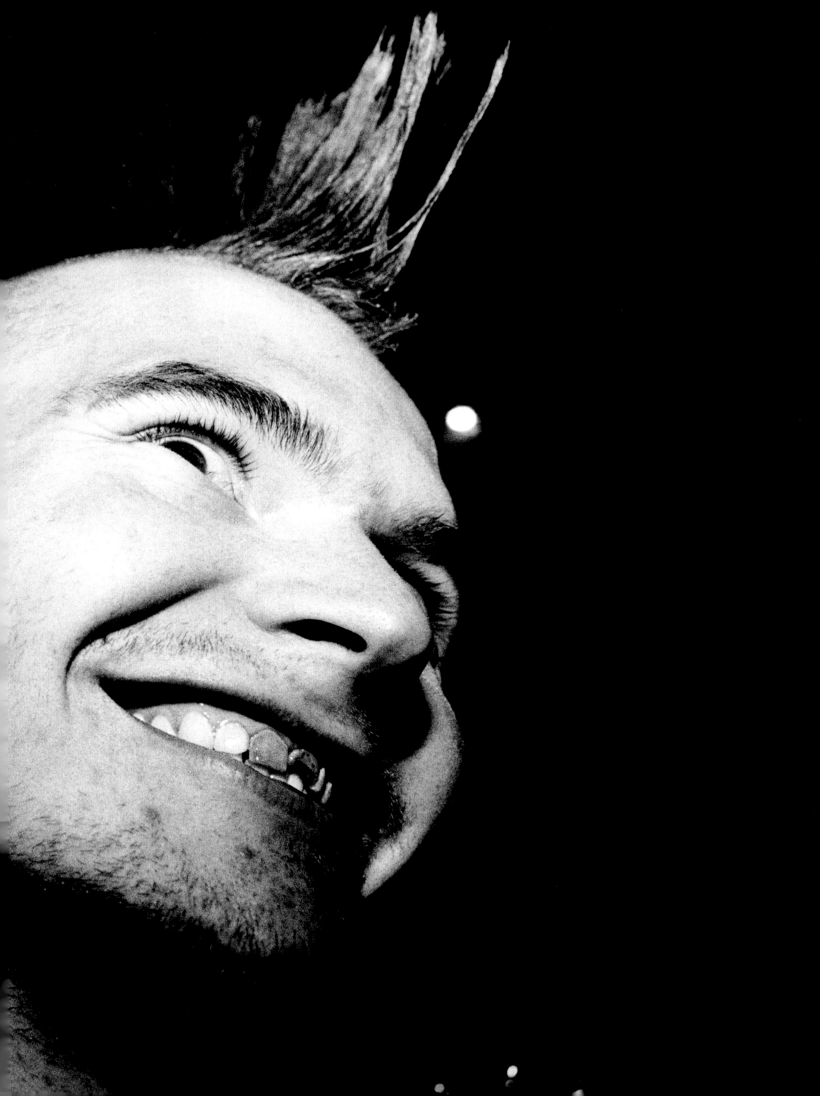

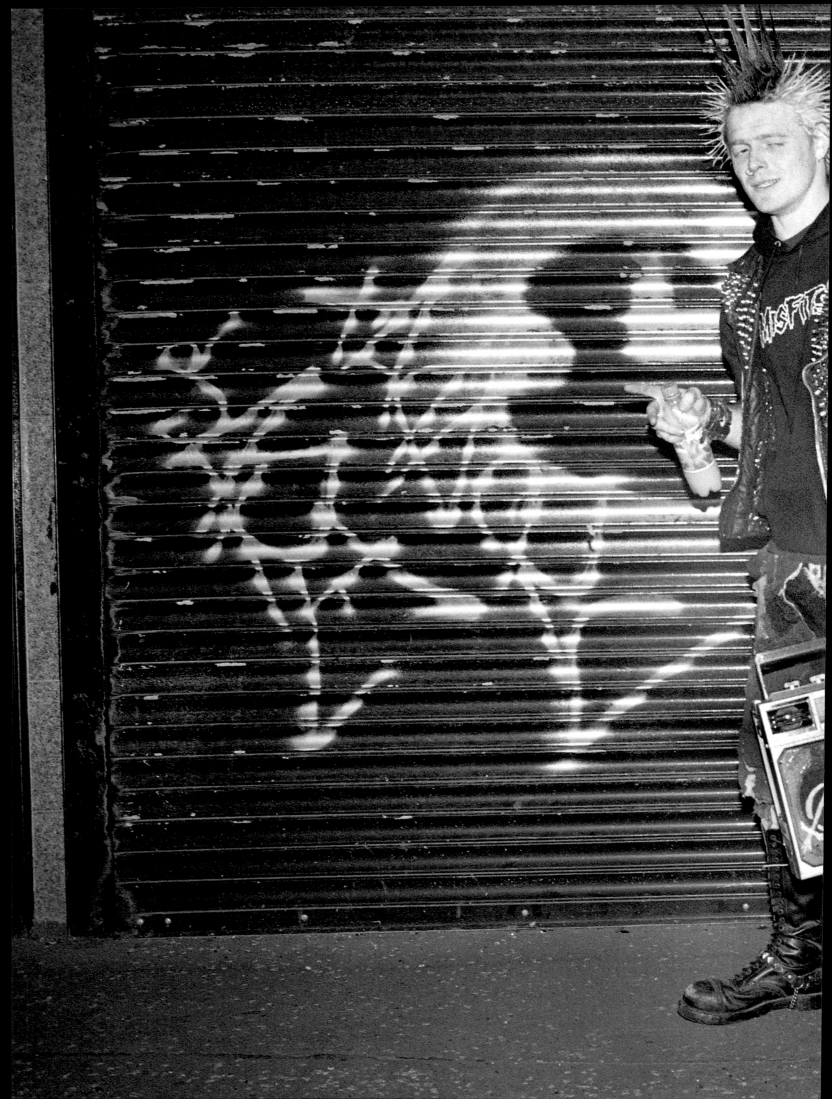

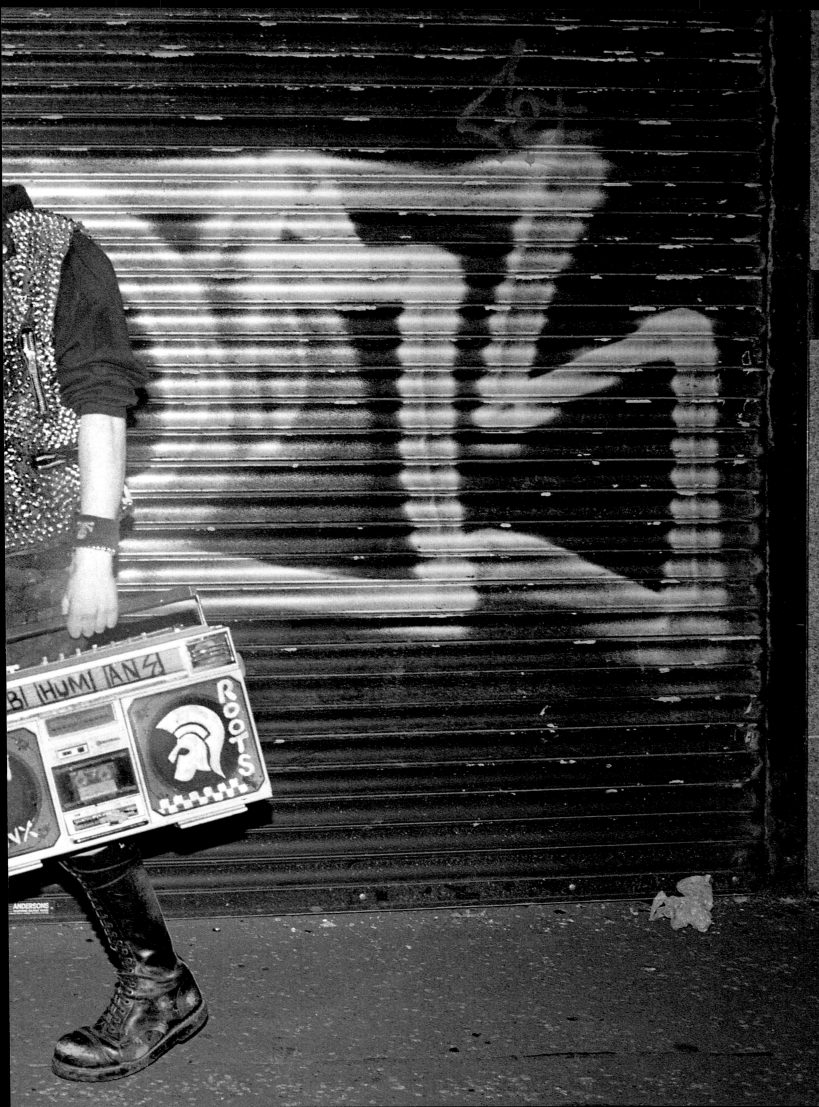

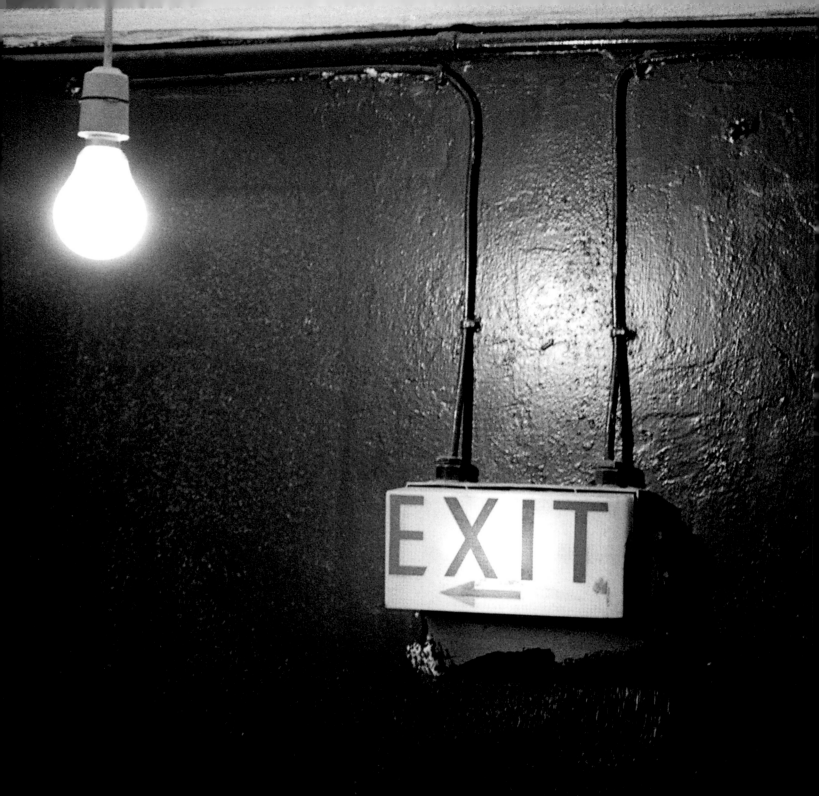

Suburban punks:
by Ricky Adam

Back in 1992 my friends and I were in our late teens and living in the
suburbs. We had started venturing to Belfast to see punk bands play
in either Richardson's social club or the Penny Farthing bar. Then we
got wind of a gig at the Warzone Centre. For years we'd kept hearing
rumours about this place …rumours which made it seem almost mythical
– shit scary and appealing, all at the same time. Nazi Skinheads would
lay in wait to beat up punks. Or, if you weren't punk enough, the punks
would beat you up! We *had* to go.

I borrowed my Dad's van – a bright yellow ex-motorway maintenance wagon
with no seats or windows in the back, (I was the designated driver as I
was the only one with a license) and a group of young suburban punkers
piled in for the uncomfortable 30 minute drive to the city.

I remember parking up outside the venue, which was in a sketchy part of
town, and spending most of the night constantly veering between: "This
place is amazing!" and "Crap, I hope the van's ok!" Every 15 minutes I'd
go outside to check on it. By this stage everyone else was too drunk
to care. But it was truly great. A place run by punks and where for the
first time in a long time oddballs like us fitted in. It felt good to
be part of something bigger than ourselves. No bullshit politics, no
Nazis, no beatings – just loud music, and teenagers making out on the
floor. It was a wild scene!

The space provided a place to go beyond the closed minded often
sectarian society that surrounded us. Punks, artists, freaks & weirdos
had a space to hang out, be creative and express themselves, regardless
of their religious persuasion, sexual orientation, or anything else.
This is why the punk scene was so liberating to many people who lived
in the shadow of Northern Ireland's violent history.

Over the years we kept going back, having our eyes and ears blasted
with blistering guitar riffage. Bands from all over the world came to
play the Warzone and it became infamous as being one of the most
credible venues in Europe for D.I.Y. punk. Some of the greatest gigs
I've ever been to were in the Centre, Jawbreaker being a standout,
and pretty much any time locals Bleeding Rectum played, with the
whole room yelling "Yer ma!" at them. (Safe to say, Belfast has some
of the best hecklers in the world.) D.O.A. singer Joey Shithead freaked
out when they played, yelling at the crowd when a tin of beer was
thrown at his head. Which is fair enough. I ended up playing my very
first gig there too, drumming in a shambolic outfit called Gauge.

ODAK 400TX

After we played, our bass player Dougie busted out his party trick:
pissing in his mouth and chasing people around, spraying it at them
through clenched teeth. And if that's not punk rock, I don't know
what is?!

The photographs in this book were taken sporadically over the years
between 1997 - 2003, a small window of time considering the Warzone
Collective opened its first venue in 1986. They were some of the first
photographs I ever shot.

In hindsight, I wish I'd taken more, but at the time, I wasn't
purposely documenting things. I just happened to have a camera and
snapped photos here & there whenever I thought of it. This was in
the pre-digital era, so there aren't many photos of the Warzone Centre
from around this time. I stopped in about 2003 when the Warzone
closed its doors.

People may say "Who cares about punk in the 90's? Wasn't it all over
by the early 80s?" But the truth is, punk (or whatever you want to
call it) never went away. It may have lost its gimmicky, commercial
appeal, but it didn't die - it just seeped into the underground.

Punks live by their own rules & these photos reveal more than
the drinking & dancing depicted here. Being a punk, especially in
a city like Belfast was a political statement in itself. Not only
were young punks kicking against 'the man', they were also kicking
against sectarian divisions. Amid a historically troubled city with
dark forces still swirling around, the 'Warzone Centre' remained a
beacon of light and became the counter-cultural alternative hub for
the greater Belfast area and beyond.

BELFAST PUNK

WARZONE CENTRE
1997 - 2003
RICKY ADAM

All of the photographs in this book
were shot on 35mm film using a few
different cameras.

*none of the images have been
cropped or digitally altered.

Thank-you to everyone who
committed time & effort over the
years to making the 'Warzone
Centre' truly great. The Belfast
Gig Collective, Hope Collective,
etc. Too many people to mention,
but you know who you are!

Special thanks to my amazing wife &
best friend Sarah.
Andrea Albertini &
Eleonora Pasqui at Damiani.
Casey Orr, Chris Magee, Niall
McGuirk, Petesy Burns, Will Smyth,
Marty Martin, Garth McClure, Simon
Morris, Kim Lundgren & of course
the punks.

Ricky Adam took these photographs
between 1997 and 2003 in Belfast,
Northern Ireland.

Featured bands:
Bastard Youth, Knifed, The Dagda,
My Name Is Satan, Submission Hold,
Debt, Runnin' Riot, Sawn Off,
Devils, The Redneck Manifesto,
The Sorts, The Farewell Bend,
John Holmes, Starmarket,
The Dickies.

*The pattern on the right hand side of
the page is an enlarged scan of fungal
mould due to some of the film negatives
being affected by damp air.
A few images have traces of fungal
mould.

BELFAST PUNK
WARZONE CENTRE
1997 - 2003

ALL PHOTOGRAPHS AND DESIGN
BY RICKY ADAM
RICKYADAMPHOTO.COM

© TEXT, THE AUTHORS

Damiani
Bologna, Italy
info@damianieditore.com
www.damianieditore.com

ISBN 978-88-6208-510-6

2017 FIRST EDITION

PRINTED BY
GRAFICHE DAMIANI - FAENZA GROUP SpA, ITALY.

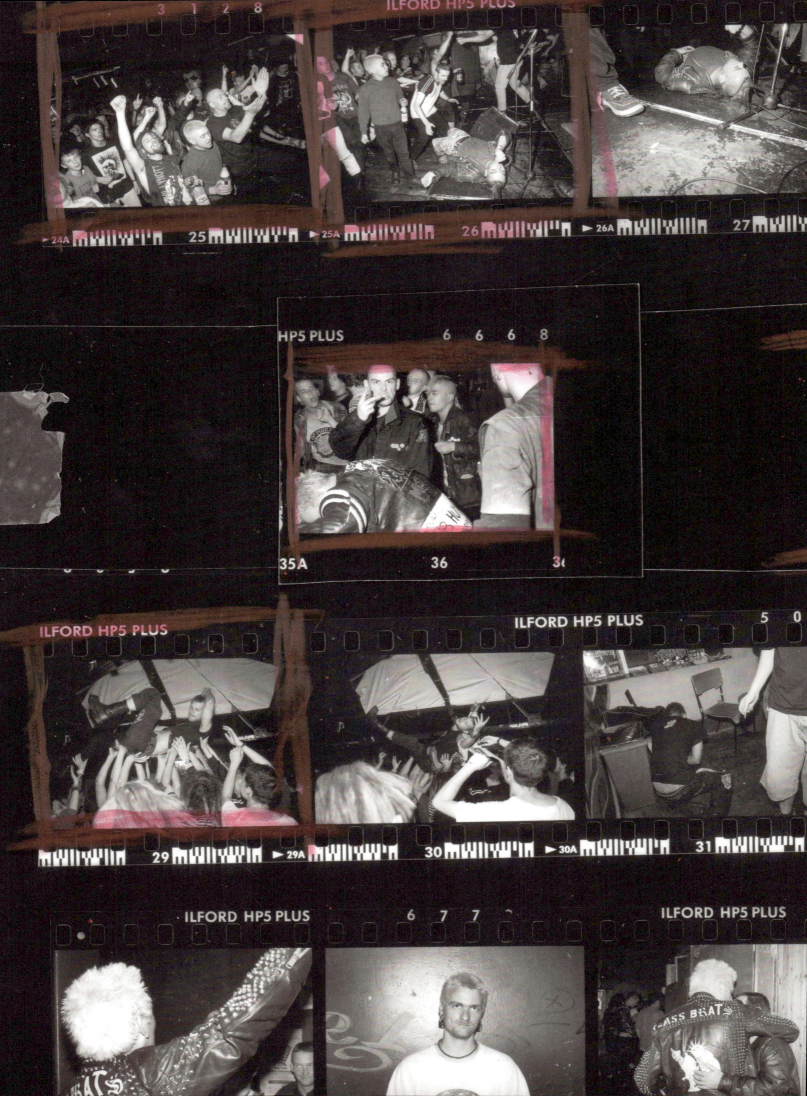